RUDYburckhardt

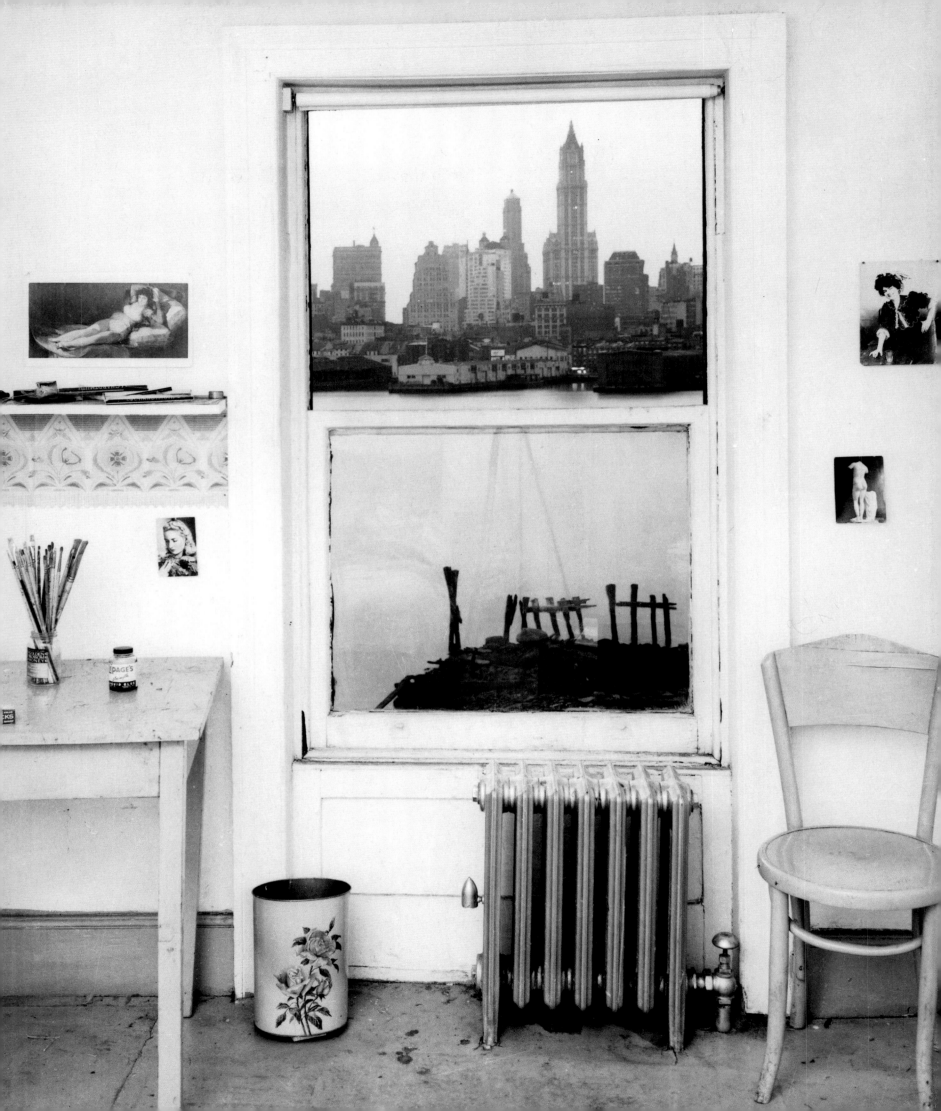

RUDYburckhardt

by Phillip Lopate with an essay by Vincent Katz

HARRY N. ABRAMS, INC., PUBLISHERS

The Estate of Rudy Burckhardt is represented by the Tibor de Nagy Gallery, New York.

EDITOR: Christopher Sweet
EDITORIAL ASSISTANT: Sigi Nacson
DESIGNER: Brankica Kovrlija
PRODUCTION MANAGER: Maria Pia Gramaglia

LIBRARY OF CONGRESS CATALOGING-IN-PUBLICATION DATA

Lopate, Phillip, 1943-
 Rudy Burckhardt / by Phillip Lopate ; with an essay by Vincent Katz.
 p. cm.
Includes bibliographical references and index.
 ISBN 0-8109-4347-6 (hardcover)
 1. Burckhardt, Rudy. 2. Photographers--United States--Biography. 3.
Cinematographers--United States--Biography. I. Katz, Vincent, 1960- II.
Title.
 TR140.B86L67 2004
 770'.92--dc22

 2003021478

Printed and bound in Singapore

10 9 8 7 6 5 4 3 2 1

HARRY N. ABRAMS, INC.
100 Fifth Avenue
New York, N.Y. 10011
www.abramsbooks.com

Abrams is a subsidiary of

LA MARTINIÈRE

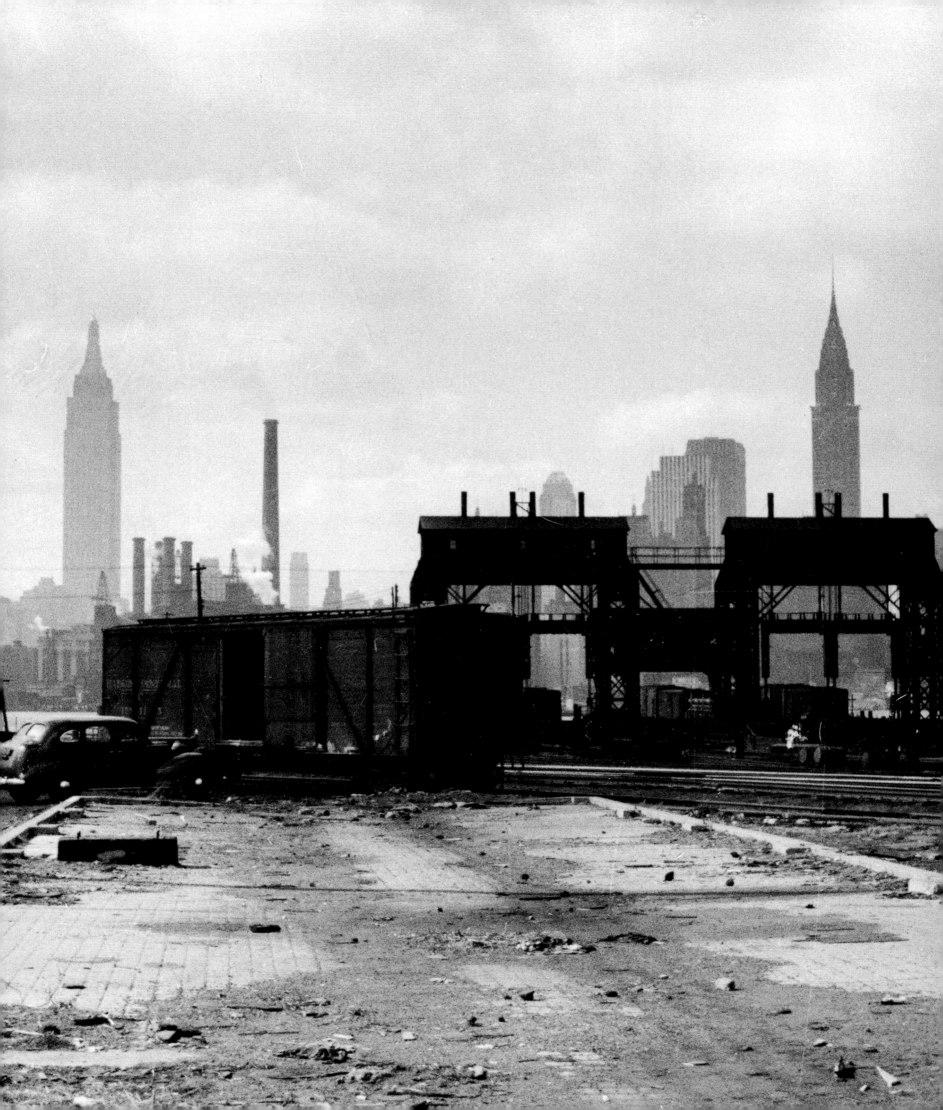

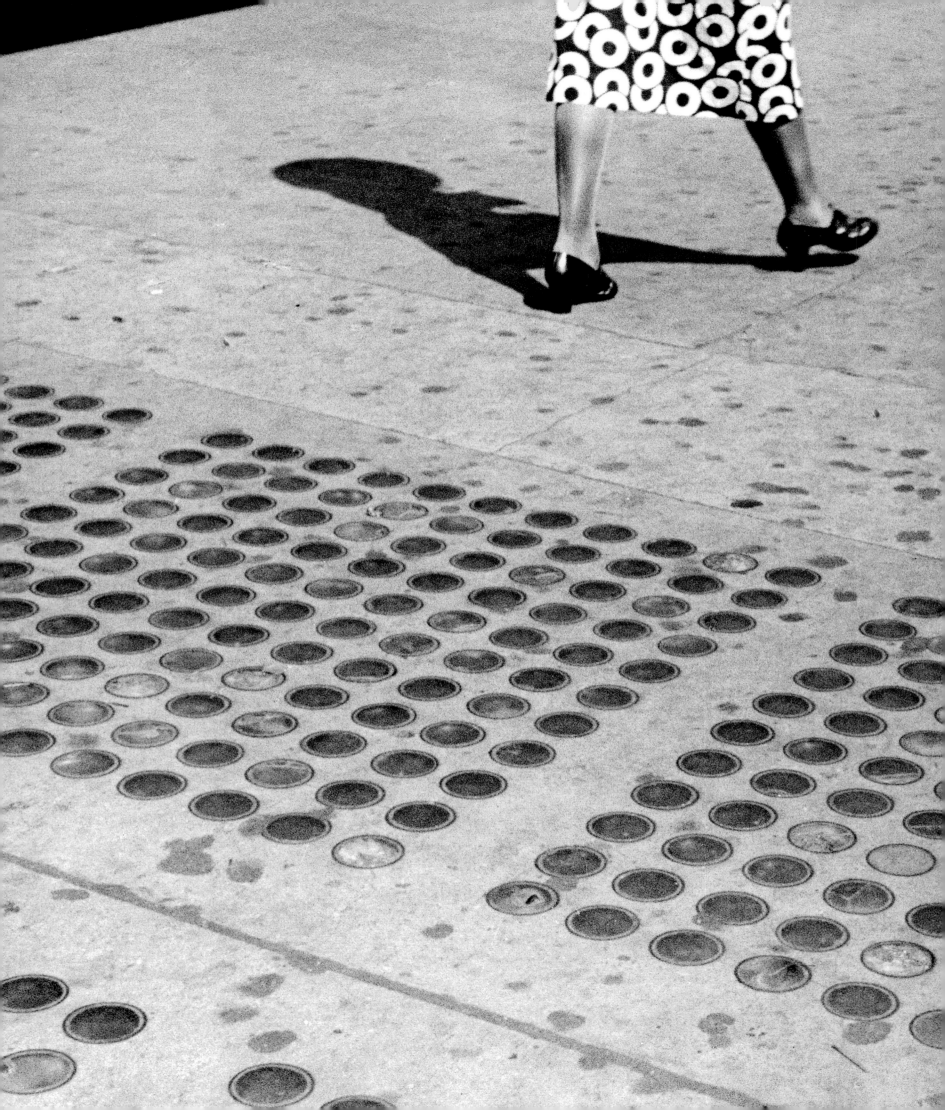

rudy burckhardt's life and work:

how wide is sixth avenue By Phillip Lopate

We are all amateurs, because we never have time to be anything more. — Charles Chaplin, *Limelight*

Dual Citizenship

Rudy Burckhardt, the Swiss-born photographer and filmmaker who spent most of his life in New York, retained dual citizenship. His two passports, in effect, were from Switzerland, the native land he never tired of rejecting, and Bohemia, the little duchy of modern artists in downtown Manhattan where he felt at home. But there were other dual allegiances in his character: he was an endlessly productive craftsman who aspired to relaxed amateurism; an avant-garde loyalist whose most effective images were often traditional and classically measured; a lusty celebrant of women, who retained a life-long emotional attachment to his mentor, friend, and one-time lover, Edwin Denby; a droll merry-andrew who disdained seriousness, and a melancholic who took his life in the end.

John Ashbery, the poet-art critic and his friend, once wrote that Burckhardt "has remained unsung for so long that he is practically a subterranean monument." So often was Burckhardt described in print as "under-rated" and "unsung" that he became virtually renowned for not being famous. Some of his images—photographs of the Brooklyn Bridge, Astor Place, or the Flatiron Building—are now icons, appearing on posters and postcards, while footage from his New York street-films pops up in countless PBS-style documentaries; and still, most of the public does not know his name, as they do the star photographers who were his contemporaries. If this is an injustice that needs to be corrected, it is also the result of an intentional policy of lying low pursued by the artist himself. How was it possible for an artist so prolific and outstanding for decades to have escaped public recognition? Part of the answer lay in the fact that Rudy worked hard at remaining invisible, out of a complicated blend of modesty, fear, and superstition.

In the street, where so much of his key work took place, the impression Rudy gave was of a regular Joe, no one to be intimidated by, the camera around his neck an afterthought. Street photographers often have the vanity that they can make themselves invisible, or so ordinary-looking that you would not give them a second glance, leaving them able to operate with impunity. Slight of build, chameleonlike in his unostentatious khakis, Rudy may have had a head start in the invisibility department.

His strategy, you might say, was to hide in plain sight, by attaching himself to one of the most celebrated artistic circles in the history of modernism. Through collaborations, friendship, and other services, he became the court photographer of the New York School. It was one of the central paradoxes of Burckhardt's career that his work was cherished by such influential painters, poets, musicians, and dancers as Willem de Kooning, Alex Katz, Larry Rivers, Red Grooms, Fairfield Porter, Jane Freilicher, Frank O'Hara, Kenneth Koch, John Ashbery, Elliott Carter, John Cage, Douglas Dunn, Merce Cunningham, Anne Waldman, and other members of the New York School, while being, until recently, all but ignored by the larger curatorial, canon-making worlds of photography. Indeed, Rudy Burckhardt's name has been almost entirely omitted from reference books about American photography, and even from monographs and historical group shows about New York street photography, his specialty. Any explanation of this disparity in reception would have to touch upon the aesthetic assumptions and prejudices of photography curators and historians; the cocooning insularity of the avant-garde; and Rudy's own somewhat self-defeating ways.

In disdaining to promote himself, Burckhardt became a hero to many younger members of

Bohemia. "By dedicating himself to making art and ignoring fame and power," wrote the poet Greg Masters, "Rudy's example mentored a great many younger artists to see the creative process as an ennobling and worthwhile, fulfilling activity." Burckhardt's neglect of the limelight exemplified "the freedom of making art for no ulterior motive," as the poet Vincent Katz put it, even as it obscured his own more complicated feelings regarding ambition and failure.

Rudy Burckhardt's art ranged from photographing street life, nudes, nature, travel scenes, and artists in their studios, to making lyrical documentaries and campy story films, to painting and making collages, to writing sharp, self-deprecating memoir-pieces. His fans, having been exposed to his various image-sets for so long, tended to see all his expressive modes as equally valid parts of this sweet, endearing man. Most critical writing about him has been done by his New York School friends, and is understandably hagiographic and uncritical, with too little sense of placing him in a larger photographic context, while those outside the circle have too often disparaged or failed to appreciate his unique vision. The time has come to take Rudy Burckhardt seriously as an artist, which means reviewing his creative development, and drawing distinctions between his finest achievements and his less inspired work.

To do evaluative justice to his art also means detaching him, to some degree, from the protective coloration of the pack he ran with. Since his death, recent exhibitions have stressed precisely his connection with New York School luminaries, and their regard for him. Perhaps underlying these pairings is the solicitous notion that Rudy's reputation can only rise from proximity with bigger names. Of course, it is entirely valid for art

historians to group Rudy Burckhardt with this circle, since he collaborated extensively with members of the New York School. But this particular biographical essay will try to place the central focus on Rudy, his life and work. As the author himself was a friend of the photographer for the last twenty-five years of his life, he can hardly pretend to a pure, scholarly detachment. The goal of this monograph is not so much spotless objectivity as the promotion of a more complex understanding of Rudy Burckhardt, by exploring a life resonant with enigmas, and by trying to interpret the rich body of images he left us.

Childhood and Youth in Basel

"I was born with a silver spoon in my mouth, and have been going downhill ever since," Rudy Burckhardt liked to say. He was born at the onset of World War I, in 1914, in neutral Switzerland. He came from a well-to-do, respected family; the Burckhardts had one of the leading patrician names in Basel. "From 1655 to 1798 there was not a year when one of the two *Burgermeister*s of Basel was not a Burckhardt or the husband of a Burckhardt," wrote cultural historian Lionel Gossman, in his magisterial study, *Basel in the Age of Burckhardt*. The art historian Jacob Burckhardt (1818–97), author of such classics as *The Civilization of the Renaissance in Italy* and *The Cultural History of Greece*, was Rudy's relation. Rudy's father, Rudolph Burckhardt, owned a silk ribbon business. The Burckhardt clan's principal source of wealth, and the mainstay of Basel's prosperous economy, was the manufacture of silk ribbon, and the *Bändelherren*, or ribbon lords, held sway over municipal affairs. Rudy's mother, Esther Iselin, came from a leading Basel banking family; her father had been a general and judge.

Evidently, this distinguished family name was a source of some chagrin to young Rudy, a burden to live down. He later recalled, in the book-length interview he did with the poet Simon Pettet, *Talking Pictures*, his acute embarrassment at entering a bakery "and the girl behind the counter would say, 'Oh, Mr. *Burckhardt*, what can I do for you?' I couldn't stand that. Now if she had been flirting, that would have been alright, but she was just being subservient, because I was from a so-called good family." Years later, the elderly Rudy paid a return visit to his hometown, and cringed when Baselers bowed and spoke his family name with deferential respect. "He hated it," his second wife, Yvonne Jacquette, who was present on the trip, recalled.

Whatever covert pride he may have felt in being a Burckhardt, Rudy was overtly repelled by the pomposity of power and dubious of his ability to assume its mantle, given his family role and early sense of insufficiency. A slight, unathletic youth with delicate features and long eyelashes—in photographs he looks handsome in the manner of a young Buster Keaton, stiff and ill at ease with the lens's attention. He had two older sisters, a younger sister, and a brother, and he grew up the affectionate butt of his older sister's jokes. They made up a jingle about him: *Without ears and without eyes/He goes through the world.* His mother, who was religious (Lutheran) and a strict disciplinarian with the older girls, pampered Rudy more, but also despaired that he would ever amount to anything. His grades were merely average: Receiving the classical neohumanist education that was then de rigueur for well-bred Basel youngsters (it stressed the study of Greek and Latin language and literature, as the best means to develop an individual, free, and creative spirit), he seemed a dreamy, less-than-industrious stu-

dent. He knew only that he did not fit into the "proper and clean" (his words) Calvinist-Lutheran atmosphere of Basel.

Rudy always spoke of Basel as a ridiculously provincial, stifling city, ruled by cultural philistines who thought only about money. While certainly true to a point, as other witnesses complained, there was more to Basel than that. The chosen residence of the great essayist Erasmus, the painters Holbein and Böcklin, and the mathematicians Bernoulli and Euler, it had been one of the centers of humanist thought. A proud city-republic (independent for six hundred years before ceding its autonomy to Switzerland in 1874), situated on the Rhine, Basel stood at the border of France, Italy, and Germany, and was nourished by their respective influences. The University of Basel, which dated back to 1460, became a training ground for young, brilliant scholars on their way to more prestigious appointments. It attracted the philosopher Friedrich Nietzsche and his friend the radical theologian Franz Overbeck, who joined two native sons, the philologist Johann Jacob Bachofen (known for his theory of matriarchal societies) and Rudy's relative, the previously mentioned Jacob Burckhardt, in the mid-nineteenth century. Together, these four thinkers developed a Baselian critique of modern society that was skeptical, ironic, unorthodox, and far-reaching.

Lionel Gossman, in *Basel in the Age of Burckhardt*, argues that precisely because Basel was conservative, insular, and somewhat off the beaten path of modern metropolitan life, it could play host to this efflorescence of "unseasonable" ideas. Jacob Burckhardt, who complained in a letter that Basel was "an unsociable city offering almost no intellectual stimulation," nevertheless chose to return there after his travels in Italy, perhaps because it

was the family seat. A lifelong bachelor (Rudy thought his great-uncle might have been gay), the historian would show up occasionally at family gatherings, perplexing his commerce-minded relatives by the combination of unmarried status and erudition.

But the town's dominant note was still one of stuffiness. "It seems, in sum, that there was no lively public culture in Basel, no large and varied leisure class, and only a limited artistic and literary life. The city's cultural activities, parceled out according to social classes, and affording few occasions for the entire citizenry to come together, had a narrow, small town character and could not cast off the constraints imposed by a commercial religious leadership," wrote Gossman. It was this very stratification of class, and the reserved, hypocritical social relations it imposed, that Rudy found most distasteful, and that eventually drove him to embrace the Whitmanesque democracy of Manhattan's streets. Beyond that, he saw New York City as a dynamic place constantly undergoing change, whereas, he said, "In Basel, nothing ever changes."

The Basel in which Rudy grew up was a small city of 100,000 that still retained its medieval outlines. It had a few museums, based on local private collections, and some burghers dabbled in art, among them Rudy's mother, who had made careful, pretty watercolors of flowers and mountains as a young woman. The one art openly embraced by Baselers was music. Rudy himself developed a wonderfully sensitive ear, which stood him in good stead (he became the most musical of film editors). Some of the mental electricity engendered by Nietzsche and others during the years 1850–1890 may have still lingered in the air three decades later—a countercurrent wafting through the academic halls and coffee-

houses of Rudy's youth. In any case, Basel probably gave him a more sound intellectual and artistic foundation than he could later admit.

A Death in the Family

When he was fourteen, Rudy's father, who told funny stories, drank beer, had an eye for women, and seemed more easygoing than his nervous, fastidious mother, died at the age of fifty-two of a blood clot after a hernia operation. In *Talking Pictures*, Rudy described the traumatic event:

> I remember when my father died, I was pretty shocked. He died very suddenly when I was 14 years old. I was in boy scout camp and got this telegram. We were sitting at lunch outside and someone hands me a telegram. That was an event in those days, a telegram. As I was opening it, one guy calls out, "Hey, he looks as if his father just died." I didn't enjoy that too much. Anyway, so it says, YOUR FATHER'S VERY ILL, COME HOME IMMEDIATELY. So one of the leaders took me to a train. I went home. My mother met me at the station. My father had already died (she didn't say that in the telegram).
>
> There was a lot of confusion in our house, all the getting ready for the funeral, ordering the announcements, how big the black border should be, things like that. And my mother was running around, totally nervous. That night I fell asleep and I slept very long and well. I got completely blanked. And, next morning, the maid says, "How could you sleep? The day after your father died!" How could I sleep? You're not supposed to sleep? I got so furious. You're not supposed to sleep, you're supposed to cry. And I could never… I cried about three times in my life, maybe. And it was always on silly occasions, like a cowboy movie (guy riding away in the dis-

 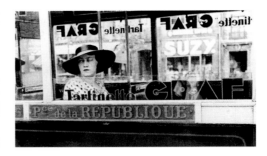

LEFT TO RIGHT: Class picture, Basel, 1932 | Gymnasium, Basel, 1933 | Tartinette, Paris, 1934

tance) when things just seem too beautiful, seem incredibly beautiful, like a sunset, so incredibly beautiful it would almost make me cry, almost. I find that I don't feel what I'm supposed to be feeling at certain times. I've always been this way. . . . I used to think there was something wrong with me.

Could it be that beneath Rudy's characteristically ironic tone there lies genuine guilt, and underneath that, a bedrock stubbornness? The sense of being odd, or abnormal, in one's reactions can also inspire a determination, typical of those with an artistic vocation, to have one's particular say no matter what. Rudy's images often exhibit an angled take, whimsy where you would expect pathos, or vice versa.

The death of Rudy's father marked an end to his childhood, and brought on a deep despondency and the longing to escape his family surroundings. Not rebellion. "I didn't have the energy to rebel. I didn't have a strong enough temperament. I was a good boy. I didn't make any trouble…because I wasn't assertive enough. So I just had to leave. If I'd been stronger, I could have stayed there and lived my own way, and shocked them a little bit, maybe, but I was too timid and quiet, so I could only do it by leaving."

At fifteen, he began plotting his escape from Switzerland. (Fortunately, he was never pressured to take over the family business, because it was sold soon after his father's death; women's fashions for short hair had in any case lessened the demand for ribbons.) At that time Rudy also started fooling around with pinhole cameras and photography. His initial career plan was to earn a medical degree. He spent a year in Geneva taking pre-medical classes. When he was nineteen, in 1933, he traveled to London to study medicine and, instead of going to classes, explored the great metropolis and photographed it—his activities as walker in the city and photographer inextricably linked from that point on. "London was immense, a revelation. I could walk all day through slums where men were lying in the street, and never reach the end of it," he wrote in his collection of memoir pieces, *Mobile Homes.* He was elated by the smell of urine.

He would escape from his social class, temporarily, by slumming. In Paris he sought out "the mysterious bordellos," where "I found out I liked Negro girls," and the seedier parts of the city. "Coming from one of the best families of Basel," he wrote in *Mobile Homes,* "I had to work my way down to find out what life was really about, but being careful by nature and upbringing, I didn't go all the way. I didn't become a beachcomber in the tropics or a bum on the Bowery or go crazy from syphilis. Drugs were not around and by the time they were, I was afraid to try. So it was traveling for me, looking for the exotic and for sex adventures far from home."

Rudy's itch for revenge against his hygienic background was lifelong: years after, he continued to seek out such experiences. "One night . . . in Baltimore, a black girl picked me up and we did it standing up in a dark alley and I felt I was getting even with my Swiss upbringing (clean)." He was not alone in this almost compulsive Swiss-artist need to affront respectability: one thinks of the Jean-Luc Godard of *Hail Mary,* or Robert Frank's *Cocksucker Blues.*

Rudy dropped out of medical school and returned to Basel, where he rented a studio room, to the dismay of his mother and sisters who wanted him to live at home, and moped around, took photographs, and experimented sexually with an arty young man named Erhard. He was twenty years old when Fate sent him Edwin Denby, who knocked on his door, needing a passport picture. Denby, subsequently one of America's greatest dance critics and a very fine poet, impressed Rudy as the real cosmopolitan: he had already undergone psychoanalysis in Vienna, smoked opium with Cocteau, and performed as a comedy dancer in Berlin. They began spending all their time together. "I remember he once embarrassed me by demonstrating a dance step right in the middle of town," he wrote in *Mobile Homes.* "Erhard told me Edwin—then thirty-two—was passé, but I could tell he was jealous." Rudy's mother was impressed with Denby's good manners, and gave her son some money so that the two could go off to Paris for a few days. "We went to gay transvestite bars. Back in Basel, I dressed up as a girl for the carnival, a time when anything goes for three days, as long as you behave properly the rest of the year." Then Denby returned to New York.

Some months later, when Rudy reached his twenty-first year, he came into an inheritance from his father, and decided to join his friend in New York. Years after, the family myth would persist that Edwin had "corrupted" the younger man: Rudy's mother spoke of Denby facetiously as "the man who abducted you." The truth was, Rudy had been itching to get away.

New York in the Late 1930s

The inheritance, $20,000, made for a considerable sum in 1935, but it had to be guarded frugally to extend his time of freedom. Rudy and Edwin rented a bare space for $18 a month at 145 West 21st Street, in the Chelsea district, "fixed it up roughly for living" though "It wasn't legal," and proceeded to live the loft life years before it became the fashion. Rudy was what we would call today a

 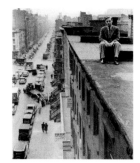 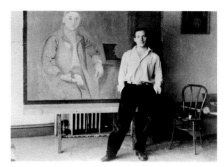

LEFT TO RIGHT: Self-portrait, New York, 1937 | In Haiti, 1936 | Edwin Denby on 21st Street, New York, 1937 | Willem de Kooning, 22nd Street, 1938

"trust-fund kid." Edwin had received a small allowance from his family, but it was not enough, and at times they both lived on Rudy's money, a situation the younger man found himself "resenting a little," he recalled later. But not much: he was getting too valuable an education to complain.

Edwin, already a connoisseur of the performing arts, knew everyone. Soon Rudy was introduced to a heady mix of New York composers and theater people, which included Paul Bowles, Aaron Copland, Virgil Thomson, Bertolt Brecht, Kurt Weill, Lotte Lenya, Lincoln Kirstein, and Orson Welles. (Denby had adapted *and* played the rear legs of the horse in Welles's *Horse Eats Hat,* a version of Labiche's farce.) They went uptown to millionaires' parties, or threw their own, attended by Weill, Lenya, and the rest of the gang. It was a Continental, Europhilic scene, which must have helped the young Swiss émigré feel at home, even if he later remembered not saying much, mostly listening.

Rudy had not yet found his métier, but he had begun to film New York, using his social circle as actors. The first of Rudy's 16mm films, a spoof called *145 West 21,* was made in 1936 and had cameo appearances by Paul Bowles, Aaron Copland, John Latouche, Virgil Thomson, and Edwin. The second, *Seeing the World, Part One; A Visit to New York* (1937), a satire of a conventional travelogue, offered glimpses of Joseph Cotten, Virginia Welles (Orson's first wife), and Edwin, of course. These films are priceless historical documents of the art world, and great fun to watch, but they remain cinematically slight, the equivalent of amusing home movies. Rudy, pursuing a hobby at this point, was tolerated though not taken especially seriously. He was referred to, humiliatingly, as "Edwin's Little Friend," a label he never forgot. In fact, he was already used to being belittled by

classmates and teased by his sisters. It was Edwin who first spotted something unique in him, a gift for pure seeing; and the older man's faith in that gift breathed confidence into Rudy as an artist.

Rudy took a memorable picture of Edwin in 1937 on the roof of their 21st Street building: the composition allows us, simultaneously, to see both its subject—staidly dapper, in a suit, vest, and tie—and the street below, with a truck unloading diagonally. There is something Keatonesque (the two men shared Buster's dazed deadpan) about a properly attired Denby just sitting there, as if he had been shot from a cannon and had landed calmly on the roof.

Rudy was certainly aware of the Freudian, father-replacement role that others might read into his relationship with Edwin; but he denied it. In a 1984 statement written after Denby's death, he reflected: "What was Edwin to me? Not a father, not an older brother, not a teacher, though he opened my eyes to many things over the years, not much of a lover (neither was I), rather a friend I could always rely on. We never seriously quarreled."

Next door to them lived a painter named Bill de Kooning, who was quite poor and played flamenco, singing very loud. De Kooning's cat used to wander onto their fire escape, which led to their becoming friends. The painter would meet Rudy and Edwin for coffee at midnight at Stewart's Cafeteria, and stay up all night talking with them, or take them downtown to the Club, where abstract artists met and had fierce discussions. "We helped him out now and then, and he gave us some paintings in return." (Years later, these small, jewel-toned early paintings by de Kooning would be worth a lot.)

Edwin Denby's reminiscent essay called "The Thirties," written in 1962, gives us some sense of the shared aesthetic the three men were evolving:

I remember walking at night in Chelsea with Bill during the depression, and his pointing out to me on the pavement the dispersed compositions—spots and cracks and bits of wrappers and reflections of neon-light—neon-signs were few then—and I remember the scale in the compositions was too big for me to see it. Luckily I could imagine it. At the time Rudy Burckhardt was taking photographs of New York that keep open the moment its transient buildings spread their unknown and unequalled harmonies of scale. I could watch the scale like a magnanimous motion on these undistorted photographs; but in everyday looking about, it kept spreading beyond the field of sight. At the time we all talked a great deal about scale in New York, and about the difference of instinctive scale in signs, painted color, clothes, gestures, everyday expressions between Europe and America. We were happy to be in a city the beauty of which was unknown, uncozy, and not small scale.

The Early Photographs of New York

"IT'S NOT SO MUCH THAT I AM AN AMERICAN: I'M A NEW YORKER."
 - Willem de Kooning

"I REALLY BECAME A NEW YORKER RATHER THAN AN AMERICAN. . . . THERE ARE SO MANY MIXTURES OF PEOPLE. THERE'S NO OTHER PLACE LIKE THIS. ANYBODY CAN BECOME A NEW YORKER, REALLY. BUT YOU CAN'T SAY THE SAME OF PARIS OR ROME, YOU NEVER BECOME A FRENCHMAN OR AN ITALIAN."
 - Rudy Burckhardt

When Rudy first came to New York in 1935 he felt intimidated: "I was quite overwhelmed with its grandeur and ceaseless energy The tremendous difference in scale between the soaring buildings and people in the street astonished me

 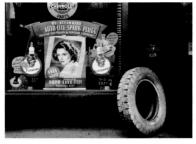 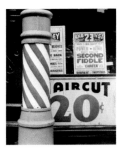

LEFT TO RIGHT: Sidewalk, New York, 1939 | Priscilla Lane, Brooklyn, 1948 | No Encroachment, New York, 1938/39 | Haircut 20¢, New York, 1939 | **OPPOSITE:** DETAIL Soda Counter, New York, 1939

and it took a couple of years before I felt ready to photograph." When he did begin photographing the city in 1937, it was initially on a modest scale: "I started with details. Setting up a 9x12 cm view camera on a tripod I made plain, direct photos of walls, building entrances, stand pipes, candy stores, barbershops, Coca Cola or telephone signs."

Soda Counter, 1939, for instance, presents a barrage of competing signs for ice cream, sodas, cigarettes, and public telephone, affixed to a flecked marble surface. Another photograph shows the actress Priscilla Lane's lovely face and bare shoulders hawking Auto-Lite spark plugs in a storefront display, upstaged by an old tire. All this advertising imagery, Pop art *avant la lettre*, mixes with the iron, rubber, and masonry of the modern street. The round Bell System public telephone logo often resurfaces, as do manhole covers, hydrants, stand-pipes, marble or granite cornerstones. The 1938 *No Encroachment* is a masterful composition of imposing doorway and outer wall, juxtaposing horizontal stone blocks and marble base with delicate vertical ironwork and stone column. Mondrian was an artistic hero of Rudy's, and from the complex rectangular compositions in these photographs we may detect that influence. It could also be argued that Rudy was one of the first to employ minimalist, Mondrian-type aesthetics in street photography.

In *Haircut 20¢, New York*, 1939, a striped barber pole, partially blocking the "H" on the storefront, shares the frame with a movie poster advertising Tyrone Power, Sonja Henie, and Rudy Vallee in *Second Fiddle*. A 1940 billboard for a double feature of *Little Old New York* and *Charlie McCarthy, Detective* pops up improbably in a weedy Queens lot. What makes these photographs fresh today is how little they attempt to seduce— their prosaic straightforwardness enticing our

jaded eyes. They also constitute an invaluable record of urban archeology, teaching us what a Manhattan manhole, fire hydrant, or the light globes on a sidewalk looked like about 1940.

From inanimate objects, storefronts, walls, and doorways, he moved on to the human presence. "With a small, handheld Leica camera I snapped moments of people in the anonymous space of midtown, as they moved through the street, barely avoiding collision, on any day, in traffic, against storefronts, hydrants, signs." The human subjects caught unawares displayed that private preoccupation in public places that is so much a part of the metropolitan melodrama.

More and more, his subject matter turned to the street itself: the concrete sidewalk, the legs moving through an asphalt intersection, the curb's declension, the jostlings of people with motor vehicles. He became a master of the subtle topography and geometry of the New York grid.

As a street photographer, of course, Rudy had plenty of company: in the late 1930s through the 1940s, he was part of a whole photographic stratum snapping away at New York. It included other émigré photographers, such as André Kertész, Lisette Model, and Andreas Feininger, refugees from Hitler-occupied Europe who also were dazzled by New York's extremities of scale (like Rudy, they photographed skyscraper tops and pedestrian legs), while amused by its grimy glamour; then there were the home-grown stars, Walker Evans and Berenice Abbott and Weegee and Helen Levitt; the grand old men, Alfred Stieglitz and Edward Steichen, still in the picture; the socially-conscious Photo League group—Walter Rosenblum, Sid Grossman, and Ben Shahn. Soon a new bunch of edgy street photographers— Robert Frank, Garry Winogrand, Lee Friedlander, Diane Arbus—would be pushing at the gates.

For all these, the street was the grand subject, the meeting-place of class contradictions, aesthetic anomalies, and historic eras (modernism versus flea-market agora). Inevitably, there was a certain overlap in subject matter, because there are only so many things you can photograph in a street. Individual differences emerge in point of view: how much to stress this pattern, that mood, whether to play up or down the freakishness.

Consider the figures walking by Rudley's cafeteria in Burckhardt's *Hot Roast Beef Sandwich 25¢* or the working man in tee shirt and suspenders shlumping past a sign that says "Reopen Soon." Poignant and vividly amusing as they are, inevitably they call to mind Berenice Abbott's or Walker Evans's earlier photographs of Depression-era shop windows. The question should not be, How original was Rudy's street iconography? but What new talent of observation did he bring to the material?

A comparison between Evans and Burckhardt may be particularly apt in highlighting the unique gifts of each artist, as well as the reasons for Rudy's unsettled place in the photographic canon. I once heard Rudy referred to by a photography curator as "a minor Walker Evans." Now it's true that many of the subjects Rudy photographed in the Thirties and Forties—storefront signs and movie posters, vernacular architecture, pedestrians, subway riders, travel shots of the Caribbean or the South— had already been magnificently photographed by Evans. Sarah Hermanson Meister, who curated a show of Rudy's Astoria photographs for the Museum of Modern Art, writes in her catalogue essay about the correspondences between Evans's and Burckhardt's approaches, without adjudicating the issue of influence: "In 1938 the Museum of Modern Art published Walker Evans's seminal sequence of images simply but boldly entitled

SERVED FROM
7 A.M. TO 11 A.M.

CREAM SODAS 1

‏RTON'S ICE CREAM

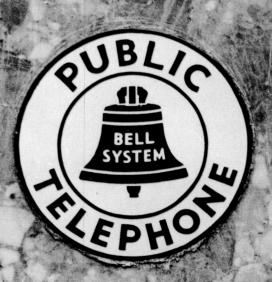

BIG DOUBLE TREAT CREAMSICLE 5¢

PUBLIC TELEPHONE
BELL SYSTEM

Double Mellow
OLD GOLD
FINER...FRESHER
CIGARETTES

Old Gold
CIGARETTES

THE TREASURE OF THEM ALL

Old Gold

"MELODY AND MADNESS"

Robt. BENCHLEY
and Artie SHAW
On The Air · Every Week

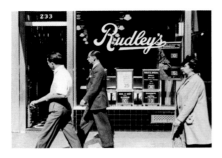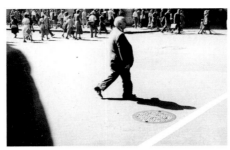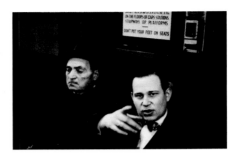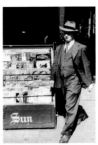

LEFT TO RIGHT: Hot Roast Beef Sandwich 25¢, New York, 1939 | New York, 1945/1947 | Hey!, New York, 1947 | Sun, New York, 1939

American Photographs. The book's eighty-seven plates illustrated a sea change in the rules for advanced photography: the most mundane or ordinary fact could be the stuff of visual poetry. Burckhardt began photographing in New York at this precise time, and his impulse to capture unheralded aspects of daily life in New York without fuss or fanfare coincided perfectly with this new aesthetic."

But Rudy's work is lighter in every sense: more playful and tender, less melodramatic, more true to the spirit of the everyday. He also printed lighter. Rudy once told me in passing that he wanted to avoid the "heaviness" that Paul Strand, great as he was, draped over every photograph. Walker Evans, too, made every photograph into a little coffin or sarcophagus—and it is precisely this *nature morte* element, this *gravitas*, which is so often perceived professionally as the signature of a distinctive style.

There is no disputing that Rudy not only knew Walker Evans's work, he knew the man himself, however slightly. One time he worked up the nerve to show the maestro his photographs. "What did Evans think of them?" I asked, curious. "Not much," Rudy recalled with a complicated smile, still trying to process the memory years after. "Bland, I guess. Something missing, from his point of view." In *Talking Pictures*, Rudy recalled that Evans had called them "precious." It is interesting to hear the episode from another angle. We find in James R. Mellow's biography of Walker Evans: "It was perhaps through Haggin [Bernard Haggin, the music critic] that Evans made the acquaintance of the young photographer Rudy Buckhardt and the noted dance critic Edwin Denby, both of whom were protégés of Haggin. Jane [Evans's wife] recalls that Burckhardt only once turned up in their apartment on some matter of business, but

suspects that no relationship developed there, largely because Evans was chary about relating to other photographers." As was Rudy, of course!

One way to look at the "something missing" from Burckhardt's work, in Evans's opinion, which he thought rendered them "precious," was something Rudy refused to put in: a kind of brutality. Many of Evans's photographs are dark, in both senses of the word: printed darkly, and with an emphasis on the harsh, unpleasant side of things. Both photographers did wonderful series on the New York subway. Where Evans's riders tended to be morosely isolated, one figure per shot, immersed in massive shadow, Rudy's riders were often more communally grouped, and more comically vivacious, gesturing like Yiddish actors (see the bow-tied extrovert in *Hey!, New York*, 1947) or turning ostentatiously away from each other (like the F train denizens of *Subway*, 1947). Similarly, while Evans emphasized the theme of alienation in his street photographs, Rudy's portraits of self-absorbed pedestrians embedded them in a consoling street life. See, for instance, Rudy's superb shot of the man with a Sydney Greenstreet belly spring-stepping into his shadow in the middle of the street, alone, yet with dozens of background strollers nearby. Evans frequently shot *up* at a pedestrian, isolating the figure momentously and expressionistically against the sky. Rudy often incorporated the sidewalk line, to ground his human figures in an objective horizon.

In Rudy's *Sun*, 1940, a man in a three-piece suit and tie walks by a newsstand stacked with magazines, his fedora hat tilted down at a jaunty angle, while his mouth tilts up the opposite way in a snickering grimace. The frame is divided almost down the middle between this formally dressed businessman on the right, lost in his own thoughts, and the periodicals, ripe with opportu-

nity for distraction, on the left; the man has just begun his stride into the space of the magazine rack, giving the photograph a needed dynamic action. The man's hat casts crescent shadows over his wary eyes, dividing his face like a Venetian carnival mask, but his chin and mouth are bathed in sunlight, and at the bottom of the newsstand leaps forth the single word "Sun" (short for a daily, the *New York Sun*). The man may be grumpy, but the photograph is not. It offers heliotropic pleasures to balance the subjective prison of self-absorption.

"Despite their bad character, their art is mild," Edwin Denby wrote of humanity in a poem. This *mildness* is the key to the shared aesthetic of Denby and Burckhardt. It is what Walker Evans was noting in Rudy's photographs as a lack. William Carlos Williams wrote of Evans's photographs, "they pack a wicked punch." That toughness, that going for the jugular, is so much a part of American photography's aesthetic unconscious, from Paul Strand's blind woman to Evans's sharecroppers to Weegee's corpses to Robert Frank's drifters to Diane Arbus's freaks to Garry Winogrand's motel isolates to Mary Ellen Mark's madwomen to Richard Avedon's dying father to Joel Peter Witkin's torture scenes, that we don't question it anymore. Even when a photographer's subject matter is benign, something about the technique must assert a more rigorous mentality for professional curators to accord it respect.

Another part of the "meaning" sometimes thought missing from Buckhardt's photographs was an explicit social-consciousness message. How many photographers from the Thirties and Forties underlined that subtext: Little-Man-trapped-in-the-coils-of-capitalist-fate. You were invited to feel pity for the poor schlubs, with vari-

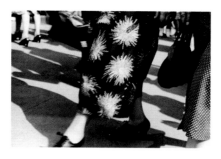

LEFT TO RIGHT: Midtown, New York, 1939/40 | Curb, New York, 1973 | Lamp Shadow, New York, 1968

cose veins, dragging their grocery sacks while toasting their triumph-of-the-human-spirit resiliency. Compared to Ben Shahn or Dorothea Lange, the people in Rudy Burckhardt's photographs have a breezy freshness; they can't be bothered feeling heroic or anguished, they're too busy going down the street, getting from one place to the next.

Rudy has often been praised by fans (including myself) for his warmly tolerant, nonjudgmental, undogmatic imagery, which avoids the clichés of social-protest art. In truth, I don't think there can be such a thing as entirely nonjudgmental, apolitical art. Burckhardt's photographs do suggest a politics of preference: the "common man," to use the term popular in the Thirties for the poor and lower-middle-class, is given the nod over the rich as subject matter; the ghetto flowerpot over the palace garden; the nude over the splendidly clothed. If he could not be bothered to participate in politics, he remained all his life a liberal Democrat who gave money to progressive causes and to poor individuals; and his stance vis-à-vis the art world implied a principled hostility toward power. Still, in comparison to the more tendentiously committed American photography during these years, his images do look relatively free of social messages—and intentionally so.

There is a lovely 1940 photograph by Rudy, called *Midtown, New York*, which shows the lower portion of two women, one in a flower pattern of white cosmos against a black background, the other in a dotted-Swiss dress, while all around them shadows cross diagonally on the pavement. It is vaguely reminiscent of Lisette Model's 1937 photograph of a heavyset woman in a floral dress. Of course, fabric pattern remains one of the working variables in street photography. But it was characteristic of Model to place a corpulent, queasy-mak-

ing figure smack dab in the center, just as it was typical of Rudy to balance several pedestrians against each other. If some peculiarities of costume and profile are offered to view by Rudy, they are not exploded at you like the obesity of a Lisette Model figure or the mad look of an Arbus subject.

The art critic Thomas B. Hess summed up these distinctions in his *New York* magazine review of Burckhardt in 1975: "Cartier-Bresson's photographs capture special actions, peculiar grimaces, that seem extraordinarily revealing and never to be repeated. Evans's views are steeped in the nostalgia of history, in a sense of the universal. Rudy Burckhardt's photographs are of things which are 'there and there and there,' as Elaine de Kooning has said. You see for the first time what's all around you. And in a magically commonplace light, filled with delicate grays—a clarity without contrast."

The Poet of Public Space

If Rudy did have a political slant, it was in celebrating the democratic possibilities of shared urban spaces. *How Wide Is Sixth Avenue*, a title he liked so much he used it for two separate films (the first, a delicate black-and-white silent done in 1945, and the second, a raunchier but equally rewarding color film, 1963), suggests his curiosity about the inclusiveness and extensibility of a workaday, unsung New York street, which he lived near and which therefore happened to be close to his heart.

Public space in New York has a different character from that of European cities. In Europe, public space is more ceremonial, with plazas, boulevards, or formal gardens laid out on such beaux-arts principles as the circle or octagon, like the Ringstrasse in Vienna, or else there are sudden openings in the narrow urban fabric, such as the large medieval squares of Basel with which

Rudy had grown up, the Munsterplatz in front of the cathedral and the Petersplatz by St. Peter's Church. In New York, however, particularly above Fourteenth Street, everything adheres to a grid, which best supports the functional urgency of traffic and pedestrians kept moving. The people using midtown streets in Rudy's photographs are not Parisian dandies luxuriating in flâneur idleness, they are going about their business with "ceaseless energy," as he put it, dodging colliding bodies, seeking the shortest distance between two points. Yet this jangling busyness only underscores the fact that New Yorkers have a great, binding trust in and relationship to public space. The city's major strength lies in its street life.

One of his greatest photographs, *Astor Place, New York*, 1947, gives us a bird's-eye view of a complicated public space, with rectangular and triangular lines converging, the result of a broad street butting up against an interruptive building and streaming off into two narrower ones. This kind of opening in the street fabric would be celebrated in Rome with a ceremonial fountain or church; in New York, the climactic icon is a billboard with the words "Have a coke" and a grinning woman ("the Coca-Cola goddess," Rudy dubbed her) with a gleaming white-toothed smile, who offers us her bottle of refreshment. Prominent though she is, everyone in this secular scene ignores her. We see in the center of the street-bed a triangle whose borders are barely painted in—the future site, perhaps, of a little park with benches for pedestrians seeking a momentary respite, though now it is nothing but a ghostly promise, and the place to put a subway kiosk. Meanwhile, passersby cross the street, some at the prescribed crosswalk and others, in lawless New York fashion, wherever they please, while still others distribute themselves randomly on the side-

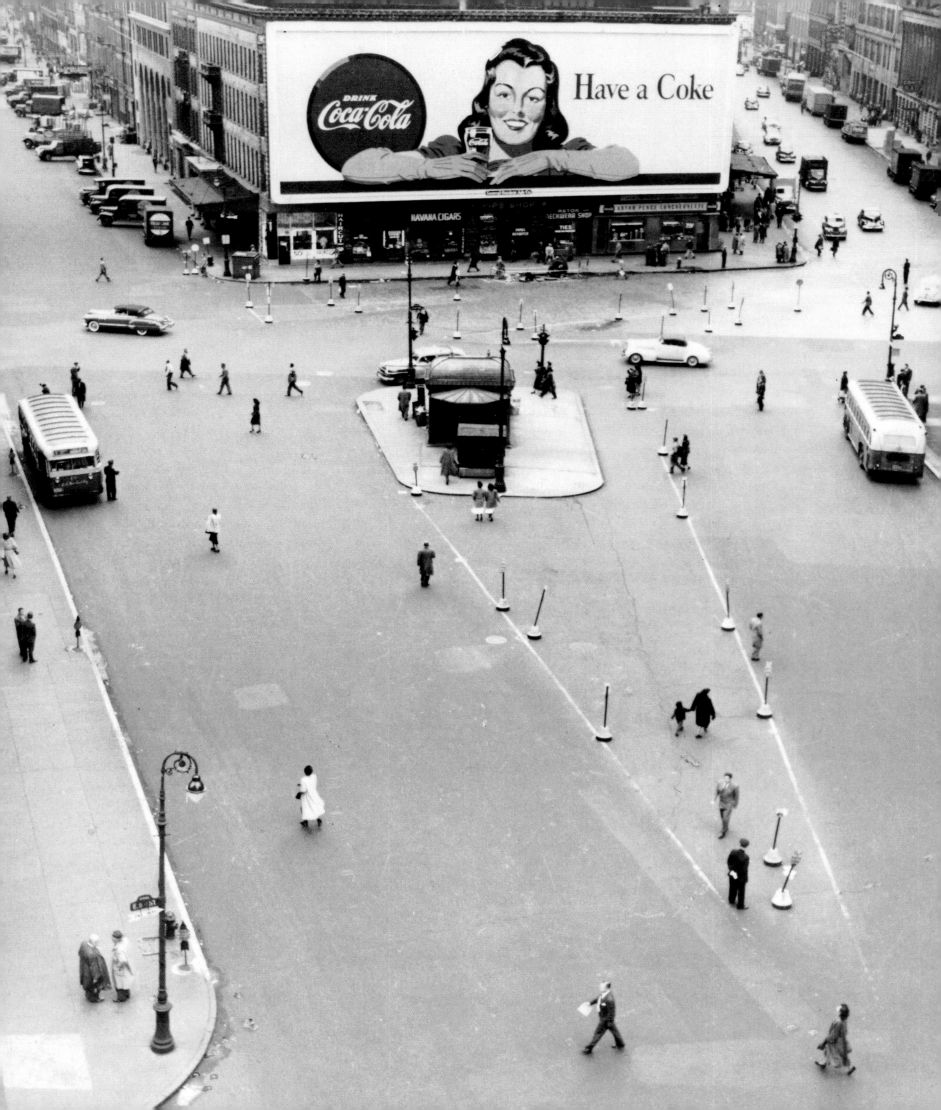

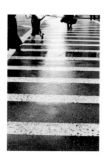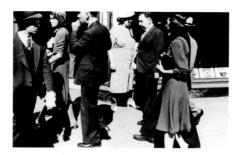

OPPOSITE: DETAIL Astor Place, New York, 1947 | LEFT TO RIGHT: Sidewalk, New York, 1993/95 | Crosswalk, New York, 1995 | New York Moment I, 1940

walk. With few cars on the road at that moment, this Astor Place has a peaceful, dreamy, emptied-out quality—De Chirico without the angst. Cars, buses, trucks, subway, strollers, all converge in an amiable, live-and-let-live fashion.

Why did public space have such an attraction to this émigré from privileged patrician stock? The streets offered anonymity, especially in regard to class origins (here he would not be recognized and kowtowed to as a *Burckhardt*), and the very existence of the pedestrian stream seemed democratic, with each passerby accorded a few seconds' respectful attention on the stage of the crosswalk. In Rudy's photographs, and even more manifestly in his non-narrative films, there is this simple, amazing recognition of the flow of bodies: one passerby, then another, then another, the one-after-anotherness of city life. As in Whitman, this equation of the crowd of passing humanity with the ocean becomes a profound solace and deep phenomenological mystery. Its seeming infinitude renders the observer powerless to do anything but surrender before it, passive yet also alert. Streams of people one might otherwise ignore in the busy course of a day suddenly become fascinating when Rudy presents them to our eyes and invites us to watch them. We follow the mystery of duration and eternity, of motion through an immobile or static site, of the endless variety and similarity of human material. This is the true spirituality in Rudy's work. He lowers our body temperature and our heart rate and compels us to attend calmly to the people, the light, and the air.

Over the six decades that Rudy photographed New York streets, he captured the city's changing demographics (being especially responsive to the growing Hispanic presence and their street-oriented culture—see his energetic 1981 film, *Cerveza Bud*); its evolving fashions in lampposts, police

uniforms, and sidewalk peddlers' retail goods. Otherwise, his methodology as a street photographer varied little over time, perhaps because his initial approach remained valid to the end. Some of the street photographs he took in the last few years of his life, focusing on traffic cones, painted intersection lines, and asphalt avenues glistening in the rain, are satisfying in the same factual, mind-calming way as those he snapped when he first arrived in the late 1930s.

The curb was one of Rudy's great subjects, a transition between uncertainties, a destination, and a refuge. Some of his curb shots took on an experimental quality approaching abstraction: shadows of lampposts, street signs, and lower bodies playing elegantly with the street-bed and draping across the line of the curb, in photographs such as *Curb, New York*, 1940, *Lamp Shadow, New York*, 1968, *Sidewalk, New York*, 1993, and *Crosswalk, New York*, 1975.

His photographs of pedestrian dispersal have an almost scientific character, like the sidewalk density studies done by the urbanist William H. Whyte, or the ethologist Heidegger's snapshots of the territoriality of pigeons on a branch. Often he would focus on busy crosswalks, where New Yorkers' ability to space themselves apart and evade collision is tested most. See, for instance, his uncannily composed, consistently engrossing series taken in 1939–1940, which documents a now-vanished world. The men wear jackets and ties, the ends of which fly up from their tie-clips; the women have on cloth coats, cloches, or wide-brimmed hats and carry little handbags. Remarkably, these pictures *work*—they exude vitality today—whether we see the figures' faces or only their trouser legs, hemlines, and shoes. What counts is not so much the psychology of the individual subjects, but their part in the

whole movement, the serendipitously choreographed dance of pedestrian life. Indeed, Rudy seems to be always asserting, in edited versions of the pedestrian stream, his choreography of everyday urban life.

His sense of cadence anticipated what Jane Jacobs would write in a famous passage from *The Death and Life of Great American Cities* (1961): "Under the seeming disorder of the old city, wherever the old city is working successfully, is a marvelous order for maintaining the safety of the streets and the freedom of the city. It is a complex order. Its essence is intricacy of sidewalk use, bringing with it a constant succession of eyes. This order is all composed of movement and change, and although it is life, not art, we may fancifully call it the art form of the city and liken it to the dance— not to a simple-minded precision dance with everyone kicking up at the same time, twirling in unison and bowing off en masse, but to an intricate ballet in which the individual dancers and ensembles all have distinctive parts which miraculously reinforce each other and compose an orderly whole. The ballet of the good city sidewalk never repeats itself from place to place, and in any one place is always replete with new improvisations." Rudy's later fascination with modern dance performance, particularly the style rooted in "ordinary" walking and running, such as Merce Cunningham or the Judson Group, can be already be glimpsed in his earliest photographs of New York streets.

Meanwhile Edwin Denby, in his poetry, was doing the same. He would often observe, like a benign, approving ghost, anonymous citizens in their forlorn mopiness, eating in cafeterias, talking to themselves on the street, undressing in furnished rooms. Denby projected in his city poems a blue-collar or lower-middle-class environment:

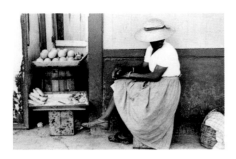 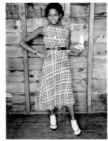

LEFT TO RIGHT: Fruit Vendor, Port-of-Spain, Trinidad, 1941/44 | Germaine, Port-au-Prince, Haiti 1938 | Sunday Best, Trinidad, 1942

a Hopperesque image one associates with New York and many of its artists in the Depression-era Thirties and Forties, when the city was still an industrial giant and pro-labor town, before the extreme polarities between rich and poor set in. Denby himself may have come from a well-to-do background, but it was part of his noblesse oblige to disdain all privilege—a trait he shared with Rudy—and to love humanity as manifested in the anonymous crowd:

> They pass in droves, detouring packing cases,
> They press up close at crossings, darting cars,
> Some stop, some change direction, and their faces
> Display unconsciousness, like movie stars.
> FROM "ELEGY—THE STREETS"

Haiti

In 1937, Edwin and Rudy both went down to Port-au-Prince, Haiti for vacation. After a few weeks Edwin left, and Rudy stayed on for nine months. There he took some still photographs and shot the first of his exquisite films that had that steady, pure feel of his best film work, a documentary film-poem called *Haiti*. What is remarkable, seeing *Haiti* today, is how measured and patient the camera style is, as though it were the work of an old man, rather than someone in his early twenties. Rudy had "old eyes" from the beginning. You see it especially in his early films such as *Haiti* or *Montgomery, Alabama*: the same patient acceptance of the obdurate, sadly lovely world, the same amazing facility for composition, perfect use of natural lighting, and tactful holding of a shot just long enough. His compositional sense seemed to derive from nineteenth-century travel photography: that classically long-shot, sepia, unexaggerated, decorously prying eye of a foreigner, such as Maxime Du Camp or Louis de

Clercq, who does not want to violate the native shrines but would like to record them nonetheless. What gives Rudy Burckhardt's images their sense of wholeness and anchoring balance is precisely that restraint derived from his Swiss upbringing and classical education, which he so disparaged.

There is none of the in-your-face, fisheye-lens, confrontational style of William Klein, say, with Tokyo, where the foreigner denies through aggressiveness his fear of the Other. *Haiti* has a stately pace, slow pans of whitewashed houses building gradually to a dancehall sequence, which, with Satie's "Gymnopaedie" on the soundtrack, draws you deep into a hypnotic, tropical rhythm—but no voodoo. "Later when I talked to a distributor in New York he immediately asked, 'Is there any voodoo in it?' 'Err…well…not really.' So he wasn't interested.…I was more interested in daily life, neighbors, jokes, gossip, small dramas, Saturday night dances, and ghost stories."

In Haiti, he seems to have distanced himself from his affair with Edwin (though never from Edwin) and homosexuality in general. "I was never any good at homosexuality," he would later remark apologetically. Edith Schloss, Rudy's first wife, said he told her: "Homosexuality is so *stark*. I prefer girls, they're more soft and cuddly."

He met a beautiful young Haitian woman named Germaine in a bar. A soft-focused photograph he took shows her in a clinging dress with diagonal pattern; she holds a triangular model of a toy boat in one hand, while her other arm rests easily on her hip, and her eyes cut to the side in a smile that is both shy and saucy. Behind this vision of seductive loveliness we make out the bare wooden slats of a shack. As he recounts it in *Talking Pictures*, "Germaine and I moved to a charming pink house next to a cemetery, with a

shower in the backyard, $9 a month. She was eighteen and I was twenty-three and we were a long way from Switzerland." Her folk beliefs charmed him ("Germaine said all cats are demons,") and he even contemplated marrying her, but in the end could not bring himself to upset his mother so by showing up with an untutored black woman as his bride. And he couldn't stay in Haiti ("I didn't want to become an expatriate who starts drinking rum at eleven in the morning"), so he bought Germaine a house for $350 and came back to New York. But for the rest of his life he loved to think of his young Haitian girlfriend as the embodiment of an elusively unselfconscious feminine ideal.

In the Army

Rudy's studies of New York were interrupted for a few years (1941–44) when he was drafted into the United States Army. It was good timing, in one sense: his inheritance was starting to run out when he received his draft notice. He was stationed in Trinidad and the South, where he continued to take photographs, sometimes as a Signal Corps photographer, sometimes on his own.

The billeting in Trinidad allowed him to explore further the public sensuality of Caribbean life. *Port of Spain, Trinidad*, 1942, is a stunning portrait of street-corner society: one man with a dazzling smile angles on the diagonal curb, about to go into a dance; another, equally grinning, leans against the building, while a businesslike woman with no time for frivolity checks out a fruit-seller's wares. In *Sunday Best, Trinidad*, 1942, a solemnly handsome young black shows off his sparkling white clothes and jaunty cap, one hand on his waist, as if posing for a passport photo, before a stucco-covered building. In the exquisitely counter-balanced *Fruit Vendor, Trinidad*, 1942, the seated vendor, a woman in a straw hat, turns indifferently away

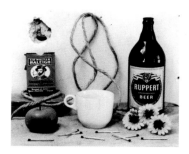 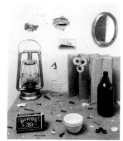 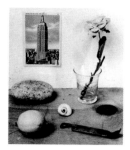

LEFT TO RIGHT: Still Life with Ruppert Beer, 1945 | "Birds Eye," New York, 1945 | Still Life, New York, 1945

from her wares, while her crossed leg draws the viewer's eye toward them.

In addition to taking photographs, Burckhardt had many serio-comic adventures in the army, trying to talk and behave like a regular GI Joe. He never saw combat. In his own words: "I was a bad soldier, did as little as I could, never was promoted, and after more than three years, got discharged for nervous disability. But it wasn't all that bad—I got used to life in the army, and as a Signal Corps photographer I was attached to many different units where I got to know big, good-natured guys, little son-of-a-bitches, chickenshit lieutenants, goldbricks, unadulterated pricks, cocksuckers, (motherfucker was still a fighting word), mean Georgia Crackers, friendly Midwesterners, funny Brooklynites, and vain generals."

Rudy sought out sexually available Trinidadian women, and often got the clap, by his own admission: "One day a medic who had seen the records said I had the second-highest number of treatments in a month (fifteen) of the whole army post." Lessons in American slang and venereal disease aside, underneath it all he was miserable. In later years, he often told the story of his honorable discharge from the U.S. Army in a discreetly boastful manner, stressing the humorous side, as though he had put one over on the army brass. Here is the abbreviated version he wrote in *Mobile Homes*: "Back in New York on a furlough, I heard of some soldiers who got out quite easily after two or three weeks in a hospital for observation. I decided to try it too…. I began going on sick-call every morning, complaining of headaches, insomnia, depression. The doctor looked bored: aspirin and back to duty. To get more depressed, I stopped eating except for one piece of apple pie and one cup of coffee a day. They tasted delicious. I said I was homosexual, and the doctor said:

With who, where, how often. I gave Edwin's name and address and he wrote it all down. Edwin, who usually would do almost anything for me, this time got angry and frightened when I told him. However, it was aspirin and back to duty for me. It didn't seem to be working. On a last furlough before being sent overseas again, this time to Europe, as I was lying in bed with a girlfriend late one morning, there was a knock on the door. Telegram for Private Burckhardt #32008713: Report immediately to Brentwood, Long Island, Hospital….Observation in the hospital turned out to be quite pleasant. Every morning a doctor came by and asked how I felt. I had nothing to do, could wander around, have visitors, read in the library…. I read Gertrude Stein's *The Making of Americans*, memorized sonnets by Milton, Shakespeare, Herrick, Donne, Shelley, Keats, Denby, and Anonymous." While feeling like a coward for avoiding battle, "I made up my mind to get out at whatever the cost." He began holding his head in his hands and shouting, "Leave me alone!" When he was finally discharged for nervous disability, he "weighed 116 pounds—I was of no possible use to the army anymore."

One afternoon, after we had been friends for several years, Rudy started recounting the story of his release from the army. But this time, he was in a blue frame of mind, and I heard a different tone in his voice, and suddenly I understood that the depression in the army had been real. More, I began to see that for his entire adult life he had struggled to overcome a depression—at times, able successfully to push it into the background, or to disguise it publicly as something closer to indifference. But it was there to be seen: it explained his moody facial expressions, his inward drifts, and his grumbling speech, and the underlying sadness that never seemed far from his

face. Melancholy became one of the keys to interpreting his work: its appearance accounted for those sudden deepening passages in the films, just as its avoidance helped explain certain obstinate, almost superstitious frivolities, even when they undercut the value of his art.

Back in New York; Edith Schloss

Returning to postwar civilian life, Rudy found himself at a high point in the city's life. "New York City had never been so attractive," Anatole Broyard remembered in his memoir *Kafka Was the Rage*. "The postwar years were like a great smile in its sullen history. The Village was as close in 1946 as it would ever come to Paris in the twenties. Rents were cheap, restaurants were cheap, and it seemed to me that happiness itself might be cheaply had."

Rudy, throwing himself into a busy romantic life, took a while to relocate his photographic subjects. In 1945, he took several still-life photographs of objects on tables in front of a wall, that were plain and forthright compositionally, and mildly surrealistic in their juxtapositions. One of the most intriguing of this series balances a Sir Walter Raleigh smoking-tobacco pouch with a sturdy bottle of Ruppert beer, while a twine of rope circles flirtatiously between them; nearby on the table are stray matches, a coffee cup, marigolds, an apple; the wall behind these has a hole in it that looks like an eye spying on the objects. Another, *Bird's Eye*, shows a lantern, a box of Bird's Eye safety matches, various nails, a beer bottle, and a postcard of an ocean liner attached to the wall with a hole in it. A third still life contains a rose in a drinking glass, a lemon, a similarly oval stone, a seashell (which oddly resembles an eye, again), and a postcard of the Empire State Building on the wall. Though still-life

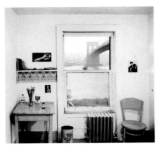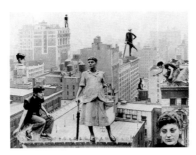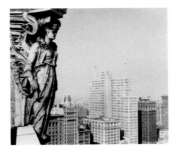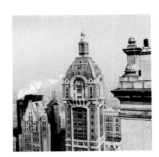

LEFT TO RIGHT: A View from Brooklyn II, 1953 | People on the Roof, New York, 1949 | Caryatid, New York, 1952 | Singer Building, New York, 1948/53 | **OPPOSITE:** DETAIL Water Towers and Smoke, 1948

photographs were a favorite practice of European and American art photographers, this particular series eschews the usual temptations of virtuoso lighting or experimental abstraction for a more straightforward line-up and placement of objects, recalling Rudy's earlier shots of merchandise adorning store windows.

They also look ahead to his great 1953 diptych, *A View from Brooklyn, I and II*: two head-on shots of what first appears to be the same stark, threadbare room, with a similar though not identical set of objects (paint-brush can, wastebasket, bookshelf, radiator, art postcards, table, chair) and, most startlingly, a double-paned window out of which appear two entirely different views of the New York harbor, one featuring the bowed Brooklyn Bridge, and the other, the downtown Manhattan skyline. This pair of photographs, combining interior, still life, and cityscape, has become a kind of visual synopsis for the splendors and miseries of New York bohemian life, where poverty and a great view may go hand in hand.

In 1945, Rudy met Edith Schloss, who would become his first wife. Edith was dark, German-Jewish, and five years younger than Rudy. Born in Offenbach, Germany of an upper-middle-class family, she had fled to England during the Nazi era, and emigrated to the United States in the early 1940s. Extremely articulate (she would later write art criticism for *ARTnews, International Herald Tribune,* and *Art in America*), and eager to paint, she supported herself by working as a masker in a photoengraving shop. Mutual friends, Walter and Ellen Auerbach, German-Jewish refugee photographers and Communists, brought the two together. Edith herself had been a politically committed Marxist when they first met, but Rudy, echoing Edwin, told her art and politics had no business mixing. For the time being, at least, she accepted this verdict, just

as she accepted the continuing importance of Edwin in Rudy's life. In their Chelsea artistic circle, which included such independent-minded painters as Fairfield Porter, Nell Blaine, and Jane Freilicher, Edwin was the acknowledged leader. "Edwin was a Prince Regent, running us all," she said. He would dispense advice and give them their marching orders for the evening: you go to this show, end up at that bar or party.

Rudy took Edith to discussions at the Artists Club on Eighth Street and to avant-garde concerts and dance recitals. His world took some getting used to on her part, as seems clear in this passage from her unpublished memoir:

> The first time I saw John Cage, it was at a birthday party full of composers for Merce Cunningham, at Merce's lower Manhattan loft. Rudy and Edwin had taken me to many parties in the music world, and I had learned already it was a world of men: Copland of course, Marc Blitzstein, Bernstein, and David Diamond, who had red hair and was the most warmly enthusiastic about other composers' works; John LaTouche, Ned Rorem, Bill Flanagan and so on. At Merce's party, except for Jane Bowles and Peggy Bates—the composer who adored Paul Bowles's work so much she wrote music nearly like his—here also there were only men. Over all these brittle and brightly amusing people with their bright comebacks and sharp banter there hung a mystery that was new to me. The strangeness was alluring but there was also something cold and cliquish about it, so I felt more timid than usual. In the eerie thin-air world of so many men drinking and touching, it was odd and puzzling at first, but then I was thrilled, it suddenly seemed to open up possibilities I had never dreamed of before. Rudy used

to tease me: "You are so wholesome," he often said….

> The first concerts Rudy and Edwin took me to in those days, most of them in Little Carnegie Hall, with very little pieces by John Cage, Paul Bowles, Dimitri Haieff, Milhaud and Rieti, were electrifying. There was such an intense glamour to the just-hatched music, played by the young Gold and Fizdale and by Marc Ajemian, that one felt acutely part of the event. The audience was made to feel special.

> Once it shot through me like a high charge: this is it, we are on top of our time! I went home and painted a still-life in blue, black and yellow enamel house-paints, one of my best, it was so serenely balanced. The piercingly fresh music had carried me.

Edith's Jewish background did not entirely please Rudy's family, initially, which may well have suited his rebellious need to shock them. On the other hand, two of his siblings also married Jews; something in that family upbringing must have contained a double message, which tolerated or encouraged breaking out of the mold. One of his older sisters was a doctor who lived openly with her woman nurse; another became a painter and secretary to Hans Arp, who pursued her in hopes of marriage over two continents; his younger brother, Lukas, was a jazz musician who carried on the Burckhardt tradition by becoming mayor of Basel and, later, a radio jazz disk jockey.

Photographing Architecture

Around 1947, Rudy embarked on a remarkable series of photographs of New York buildings, which are among his best-known images. Rudy concentrated, for the most part, not on the flashiest, sleekest, or most streamlined skyscrapers,

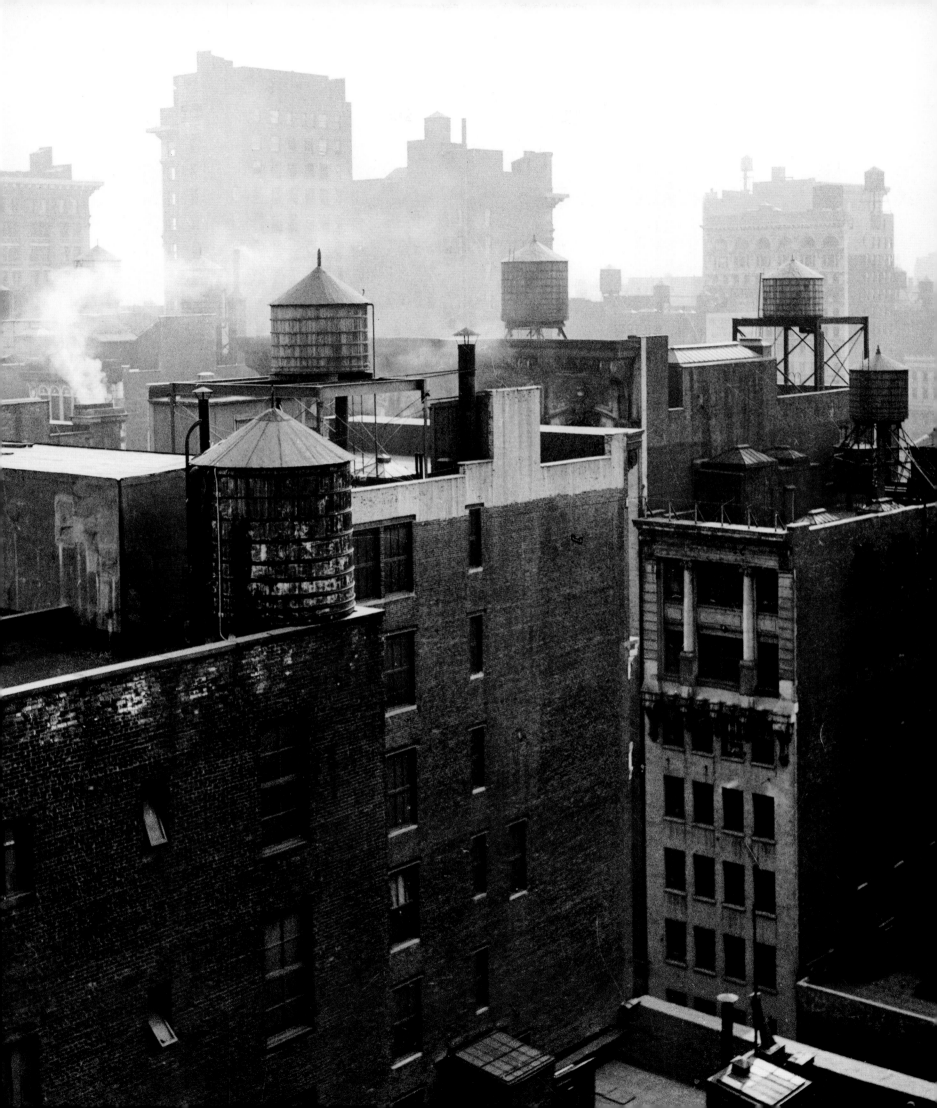

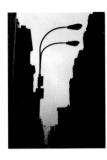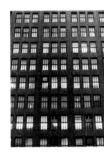

LEFT TO RIGHT: Times Square, New York, 1947 | Flatiron Building, Summer, New York, 1947/48 | Flatiron Building I, New York, 1973 | Street Lamps, New York, ca. 1970 | Factory Building I, New York, 1979

but on those that already wore a grimy patina. He doted on venerable landmarks such as the Flatiron Building, the Times Tower, and the Singer Building, but did not photograph, for instance, the Chrysler or the Empire State Building, the McGraw-Hill or Rockefeller Center. His "beat," so to speak, was Downtown and a bit of Midtown, nothing above Forty-Second Street: in short, the districts and edifices that had gone up in the early decades of the twentieth century, before he arrived in New York. He was particularly drawn to buildings that sported historicist, "impure" (from a high-modernist perspective) ornamentation. By attending to their particular grace notes (Florentine cupolas, Greek columns and pediments, Gothic gargoyles, French Empire, and beaux-arts details), he may have been looking for his own European heritage in New York architecture. Additionally, he was smiling at the vanity of such flourishes in specu-lative buildings put up by developers for a quick profit. These adornments were undoubtedly beau-tiful in his eyes, but they were also touchingly fool-ish, by virtue of their archaic nonfunctionality and the way they went unnoticed by most passersby. They were Rudy's secret discovery, his own private New York.

At first he would shoot just from the rooftops, ascending to a high story or the top of a nearby building with the aid of a friendly janitor, and lean out and snap the picture. It took him a while, he admitted later, to figure out how to get the building and the people in the same frame at the proper scale. This he accomplished for the first time in his 1947 Times Square Building photo-graph. The old Times Tower, built in 1905, is shown with its original Italian Renaissance terra cotta skin (long since lost), coming to a narrow, one-window width; to the right are the billboards on Times Square; the people on the sidewalk,

shadowed in the foreground, seem to be going about their business without a shred of awe for the skyscrapers around them. The mood is midday, active.

Shortly after, he started to take pictures of the Flatiron Building. Here again, as with the Times Tower, he exploited the triangular pattern that occurs in Manhattan when the diagonal of Broadway crosses another avenue: each of these edifices sits on a little triangular island, which it wholly occupies, while pedestrians and traffic swirl in front of it and to either side. Because the Flatiron is itself triangular-shaped, its profile coming to a point at the northern end, there is a particularly neat sense of positioning in the photograph: the building juts forward like the prow of a ship, secret-ing a double by means of its full, penile shadow stretched on the ground. This picture, at an angle looking down from a taller building in the vicinity, conveys the poignant sense of a once-highest building now dwarfed by an invisible successor. We see far into the distance, along the sunlit diagonal streets that enclose the Flatiron; the trees of Madison Square Park, occupying the left fore-ground, introduce a spacious, Impressionist-paint-ing note, and the crosswalk in front of 23rd Street is curiously depopulated. It is impossible to know what effect the photograph had on viewers when first taken; but today it seems to bear witness to an innocent, jaunty New York, comfortably settled into its own skin. Years later, in 1973, he returned to the subject of the Flatiron Building with exquisite photographs that captured its noble reflection drooping upside-down in a rain puddle, sliced by the diagonal white stripes of the crosswalk.

Rudy's photographs of the city's buildings cap-ture the way a local New Yorker, dashing around and looking up suddenly, might see them. He does not take the everyday and shock it into the

new by stylized cropping or abstracted distortion; rather, he captures the off-handed order of the jerrybuilt environment when it is just standing there, scratching itself. Berenice Abbott's skyscraper photographs, by contrast, shot from below looking up, emphasize the negative space between buildings, and the jagged, abstract com-positions their ziggurated tops make as they tilt toward each other, like lightning bolts cracking the sky—filled with the Cubist romance of the machine. Rudy's compositions of tall buildings from below incorporate the human scene on the sidewalk with the architecture, and render the graceful, full-scale ascension of high edifices with a minimum of distortion. When he is shooting at eye level from the window or roof of another skyscraper, his rooftops are serenely dispersed like castle turrets; and one is made especially aware of the odd, homey constructions—water towers, roof gardens, attics, skylights, and so on—by which the skyline is tamed and humanized.

Water Towers and Smoke, New York, 1948, breath-takingly shows off a nest of those characteristic Manhattan roof structures—stubby cylinders with conical tops, like coolie hats—distributed over the Chelsea skyline, resembling turrets in a medieval Italian hill town. The neighborhood of Chelsea, where Rudy lived, had been neglected by tourist picture books, filled as it was with a workaday mix-ture of textile factories, warehouses, and apartment buildings; the fact that it was not conventionally picturesque made it all the more compelling for Rudy and his lens.

The hiatus on construction in the city, first as a result of the Depression and then the scarcity of parts during the war years, lent postwar New York a shabby-chic quality; its shiny-penny futurism had worn off, allowing its more stoic, timeworn phys-iognomy to be appreciated, perhaps for the first

time. Edwin Denby's essay, "Dancers, Buildings and People in the Street," perfectly captures that historic moment when the cultivated world at last *got* the layered aesthetic meaning of New York.

Daily life is wonderfully full of things to see. Not only people's movements, but the objects around them, the shape of the rooms they live in, the ornaments architects make around windows and doors, the peculiar ways buildings end in the air, the watertanks, the fantastic differences in their street façades on the first floor. A French composer who was here said to me, "I had expected the streets of New York to be monotonous, after looking at a map of all those rectangles; but now I see the differences in height between buildings, I find I have never seen streets so diverse one from another." But if you start looking at New York architecture, you will notice not only the sometimes extraordinary delicacy of the window framings, but also the standpipes, the grandiose plaques of granite and marble on ground floors of office buildings, the windowless side walls, the careful, though senseless, marble ornaments. And then the masses, the way the office and factory buildings pile up together in perspective. And under them the drive of traffic, those brilliantly colored trucks with their fancy lettering, the violent paint on cars, signs, houses, as well as lips. Sunsets turn the red-painted houses in the cross-streets to the flush of live rose petals. And the summer sky of New York is as magnificent as the sky of Venice. Do you see all this? Do you see what a forty- or sixty-story building looks like from straight below? And do you see how it comes up from the sidewalk as if it intended to go up no more than five stories? Do you see the bluish haze on the city as if you were in a forest?

As for myself, I wouldn't have seen such things if I hadn't seen them first in the photographs of Rudolph Burckhardt.

This passage not only shows us how indebted Denby felt to his younger friend for teaching him how to look, but also offers a summing-up of the whole postwar New York School aesthetic. The very clashes of planned and unplanned, new and old, which had formerly made foreign visitors sneer at New York, suddenly began to seem, in the flush of America's imperial strength and New York's cultural centrality, harmonious, like an intended collage. (In Rudy's own words: "Well what I love about New York is that it just grew up wildly. Everyone tried to make a bigger building than the guy before him, that there was no design, no, it just happened.") These high-low dissonances of the city's daily life were already turning up, or would soon do so, in the paintings of Robert Rauschenberg and Larry Rivers, in the poems of Frank O'Hara and Kenneth Koch, and in the dance performances of Merce Cunningham, Yvonne Rainer, and George Balanchine.

Rudy's portraits of buildings seem far different from the idealized real-estate images taken by architectural photographers. For one thing, they are not serenely self-sufficient, but encroached upon by indifferent neighbors; the skies above them are not picture-perfect clear or dramatically clouded, but more mundane. Each tower stands like a tall human in the street, surrounded by fellow pedestrians, a grubby giant soliciting our sympathy or curiosity, only to be forgotten a moment later. As his painter-friend Alex Katz described the effect, in an article on Rudy for *ARTnews*: "It's great to have someone show you something you have passed thousands of times as something you never saw,

and after seeing it you continue to pass it again and again and not see it."

Rudy had the rare ability to photograph with emotion the facade of a building. To some edifices he brought a grave, almost ancestral respect, as though it were a Titian portrait of an old Roman senator. In his films, up to the end of his life, some of the most hauntingly effective shots were of the city's buildings: an office tower at twilight, or after hours, emptied but with the fluorescent lights still on, conveying a curious nostalgic ache. These buildings had become a site of memory and displaced spiritual longing, the modern world's temples. Together they constituted a disguised autobiography.

Rudy would often stride through the streets, pointing out to you the past history of certain edifices ("This used to be a department store; they're turning it into an office building now"), or recollect some personal event in his life ("I used to come here with my first wife"). Looking at buildings without seeming to, a spy with his head kept slightly "downcast" (as a *New Yorker* reporter once described him), walking quickly, no insouciant dawdling, he seemed always comfortable in the streets, where his restlessness acquired a reason, a function: to court surprise and scavenge for the fragments of his art.

Travel

In 1947, Rudy went to Europe with Edith, the first of several travels abroad during these postwar years. The pictures Rudy took on his European trips of 1947 and 1951 have a different quality from his New York street scenes: they seem more in keeping with the narrative-vignette style of the great Parisian humanist photographers, Cartier-Bresson, Doisneau, Brassai, and Boubat. Burckhardt admired their work, particularly

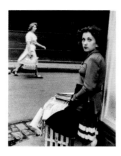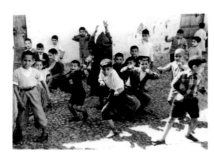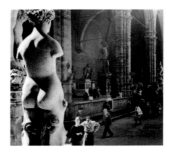

LEFT TO RIGHT: Two Women, Paris, 1947 | Tetuan, Morocco, 1955 | Jacob Running, Venice, 1951 | The Art Lovers, Florence, 1951 | **OPPOSITE:** DETAIL Times Square at Dusk, 1948

Cartier-Bresson's. Perhaps the European faces triggered a response in him that activated these influences, or the lifting of the New York speed and tension inspired a more relaxed approach to documenting the street. *Two Women, Paris,*1947, shows a pretty newsdealer, who could have stepped right out of a Brassai photograph, staring with sexual directness at the camera. In *Paris Realization*, 1947, a stooped old woman carrying a wrapped parcel ducks her head in front of a painted billboard featuring a glamorous movie star, as though she were literally trying to make way for youth. The contrast between the idealized image of Woman and the wizened specimen staring at the camera is both hilarious and anecdotal, more so than Rudy's New York work.

Some of the travel pictures may be a bit too easy in their anecdotal exploitation of contrasts; others, a mite derivative. Rudy's shots of Moroccan children mugging with raised fists for the camera are appealing but suggest something by his idol, Cartier-Bresson, while the comic photograph of a tourist couple staring at a nude sculpture in Florence, *The Art Lovers, Florence*, 1951, recalls the Doisneau shot of the wife disapproving her husband's admiration for a painted nude. Other travel photographs in this period embrace the genial and the cute, like the black cat in the Piazza San Marco. Few professional photographers can resist a cute picture, and Rudy was not the sort of purist who would turn down a crowd-pleasing image.

If the European travel photographs suffer in comparison with the New York ones, it is partly because they lack the consequential sense of anchoring in a complexly felt environment. For instance, Burckhardt's well-known photograph of the Brooklyn Bridge outside a painter's window gives us the bridge as both material structure and mediated myth. Or the magnificent *Times Square*

at Dusk, 1948, where the wintry, hatted urbanites navigating rain-soaked Times Square from four directions, with the Ruppert beer sign in back, have an iconic inevitability, comparable in power to Giacometti's skeletal, sculpted pedestrians crossing the square.

The photographs he took during a 1948 trip through the South (Alabama, Arkansas, and Mississippi) convey more of the power and grit one associates with his best images. It is as though he were returning to the redneck America he had encountered in the U.S. Army, this time with more perspective and self-assurance. For instance, the compelling, timeless stolidity of a Little Rock man reading his newspaper in the window frame of a warehouse loading dock, with two tires below him, beside a two-toned brick wall. *Lunch Basket* and *At Ease*, both Alabama street scenes, show blacks waiting in an enforced idleness, their faces more somber than the Trinidadians he snapped as a soldier. Notable, also, is the fascinating composition, *Parallel Poetry*, which shows us a panoply of transportation options, banded in horizontal strips, one atop the other: railroad track through which a human figure is walking, parked cars facing right, parked cars facing left, fishing shacks, boats, river, bank, river again, and tree-line. It is an image that satisfies simultaneously as representation and abstract composition.

In 1950 Rudy and Edith went to Italy with their small son, Jacob (who had been born in 1949); Edwin Denby came along as well. Rudy photographed in Rome, Florence, Venice, Tuscany, Umbria, Sicily and Greece. He extended his studies of pedestrian behavior in a droll 1951 series of a piazza in Siracusa, Sicily: using a sort of time-lapse approach, while varying the angle onto the piazza with each shot (note the changing position of the church steps), he captured, from above,

dark figures on foot or bicycle against the white square, each time a different configuration, like a shaken kaleidoscope. The photographs and motion picture footage he took in Naples often focused on the warm sociability between Italian men in public places, taking each other by the arm or gesturing by hand to make a point. The shots of women, by contrast, were mostly individual figures, staring at the camera, like the sunglassed Napolitana waving a blurry fan, or looking off to the side, like the frowning little girl braced against the window frame.

Rudy also visited bordellos in Naples (as he would later, in 1955, in Algeciras, Spain); he photographed the whores, looking friendly, smiling and rather chunky, embedded in their shabby-rococo interiors—more genre study than erotic pinup. "He was a European middle-class man, so he went to the brothel," Edith remarks today with a shrug.

As for Edwin's presence on the trip, Edith claims she was never threatened by Rudy's feelings for Edwin, or men in general, as he was only unfaithful to her with women. The two men, she says, had a "beautiful and strong friendship," though she admits there was some tension when Denby accompanied them in Naples. "It was a sort of emotional ménage-à-trois," says Rudy's son, Jacob, in retrospect; "of course there were tensions." Edith ended up taking Jacob off alone with her to Rudy's mother in Switzerland when Rudy and Edwin went to Morocco. The elderly Mrs. Burckhardt asked Edith if she resented having a mother-in-law. Edith said she was used to it already, because of Edwin!

Rudy and Edwin stayed on in Naples, where they collaborated on a beautiful limited-edition book, *Mediterranean Cities*, an album of Edwin's travel sonnets and Rudy's photographs. Each

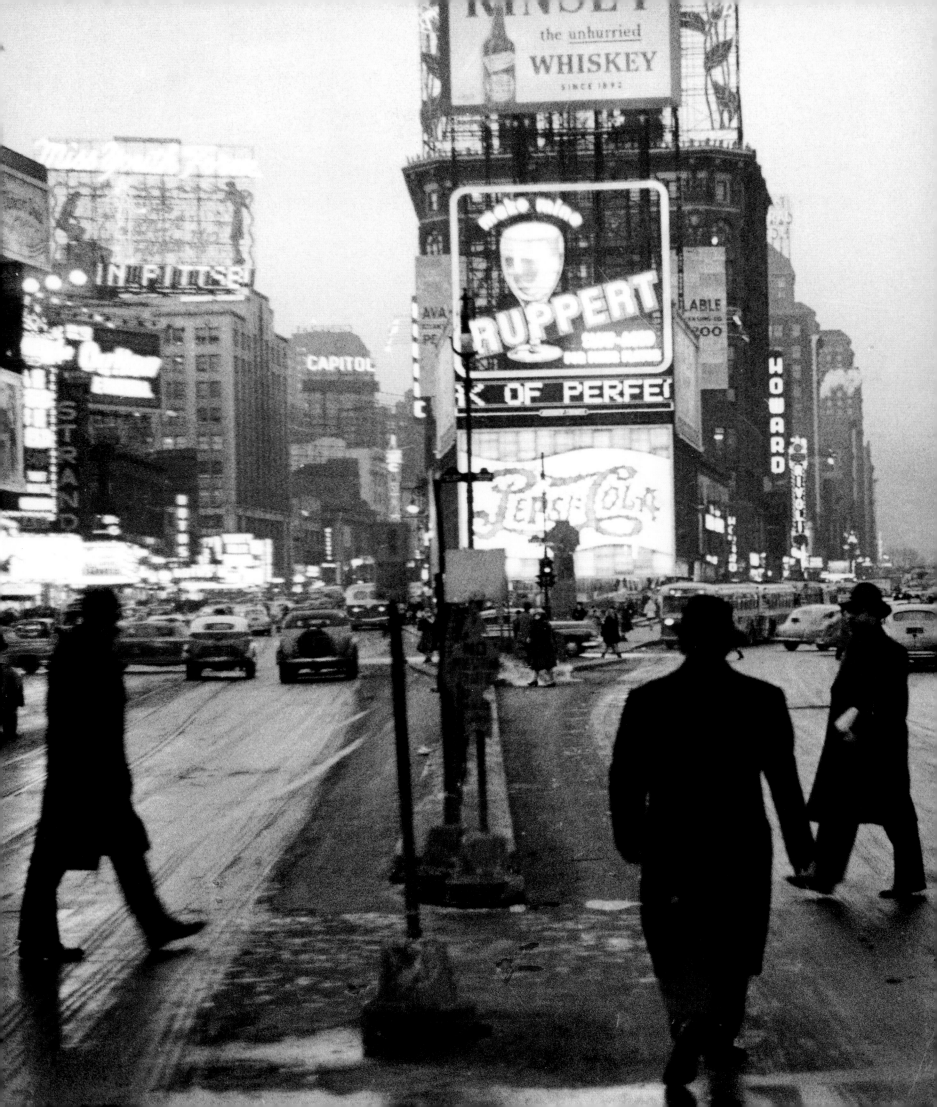

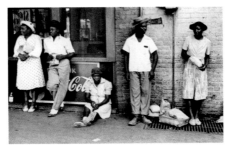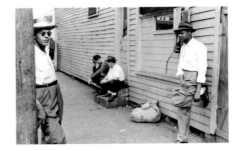

Denby poem in this collection tries to capture the spirit of an Italian place, in a way that "rhymes," intentionally or not, with the accompanying Burckhardt image. "Rome" begins:

> Pear-brown Rome, dyed for the days whose blue
> is sweet
> Disencoils as a garden would the wreaths and noses
> Waists and loose fountains it adores to prodigate
> A fair-weather darling as loose as roses
> Soft up to the scar, dead Imperial Rome's;

Rudy's photograph is bathed in the softest light, the Colosseum's ruins floating in the background, the hill cypresses rising in shadow off to the side, a sixteenth-century Rome without a single tourist visible. His pictures from this Italian period are note-worthy for being tinged with a more unabashedly romantic quality than usual for him: the lush Roman landscapes and Venice roofs in *Venice from Campanile*, 1951, as well as the lyrical ones of Edith, or the fond snapshots of little Jacob sitting and running in Naples. The trip also produced an eighteen-minute travelogue film, pure joy to watch, *See Naples and the Island of Ischia*.

The Relationship between the Still Photographs and the Movies

There was considerable give-and-take between Burckhardt's still photography and his movies. In his strolls, first in the streets and later in the woods of Maine, he would often bring along both a 16mm movie camera and a 35mm still camera, and photograph the same subject or scene in both mediums. Sometimes he would use the still cam-era as a reconnoitering device, and return to the same location later with his 16mm Bolex.

An especially illuminating example of this pro-cess began with the set of photographs he took in February 1940, which he mounted in a private album called "An Afternoon in Astoria." (These photographs were finally exhibited by MoMA in 2002, at the opening of their Queens facility.) Rudy was attracted to this section of Queens, because it seemed so quiet, spread-out, and off the beaten path, where "you get away from every-thing… and then you just walk away from civi-lization." The resulting photographs pushed the envelope of the unanecdotal and nondescript, consisting as they did, for the most part, of weedy lots, deserted gas stations, corrugated tin sheds, parked cars, and brick piles. Without the everyday human spectacle or background density found in the heart of the city, the pressure was placed on sheer compositional force and the residual glam-our of brute, iron materials to provide the all-over interest he demanded of each photograph. It is as if the photographer were throwing down a gaunt-let and daring us to find visual stimulation here. The strange part is that we do: these austere pho-tographs charm by their very "glass-half-full" minimalism, and suggest something both comic and dignified about the modern world, its woeful barrenness and junkyard plenitude. By the time we get to the penultimate shots of children dig-ging in dirt-piles or mugging on the sidewalk, we are more than grateful for any human presence. The final image is a moving one of a freight trans-fer bridge, blackened in the foreground, with the New York skyline grisaille-shaded behind it: the perfect representation of working-class Queens stalwartly servicing Manhattan.

The sequencing of images, sometimes four to a page, functions like a cinematic montage. The loving care with which Rudy arranged, dry-mounted (on neutral gray board), and hand-labeled this album betrayed an ambition to create as exquisite an artwork as possible, how-ever secret it remained. This was followed by another album he did in 1943, "A Walk through Astoria and Other Places in Queens," for which Edwin Denby wrote a sequence of five accompa-nying sonnets. Rudy then took the process to its logical conclusion by quoting the Denby poems in *The Climate of New York* (1948), one of his best films, with many scenes shot in the same Astoria locations he had explored eight years earlier by still camera.

Rudy was certainly not alone in his alterna-tions between the two mediums. A tome might be written on the movie work of American still photographers—such as Paul Strand, László Moholy-Nagy, Helen Levitt, Robert Frank, Ruth Orkin and Morris Engel, Bruce Davidson, Jerry Schatzberg, Danny Lyon, and so on. The difference is that Rudy's eye was primarily cinematic: his photographs often look like stills ripped from a motion picture, rather than frozen epiphanies.

Significantly, he continued to make movies without interruption from the time he began doing them until his death, while he went through at least a decade, around the 1980s, when he gave up still photography altogether. The poet David Shapiro once complimented Rudy by calling him the greatest living American photographer. Rudy reacted with facetious indignation: "That's an insult!" Shapiro asked what he would like to be called instead. Rudy answered: "The greatest living filmmaker, of course." The likelihood is that, had Shapiro begun by crowning him the greatest living filmmaker, he might have reacted with equal mock-umbrage. Rudy's modesty and realistic self-assess-ment precluded him from taking either claim seri-ously. Still, I think it is fair to say that he regarded himself as having evolved from a still photographer to a filmmaker. "Well, filmmaking, that's probably what I'm best at," he is on record as saying.

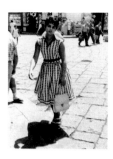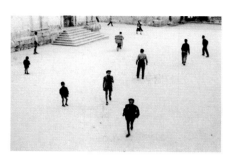

LEFT TO RIGHT: Polka-Dot Dress, Naples, 1951 | The Fan, Naples, 1951 | Algeciras, Spain, 1955 | Siracusa II, 1951 | Edith in Parc Güell, Barcelona, 1955

Rudy claimed he began making movies because he found still photographs too easy: "That's why photography is slightly unsatisfactory, because it's too quick, too instantaneous," he said in *Talking Pictures*. On the other hand, he thought photographs were too unforgiving and demanding. "It's actually harder to get a still photograph that really stands up, because when it gets printed and comes out a picture it becomes like a fact, you know, and it's hard to stay interested in a photograph very long…A photograph has to be interesting all over, not just a picture of somebody and a background. But in a film it's fleeting, things come and go. Also, most of my films are not directed. I like the feeling that, suppose I do a scene in the street, I don't know what they're going to do either. Sometimes something happens that is better than I would have imagined it, if I had thought it through."

These attributes—openness to flux, ephemera, accident—are also part of the tradition of street photography; but Rudy saw them as flowing more naturally from the movie camera. Once he began shooting film, he brought a cinematic eye to his still photography as well as to his movies. This can be seen not only in his predilection for series (such as *An Afternoon in Astoria*) that operate on montage principles, but even more by the casual, asymmetric, catch-as-catch-can quality of many of his photographs. Compositionally, someone like Paul Strand was always mainly a still photographer, whether shooting stills or movies. The opposite may be said of Rudy.

It's not that Rudy's photographs lack compositional rigor, but that they do not lay such rhetorical stress on one particular meaning or formal arrangement, the way many still photographers do. They seem less "the decisive moment" (in Cartier-Bresson's famous formula-

tion) and more just—*a* moment. Perhaps Edwin Denby said this best when he spoke of Rudy's cinematic lightness: "Filmmakers often try to make a great film by making it feel heavier than film is by nature. Rudy Burckhardt seems happier if he can make his feel lighter." This lightness went beyond buoyancy of spirit to include Rudy's use of the f-stop: "It's much better to over-expose than under-expose," he would say about filmmaking technique.

Still, within this general striving for lightness, there were degrees of artistic gravity. Between 1948 and 1953, in the first years of his marriage to Edith, Rudy executed two of his most unequivocally ambitious works: *The Climate of New York* and *Under the Brooklyn Bridge*. There is nothing in these two city symphonies to undercut their seriousness; they aren't joked away, they're built very solidly, and they stand out as major efforts in the context of his film work as a whole. Before them, Rudy had made a number of fresh cinematic sketches, such as *Up and Down the Waterfront*, *How Wide is Sixth Avenue,* and *The Pursuit of Happiness*, which tended to focus on a few locations and visual motifs. But these two city symphonies, *The Climate of New York* and *Under the Brooklyn Bridge*, bound together complex suites of scenes. Rudy knew the tradition of the city symphony: Walter Ruttman's *Berlin: Symphony of a Great City*, Cavalcanti's *Rien Que les Heures*, Siodmak and Wilder's *People on Sunday*, Dziga Vertov's *Man with a Movie Camera* and Jean Vigo's *À Propos de Nice*. He took from them a certain faith in the poetic power of simple urban moments caught on the fly, and their inherently fuguelike montage form, while avoiding their didactic efforts to extract larger sociological or political meanings. Also, he made his films without a crew, on a minuscule budget.

Edith Schloss comments on this fact in her unfinished memoir:

Rudy's films were "home-made" so to speak, I mean entirely shot, cut, and edited only by himself with the most basic of equipment…. For lack of anything better people called it "documentary" or "experimental," though it was neither.

After John [Cage] saw *How Wide Is Sixth Avenue*, he said to Rudy 'I think I would like to write the music for your next movie. Let me know when it's finished.' And Rudy was very pleased.

His next movie was called *Under the Brooklyn Bridge* and I believe I gave it that title. In it was a lovely sequence of little boys jumping into the East River from some old rotting pilings. They must have been Italian or Puerto Rican, at any rate Catholics, because each one made the sign of the cross before it was his turn to dive. They were naked and outlined clearly, and when they jumped holding their noses their little penises swung out like the clappers of church bells in the breeze. It was a touching moment. And the great bridge and all its approaches and traffic, all the many-faceted steel and stone, made a glittering background for all the bemused humans. It was like all the other films of Rudy's, a gentle, slightly melancholy observation of ordinary people caught moving, from close-up and from far, against the climate of New York.

But after John had seen it he shook his head. "It's too social conscious," he said, something that has puzzled us ever since. The camera work was so straight, and the detail seen plainly and without trickery, it could appear bleak. But everything was done with sympathy and conceived in terms of contrapuntal composition

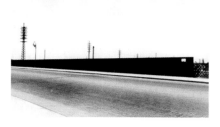 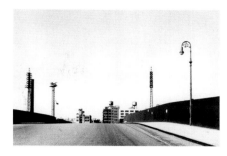

OPPOSITE: DETAIL View Looking North from 50W 29th Street, c. 1975, oil on canvas. | LEFT TO RIGHT: Astoria, Queens, 1940 | Expressway, Laurel Hill, 1940 | Overpass, Astoria, Queens, 1940

and movement, far from trying to show misery and pity and to exhort us. To this day I don't quite know what John meant.

By "social conscious," Cage may simply have meant it was too realistic without facetious disclaimers, or not Dadaist enough. The avant garde had slapped Rudy on the wrist for getting too serious and sincere. Interestingly, he never made another film vulnerable to those charges.

Now we can see *Under the Brooklyn Bridge* for what it is, neither social-conscious nor avant garde, but a perfect time capsule left for the next century. There is something Atget-like in its nostalgia for the disappearing present. As the art critic Robert Storr has written: "Burckhardt's New York doesn't age; like the makeshift comforts of low-rent accommodations and the iconic bridge itself, the city is perennial. Black-and-white films such as *Under the Brooklyn Bridge* have the same power to evoke an ambiance and describe the recurring events, as if one were drifting in a reality that altered little from day to day but was worth lingering over any day."

For whatever reasons (and Cage's reproach may have played only a small part in his disenchantment with the form), Rudy came to abandon the city symphony and the serious intentions that came with that effort. The movies directly following *Under the Brooklyn Bridge* were mostly story films, parodies of genre narratives made in a collaborative spirit. He continued to make straightforward little poetic documentaries about neighborhoods, such as *Eastside Summer* and *Square Times*, which were gems of observation, but without the apparatus of a larger framing ambition. In years to come, he also gravitated towards collage films, sometimes lengthier than his city symphonies, but less obviously "serious," mixing as they did

comically disparate elements, intentionally shaggy and rambunctious.

Painting

When Rudy was a schoolboy in Basel, he received some of his lowest marks in drawing—a fact he often mentioned when accounting for his later difficulties in painting. "Drawing, if you don't have a natural gift, you really have to work at it."

Shortly after marrying Edith, Rudy, dissatisfied with the instantaneous ease of photography, studied painting on the G. I. Bill with Amédée Ozenfant. Other members of their circle, such as Jane Freilicher, Larry Rivers, and Nell Blaine, were taking classes with Hans Hofmann, the charismatic Abstract Expressionist and pedagogic liberating force, but Rudy was drawn to the less inspirational Frenchman, a School of Paris painter whose best days were behind him. "Maybe I should have studied with him [Hofmann], he would have loosened me up a bit; instead I stayed with Ozenfant who was very tight." Ozenfant disapproved of abstraction, saying angrily, "I…*spiiit* on Pollock." Though Rudy certainly admired the Abstract Expressionists, his own leanings as a painter were more in a figurative direction. One day de Kooning offered to give him art lessons, an unprecedented honor. As Rudy told it, he brought over a painting he'd been working on, "of buildings in New York, and he [de Kooning] said, 'I tell you what, do something else,' and he took a piece of wrapping paper and crumpled it up, and put it near the window where it got light on it, and he said, 'Why don't you paint this, the way the light falls on these different surfaces?' And I said, 'Oh no, I couldn't paint a piece of wrapping paper. I have to paint something that interests me.' And he said, 'OK, if you know what you want to do, keep on doing it.' That was really terrible of me."

So Rudy set himself the goal of painting realistically. But his background in photography became a problem. "As a photographer you develop an instant vision. See a situation: that makes a picture. And when you go to paint later, you can't get out of that, it's like a handicap…. I saw the painting already finished, but I didn't have the faculty to get it. It was too laborious." Ozenfant told him if he studied with him for three years he *might* become a painter. "He rather liked the careful, somewhat primitive paintings I was doing…. My painting is still very primitive…. I'm very unhappy about it. I mean, there's a saying, 'Once a primitive always a primitive.'… I don't think my paintings are really any good," he admitted to Simon Pettet in their interview.

Burckhardt's paintings are not *bad*, exactly; in fact they're easy on the eyes and often quite charming. But technically they can seem painstaking and labored, in the characteristically over-conscientious, awkward manner of primitives painting from life. A certain amount of intentionally naïve, "awkward" drawing was part of the New York School's aesthetic: Alex Katz, Jane Freilicher, and Fairfield Porter all, on occasion, exploited a stiff sort of grace, though with brushwork never less than suave. That particular generation of representational painters had arisen not in opposition to Abstract Expressionism but in modest extension of it. As Rackstraw Downes, a fine landscape painter who also came to this circle, wrote: "Porter, Katz, and Freilicher took Abstract Expressionist, more particularly de Kooning's, brushwork and pitted it against direct observation, seeking the instantaneous glimpse, the surprise sensation; whatever labors their art may have cost them, theirs was an art that conceals art; it had the look of easy improvisation, as though the moving of paint collided accidentally with the description

of an object." Somehow Rudy could not break through to that level of graceful stylization; his cityscapes of rooftops, true, have a flat, Sienese conviction, but his human figures, particularly nudes, remain clumsily rendered. The problem may have been that he was trying so hard to get it right, to capture exactly what he saw, that he overshot realism, whereas, with a camera in his hands, he took verisimilitude for granted and could concentrate on making an expressively quick, interpretive response. Rudy, so quick to pounce on accident in photography, either could not access that gift while painting, or disdained what came too easily.

Still, he would not give up the dream of becoming a painter. In 1950–51, he studied painting again on the G. I. Bill, first at the Academy of Naples, then with a Professor Beppe Guzzi in Rome. Over the years he exhibited paintings at the Green Mountain Gallery, which later morphed into an artists' cooperative in Soho, the Blue Mountain Gallery, where he also showed his paintings. Often he would draw his subject matter on canvas from the same image bank as his photography: a sidewalk manhole, the Manhattan skyline from Queens, the fluorescent lights inside a stately office building, or the fronds and tree barks of his nature studies in Maine. Rarely would a painting improve on what was already in the photograph; but rarely would it lack some dogged charm—call it "naïve," "primitive," "childlike," or what have you. If nothing else, Rudy's paintings showed how determined he was to penetrate the mystery of certain visual facts by representing them in as many mediums as possible, and learning from the differences. He became a better painter over time, as evidenced by the fact that his later, austere studies of the disorder of the woods were among his strongest, most successful canvases.

Collaborations

From the beginning of his filmmaking career, Rudy made parodied, joshing story films that utilized the presence of artist friends. After he completed *Under the Brooklyn Bridge*, in 1953, he turned again to this type of filmmaking, probably more for the pleasure of collaborating with artists he looked up to than to perfect his hold on narrative cinema. These off-the-cuff shorts by Rudy and various New York School artists and poets included *Mounting Tension* (a spoof about art and psychiatry, with John Ashbery, Larry Rivers, and Jane Freilicher); *A Day in the Life of a Cleaning Woman*, with Fairfield and Anne Porter (as the cleaning woman), and Larry Rivers and Edith Schloss; *The Automotive Story*, a bogus industrial documentary with Jane Freilicher, a text by Kenneth Koch and music played by Frank O'Hara; *Miracle on the BMT*, a love story with Red Grooms and Mimi Gross; *Lurk*, a horror film with Edwin Denby, Red Grooms, and Mimi Gross; *Paradise Arms*, a soft-core porno with Neil Welliver; and *Tarzam*, a remake of the Edgar Rice Burroughs classic, with Taylor Mead, Denby, and Welliver again.

Collaboration was ingrained in the New York School aesthetic. In part, it was a borrowing from the French Surrealists, who promoted "exquisite corpse" techniques of group construction as a subversive challenge to the rational, cohesive artwork and the lone genius/masterpiece narrative of traditional Western culture. There was also a social aspect to collaboration, a getting-away from the artist as tortured soul, and an insistence that art could be fun. Rudy's personality perfectly suited collaboration, because he felt a genuine admiration for other fine artists and writers, because his ego was modest enough not to fret about issues of credit, and because he had a play-

ful, nonperfectionist approach to art making. He worked for a year with Red Grooms on the animated film, *Shoot the Moon* (1962).

Rudy also loved to collaborate because he sometimes found it too much responsibility to generate all the ideas by himself. On the other hand, the story films exhausted him in another way, by requiring him to oversee a cast and crew of up to thirty people; after finishing one, he would want to go off and work alone again.

The chief value of his story films consists in granting us priceless records of the New York art world at play. What would we not give to see a silent film of Cezanne, Monet, Cassatt, and Pissarro making believe they were cowboys and Indians. In Rudy's *Mounting Tension*, we get to watch Larry Rivers, John Ashbery, and Jane Freilicher pretending to be, respectively, a manic-depressive artist, a mindless baseball jock (quite a stretch for Ashbery), and a psychiatrist. Burckhardt's story films (with some exceptions, such as *Money*) are basically one-joke larks, barely shaped into coherent stories.

By contrast, his collaborations with Joseph Cornell resulted in five films, made between 1955 and 1957, which were more artistically worthy. Cornell, the visionary Surrealist sculptor, from time to time enlisted the aid of experimental filmmakers (Brakhage, Burkhardt, and others) to realize his cinematic ideas. As Rudy recounted the experience:

> He called me one day and said, "Do you want to make a film with me?" I knew his work, his boxes. Somebody told him I was making films, I guess, though he was never interested in my films. It was strictly on his own terms. He picked the place where we would start, Union Square on a cold, December afternoon. I brought the camera and he brought some rolls of film. Pretty

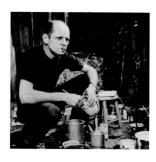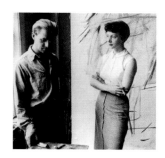

LEFT TO RIGHT: Jackson Pollock, Springs, New York, 1950 | Joan Mitchell, New York, 1957 | Bill and Elaine de Kooning, New York, 1950 | Mark Rothko, New York, 1960

soon I seemed to get it the way he wanted it. We looked at the film together. Most of the time he was very disappointed. "Oh no, that's nothing." He could look so sad. But once in a while something pleased him and he had this wonderful, slow smile. He liked to film birds; starlings, sparrows, swarms of pigeons, a lonely seagull in the sky. "I'm a sucker for birds," he confided.

These Cornell collaborations brought out the same observant, poetic sensibility that had gone into Rudy's city symphonies. One of them—a little masterpiece, *What Mozart Saw on Mulberry Street*—feels entirely like one of Rudy's street films (possibly because it is the only one Rudy shot and edited on his own). The others, *The Aviary*, *Nymphlight*, *Angel*, and *A Fable for Fountains*, have a wispy, fragile quality poised somewhere between documentary and reverie.

Again, to quote Rudy in *Talking Pictures* discussing *Nymphlight*:

A few things happened that were kind of miraculous. I remember a sunny summer day in Bryant Park. He wanted to make a sequence about a young girl who had been at her first ball and had danced all night. Now it was early in the morning and she came running into the park carrying a tattered parasol, strangely excited. I knew someone who had a daughter who was studying ballet, so she came. We filmed her, a lot of pigeons around the fountain, old men sitting on benches, people walking by. Then we both noticed this little girl who was maybe ten or twelve, wearing a blue dress. She was wandering around as if completely in a dream. Cornell pointed to her, whispering excitedly, I pointed the camera. She never looked at the camera, never noticed it. He was very happy

with that. We had filmed the other girl, also lost in thought. So he decided she was thinking about the little girl in blue as herself when she was younger.

Making a Living as a Gallery and Museum Photographer

One way in which Rudy collaborated with and served his artist friends was by taking studio portraits of them, while he was photographing their art. He began around 1950 when, finding himself with the responsibilities of a husband and father, and his inheritance exhausted, he had to hustle for work.

Suddenly I was thirty-five, my money gone, except for veterans' benefits. I went around for awhile saying I was licked and then I started a career doing black-and-white photos of paintings and sculptures. I photographed artists and their work for Thomas B. Hess at *ARTnews*, made photos for Leo Castelli and many other galleries and museums. I was good at angles, lighting, sometimes the drama of sculpture photography, but never glamour, which was O.K. because glamour then was reserved for fashion magazines and advertising.

For portraits, Rudy generally took no more than five or six exposures at a sitting. He stayed away from head shots: always, there is a good deal of studio space surrounding the figure, which may be explained by the fact that they were part of an *ARTnews* series featuring visits to the artist in his or her studio, as well as by Rudy's Sander-like tendency (minus Sander's stiffness) to place subjects in their daily work environments.

Some of his artist portraits have become classics; endlessly reproduced, they fix our image of a

particular master, even if the name of the photographer never registers more than subliminally on the public's consciousness. In general, they serve to bring the artist down to earth, to demythify, and humanize. Hans Namuth's famous series on Jackson Pollock immortalizes the abstractionist as a titan with pulsing-veined forehead; Rudy's Pollock looks like a car mechanic with a cigarette dangling from his mouth, mixing paint in a can. In another shot, very much married, Pollock and Lee Krasner stare up quizzically at the camera (Rudy must have been on a ladder). Joan Mitchell crouches catlike next to her canvas. Alex Katz, glowering in white tee shirt, stabs athletically at his painting.

These photographs of artists in their studios range from the psychologically insightful to the impersonal: the difference between highly-charged revelation and standard portrait shot seems to have less to do with variations in Burckhardt's artistic approach than with the subject's presentation of self. (How much the artist knew the photographer beforehand may also have factored into the degree of vulnerable candor that came through.) A taut de Kooning pauses for a cigarette or looks chastened in the presence of his wife, Elaine; Rothko, wreathed in smoke, tilting away from us, looks like a rabbinic mystic preparing to levitate to another plane; Marisol, on the other hand, is perfectly composed, the painter as starlet, her face giving away nothing more than Natalie Wood in a publicity still. In short, some of Rudy's studio portraits convey the excitement of a heroic age in American art; others are merely good commercial photojournalism; still others show craggy-featured, preoccupied laborers engaged in an engrossing manual task, which just happens to be painting.

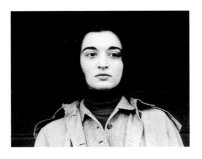

LEFT TO RIGHT: Marisol, New York, 1960 | Yvonne Jacquette, c. 1961 | Family portrait, 1979

Rudy also took numerous photographs of paintings themselves, documenting the whole Pop Art scene, among other things, for art magazines and galleries. He was quite good at photographing art, partly because he loved to look at paintings long and close, and especially skilled at photographing sculpture, giving each piece a clear spatial reading.

Yvonne Jacquette

Over the fourteen-year course of Rudy's marriage to Edith, certain tensions had developed. Rudy was unfaithful and not very apologetic about it; the sheer luck of bedding women as he got older gave him increasing astonishment and delight. In *Mobile Homes*, listing "moments of foolish pride," he wrote: "When I had a wife, a secret girlfriend, and a third girl was willing to go to bed with me even after I told her about the other two." While his visits to brothels on the road had not bothered her, the affairs he had in New York led to many quarrels. Edith was also dissatisfied with her public status as "artist's wife." She regarded herself as a New York artist in her own right, and while she showed from time to time at galleries, she felt ignored and artistically blocked. Partly it was her fault, she said later, for being disorganized, undisciplined, and distracted by maternal concerns.

In 1961, Rudy met Yvonne Jacquette, an attractive young painter, at a party for Nell Blaine. Yvonne, an ex-student from the Rhode Island School of Design who had come down to New York to join the art scene, was already primed for the meeting with Rudy, having recently encountered "a beautiful photograph of his done in the late 1930s and, a week later, a painting he'd done of Deer Island [Maine]… quite skillful in a slightly naïve style." She was

going to a life-drawing session at the time on Eighth Street, and coincidentally Rudy also dropped into the class; eventually he invited her out for coffee afterward. She was twenty-seven at the time; he was forty-seven, twenty years older. Yvonne, according to Rudy, had had numerous affairs before they met, "the kind of thing young people do," but she told him he was the first man she felt comfortable with. Her father, an accountant and management consultant who specialized in time-and-motion studies, had been rigidly moralistic, unsympathetic to her artistic vocation, and quick with his temper; by contrast, Rudy was the opposite: gentle, funny, generous, and uninsistent.

They went around to galleries together, and became lovers. This time, uncharacteristically, Rudy fell in love as well. Yvonne, raised a good Catholic, felt guilty about being involved with a married man, and tried to break off the affair; but Rudy wrote her an incredible letter, she recalled— "the handwriting was beautiful, also"—which convinced her to stay.

One night, in 1962, Edith went to an opening of Joan Mitchell's paintings and saw Rudy and Yvonne standing together "in the light." There was something about their body language—she hadn't known anything about Yvonne yet—but at that moment she had a terrible feeling. Rudy "slinked off" and went home with Edith. Later, the truth came out. Rudy had already placed a down-payment on a small loft in Chelsea for himself and Yvonne, and Edith found the receipt. In the past, there had been terrible fights about his affairs. This time, she said, she didn't have the strength to fight—she took herself off to Rome with Jacob for three months. "I only wanted to leave for a short while, to be out of the way. I still don't understand what he had against our marriage."

As it grew evident that Rudy would be sticking with Yvonne, Edith remained in Rome (where she still resides, painting and writing). By 1964, Yvonne was pregnant with Thomas. Edith remembers her mother asking Rudy: "Why are you leaving this woman with a child, only to start with another? Why are you making such difficulties for yourself!" Rudy, with Calvinist humor, replied: "That's my punishment."

For Rudy, the transition from one woman to the other became, in retrospect, a pivotal moment of his life: for once, he had been shaken out of passivity and drift. "That was the one time I had to be decisive in my life—leaving Edith and moving in with Yvonne. Usually I just let things happen. When Yvonne and I got married she was only two weeks away from having Thomas!" In his memoir-essay in *Mobile Homes*, he phrased the events in a more cut-and-dried manner: "I turned fifty, was divorced, married Yvonne Jacquette from Pittsburgh, Pa., Thomas was born—all this within one month in 1964."

Searsmont, Maine

In the summer of 1963, Rudy and Yvonne visited Lois Dodd and Alex and Ada Katz, who all shared a house in Maine. That week set the template for a balance between city and country that would become a constant in the Burckhardts' life. As Yvonne described it:

I saw for the first time what it could be like. We could get a house, near Alex, near a lake, probably that lake, but better if we found another one. Our whole idea of what you need to have in Maine was based on that week—a good place to swim, where you don't need to get in a car to drive to it, a barn to work in as a studio. It didn't matter too much about the house, but hopefully

LEFT TO RIGHT: Ferns, Maine, no date | Bunchberries, Searsmont, Maine, 1997

it wasn't too ugly. Just some space down a dirt road, away from traffic. And hopefully, close enough to friends.

There was another reason for wanting a country home: to house Rudy's son, Jacob, decently during the summer months when he came to visit. Jacob, thirteen at the time his parents separated, may have suffered the most from the break-up: expecting to become a typical American teenager, roaming New York City with his friends, he suddenly had to adjust to school in Rome and the loss of his father, except for summer vacations. Perhaps because he had been so close to his father and they were so identified with each other (they even shared a strong resemblance), Jacob directed all his anger toward the new woman in his father's life, and at first would barely speak to or look at Yvonne. She, in turn, made it a priority to improve things for Jacob.

In 1965, the Burckhardts realized their dream, buying a house with Edwin Denby near Lawry Pond in Searsmont, Maine. (Their sale of a de Kooning helped secure the purchase price.) For the next thirty-four years, or until Rudy's death, they would spend every summer in their house in Maine, going up in June and not returning until September or, sometimes, October. Yvonne would paint her increasingly large canvases in the adjoining barn. They would swim in the pond (Yvonne had been a member of her high school swimming team, and Rudy was also a strong swimmer), or row a kayak around it, and take turns cooking. For company, a number of painter-friends, Alex Katz, Neil Welliver, Rackstraw Downes, and Katherine Porter, had property in the area. In time, some of these associates ended up quarreling with each other, off and on; but for the first years, at least, it was as idyllic as any informal artists' community could be.

Rudy was not exactly a stranger to the country: he had rented a small cabin on Deer Isle, Maine, for some years, when he was married to Edith, but during most of these summer periods he would install his wife and son up there while he remained back in New York. (He preferred, he said, photographing people in the streets without big coats on.) Once they bought the house in Searsmont, Maine, however, he began staying all summer long up there with Yvonne, Thomas, and Edwin. Rudy would keep occupied by taking photographs and making movies, or painting oils, usually bringing a canvas into the fields and setting up *plein-air* style. Nature opened up a new subject matter for him. In the country he would focus on some woodland tangled undergrowth, a pine-needle forest floor, the gnarled-root base of a tree, say, or a moth arrested on a single leaf. He was drawn to the myopically dense, wild cross-section of New England nature (as was his friend, the landscape painter Neil Welliver). He was fascinated with the slashed trees and fallen logs after a major storm, the interpenetration of life and death, growth and decay in the woods, which suited his philosophy of entropy.

Some of Rudy's nature studies—his photographs and oils of fern fronds, for instance—have a pristinely observed feeling for organic structure. His film entitled *Caterpillar* (he found out later it was actually an inchworm!) follows that creature's arch-backed progression in a lovely exercise of patience and persistence. The all-over carpet of flowers *Searsmont, Maine*, 1975, or *Bunchberries, Searsmont*, 1997, hold up as an abstract photographic equivalent of pattern art. The best of the close-ups of trees, particularly the series he did of birches, are stunning. But many others—shots of ponds, clouds, hills, and treetops—verge on the tritely scenic: he often seemed at a compositional

disadvantage without the orthogonal geometries of the street, where he was master of his domain.

The 1960s and 1970s

The Sixties were a period in which Rudy felt right at home. The counter-cultural energies released by youth culture and the anti-war movement dovetailed with his own proanarchist, antibourgeois, mockingly subversive sensibility. He participated in the occasional peace march, and accepted the logic of women's liberation, helping to take care of Thomas so that Yvonne could do her artwork as well. With the growth of an underground film circuit, colleges and universities started renting his films more frequently than before, and Rudy's movies were suddenly in step with the times. In a statement called "How I Think I Made Some of My Films," he charted this progression, noting how, in the 1950s, a period of 16mm "chamber" cinema dominated by Maya Deren and Stan Brakhage, "My films didn't quite fit in. Then came the hippie, underground, pro-sex, anti-Hollywood revolution in the early Sixties which were my late forties. I became a fellow-traveler and beneficiary as my films were seen more often. I had a good review by Jonas Mekas who was fighting censorship and promoting far-out, uninhibited films."

In 1967, Rudy also began teaching film (and later, painting) at the University of Pennsylvania, recruited there by Neil Welliver, who was head of the art department. He continued teaching there for seventeen years, until 1984. He would commute one or two days a week to Philadelphia, and stay at Welliver's house or at his friends Will and Emily Brown's overnight. He was also able to see his older son weekly during Jacob's college years (from 1967–71) at Penn. Jacob remembers sitting in on Rudy's classes, and seeing for the first time such avant-garde stalwarts as *Un Chien Andalou*,

Anemic Cinema, O Dem Watermelons and *Window Water Baby Moving*, as well as the films of René Clair, a particular favorite of Rudy's. This experience undoubtedly affected Jacob's decision to become a filmmaker himself, as did Rudy's gift to Jacob of his old Bell & Howell movie camera, when he switched himself to a Bolex.

The Sixties and early Seventies were a busy social period, with frequent dinner parties that combined Rudy's, Yvonne's, and Edwin's friends, and often concluded with a private showing of one or two of his films. Rudy was now part of the downtown scene, geographically as well as spiritually: in 1969 he and Yvonne began living in a larger loft on East 14th Street, above an old movie theater, the Jefferson. The happiness of their union and their newborn son proved a stimulus to creativity.

From the start, Yvonne and Rudy influenced each other aesthetically. In a high school English composition, Yvonne had expressed the lofty ambition to become "the portraitist of cities." From Rudy, she learned to work with "just a bit of something you can see out the window, instead of trying to do a big spread," and to accept that "anything exists as a possibility for art" and to see the city from above, on rooftops looking down, with its modest details such as water-tanks that "got an evocative thing into something very physical." She also learned from him how to loosen up with an "anything goes," homemade attitude that would invite serendipitous accidents. Yvonne acted in his movies, and designed sets and costumes for him and Red Grooms.

Finally, she now thinks, she learned habits of discipline from him. "In his own way, Rudy was very disciplined. And very tidy. In his studio, he would pack up his work in one art, clean it up, and go on to the next thing. He could photo-graph, paint, and film in one day. He always said it was because he had a short attention span, but it was also because he was so disciplined. He would schedule one or two days a week for shooting other artists' artwork or portraits, and print them for half a day—he liked to keep the lab work to no more than half a day—and the rest of the time would go to his non-paying projects." In turn, Yvonne, who had worked at drafting and textile design when she first came to New York, and had a fastidious eye, helped Rudy retouch his prints of artists' portraits for the Leo Castelli Gallery and other clients.

Yvonne developed very disciplined work habits herself and, with that, the ability to keep taking a concept to the next level of challenge. For instance, her meticulously executed, daring aerial views, for which she is now renowned, started with painting clouds from an airplane window; then she went on to do landscapes of farm areas on a cloudless day, then on to paintings of small cities (hiring Cessna pilots to fly her around for an hour or so), then the harbors of major metropolises such as Chicago and New York, then downtown districts in Asia and America (mixing high-rise views with aerial ones), cities and townships at night, multicelled sequences that would rotate the angle of the terrain from canvas to canvas, then aerial views extended from oils to different mediums (lithographs, woodcuts, etchings, charcoals).

Yvonne readily admits she may have been influenced in this bird's-eye perspective, however unconsciously, by her husband's numerous roof shots, just as her interest in cloud formations was sparked by some footage Rudy had taken of clouds. The point is that she developed each of these stages in a highly analytical, professional manner. And she met with considerable success, showing first at the Fischbach Gallery, then at the Brooke Alexander, and presently at D. C. Moore, all major galleries. In the process, she became an inspirational model, advisor, and mentor to many younger women painters. She received commissions from municipalities and corporations that wanted to celebrate the local landscape with an Yvonne Jacquette aerial composition: her work was boardroom-friendly, even as it presented complex perceptual challenges that delighted critics and peers.

Rudy was, for the most part, supportive of Yvonne's painting and proud of her success. He made a short film about her execution of one such commission, *Yvonne Jacquette Painting Autumn Expansion* (1981), a triptych of woods seen from above in blazing fall colors, for the federal building and post office in Bangor, Maine. (It was one of four films he made between 1974 and 1981 about artists at work, the other subjects being Charles Simonds, Alex Katz, and Neil Welliver). Being human, of course, Rudy did have jealous moments when his wife became more successful than he: for instance, after she was included in a New Works on Paper show at the Museum of Modern Art, he threatened not to come to her opening there, or when Brooke Alexander picked her to be in the gallery at the same time that Rudy could not find a gallery to sponsor him. (His own occasional photography shows, at the rate of one a decade, were at places like the Limelight Coffeehouse or the Gotham Book Mart.)

Yvonne advised Rudy on his film projects and, in their mutual "crits," tried to get him to think more analytically about his paintings. But she rarely budged him from his preference for intuitive creative methods, and she certainly did not succeed in imbuing him with her own professional attitude toward getting the work out:

Rudy didn't know how to promote himself, in a way that he would feel comfortable with. One time, long ago, he rented the Provincetown Playhouse [in Greenwich Village] to show an evening of his films, and he rented an arc-light projector, and something went wrong with the equipment. He had to cancel the show. He was mortified, and after that he was very discouraged and skittish about promoting himself.

The Utopia of Amateurism

In his preface to the catalogue of Burckhardt's retrospective in Valencia, Spain, Juan Manuel Bonet, director of the Institut Valencià d'Art Modern, forthrightly stated that Rudy liked "playing at being the amateur." It was true: as an artist, Rudy seemed to want to retain amateur status. The word amateur derives from the Latin word for lover. Rudy liked to see himself as a lover, not a fighter, but he also had a conviction that life was an amateurish business. He wrote:

> I am enough of an amateur existentialist and Buddhist to believe that we actually just mess around because we're alive and awake—working, playing, scheming, falling apart, getting it together again, but never in control. The ideas of development, career, achievement, history are superimposed with hindsight by ourselves and others, in a desperate attempt to bring continuity and purpose to our confused days and nights of living.

The role of the amateur in art has its positive side: saying one is just "messing around" opens up a space for expressiveness. And indeed, why must art be labored, a Flaubertian agony? Why not child's play? The New York School helped create a climate for making art as experimental foray,

without undue worry about perfection or career advancement.

Robert Storr's evocative title for his essay on Rudy Burckhardt, "The Gentle Art of Pleasing Oneself," suggests the advantages of ignoring the need to please critics or buyers. Still, the notion of career amateur is fraught with contradictions: how could someone like Rudy, who produced some 7,000 negatives and made a living for decades as a gallery and museum photographer, retain amateur status, so to speak?

One way was for Rudy not to take seriously the guild practices by which "fine art" photographers jealously asserted their claims as artists. He scoffed at the notion of the "vintage print," which he saw as a form of preciosity and price inflating, given the medium's infinite capacity for reproduction. He also made no attempt to push the sharpness of a print to the limit, opting instead for what his old editor at *ARTnews*, Thomas B. Hess, called "clarity without contrast." Hess summarized the homemade, good-enough character of Rudy's printing technique: "He makes his own prints, sometimes enlarging, cropping, even retouching … He seems to be a bit sloppy— let's say insouciant—as a darkroom technician. The prints occasionally have odd bumps and specks. Yet they look and feel perfectly natural. Their imperfections seem inherent to normal development."

This tightrope-walk between "sloppy" and "insouciant" gets at the heart of Rudy's arduously maintained casualness and cultivated imperfection. Friends testified to his generosity in giving away piles of his photographs, while noting that the prints often had spots or other defects. (Did he regard them as defects, I wonder, or as self-reflective markings, the way underground filmmakers might include the light-bursts at the end

of a roll?) In shooting his movies, his son Jacob, who assisted him on occasion, recalled, "he was hardly a perfectionist. He was able to hit things pretty well the first time, but if not, he'd get bored, the hell with it. He never took many takes. He didn't direct his actors very much at all." Rudy would customarily use handwritten chalk on black paper for title cards, as a sort of low-tech joke. Yet he was a natural filmmaker, his compositions and editing invariably sure-footed and graceful—not in the least amateurish.

Rudy availed himself of the "amateur" privilege as an intermittent option. It was a way to avoid taking himself and his ambitions too seriously, as well as lowering the bar of audience expectations. In his early still photographs and the city-symphony films, which had consisted of documentary shots sympathetically edited together, amateurism never was a factor: the images were well composed, evocative, and appropriately visible in terms of light and shadow. It was only with the story films—to which an audience, bred on Hollywood talkies, would bring higher expectations of sync sound, realistically modeled lighting, naturalistic or at least consistently stylized acting, narrative coherence, and respect for genre conventions—that Rudy tried to make a virtue of sloppiness, via the paltry budget for sets, props, and special effects, the use of nonprofessionals (usually enthusiastic friends) as actors, the artlessly dubbed dialogue, and the story-lines that often disintegrated into mayhem, as though the scenarist's short attention span for prolonged fantasy were part of the point.

I do not mean to belabor the shortcomings of these story films. Though they took up a big chunk of Rudy's art-making time over the years, they were merely meant to be fun—throwaway efforts—and remain fun, if seen in the properly

indulgent spirit. "The contemporary moment, when rockets actually were going into outer space, made the rough-hewn sets and props of *Shoot the Moon* seem ludicrous, a quality the filmmakers desired," wrote Vincent Katz about a collaboration between Rudy and Red Grooms. What is important for our purposes to contemplate here is why Rudy was so stubbornly devoted to the "ludicrous" or the "silly." What functions did it serve for him?

Rudy seemed to have embraced an avant-garde notion that art should be playful, serendipitous, organic, and not take itself seriously. One can locate the roots of this ethos in Dada, Surrealism, and chance/performance art practices. David Lehman, whose book, *The Last Avant-Garde*, is a useful introduction to the New York School scene, emphasizes how ideas of fun, *blague*, leg-pulling, chance, and accident inspired parodistic, collaborative, collaged, pop-culture irreverence, and a horror of noble sentiment. "Poetry did not have to be limited by the life experience of the poet; it could be generated linguistically, conjured up via innovative methods of composition," wrote Lehman. The same idea applied to the visual arts, especially experimental film. Rudy's use of speeded-up, slow-motion, upside-down, split-screen photography, intentionally crude animation, collage, genre parody, infusions of women's breasts, amateurish acting, and transparently clumsy special effects—all refreshing up to a point—seem to me, over the long haul, also like defensive gestures to placate the avant-garde gods against charges of "mere" social documentation.

In helping Rudy get a film retrospective at MoMA in 1987, I had helped flush him out of the underground and make him semiofficial—not an entirely good deed, it would appear. In return, I

came to understand much later, *I* wanted something. I wanted him to take himself more seriously as an artist—to put aside what for me was becoming the tiresome posture of discomfited embarrassment at having to wear a necktie while receiving congratulations and awards—and to be a little harder on himself, to push his art to a more severe, perfected place in the few years he had left.

Interestingly, he never practiced much of this self-reflexive subversion of representation in his still photography. There he seemed content to take a traditional or old-fashioned "realistic" approach, even at his most minimalist. Rudy's highest artistic achievements derived their strength from the same witnessing impulses as Atget's photographs of a soon-to-vanish Paris, or the Wilder-Siodmak glimpses of Berlin in *People on Sunday*, and what humor they evoked tended toward a subtle, droll smile. When Rudy tried for broader, aggressively Dada humor, he almost invariably trivialized. But the need to be silly, to fracture his own observant, quietly graceful surface, became a shorthand for modernist intention, the dues paid, perhaps, to remain a card-carrying member of Bohemia and supporter of youth culture, as well as a way for him to continue to thumb his nose at stuffy, gravely classical-humanist Basel.

After Age Sixty

When people remarked how unchanged and vital Rudy was between the ages of sixty and eighty-five, they were perhaps responding to his relaxed body and mind, and his ability to stay in the moment. But they were also saying, without quite realizing it, that a part of him had long been prematurely elderly. He had "old eyes," as noted earlier, and was melancholy from the time he was

very young. Therefore, he seemed to be ageless. The elderly Rudy hung around young people: he went to their art events, listened sympathetically to their self-doubts about life choices, and seemed more at ease with them than with people his own age. This was something we could, comically enough, never agree on in our friendship: I did not find young people particularly fascinating, and have always looked to my elders for inspiration—hence, my admiration for Rudy. He, on the other hand, may have been initially drawn to me because I was still relatively younger than he was, if not exactly young—I was about thirty, to be precise, when we first met.

I first befriended Rudy sometime in the early 1970s. It was inevitable that we meet, since he was devoted to the Poetry Project at St. Mark's Church on the Bouwerie, where the New York School of Poets held sway, and I had long been a fellow traveler of that scene. "How can it be possible you two don't know each other?" asked the poet Bill Zavatsky, introducing us. After sheepishly admitting we didn't, we proceeded to make up for lost time, by acting as if we had. I liked Rudy's impulsive humor and cultivation, his love of New York, his physical presentation of self. He had a herky-jerky way of bowing from the waist, like Pinocchio, and a set of perfect Swiss manners he would catch himself at and mock. Though he seemed most pleased with his incursions into the bawdy or low-rent (he loved to play a bum in films, and had a kind of *clochard* envy), it was actually his sense of decorum that I cherished, as the living remnant of a vanished civility.

He would buzz you in, usually joking over the intercom, "Is this the mailman?" When you got off the elevator at his floor, he would be waiting, hiding behind the door. Opening it with an apologetic grin, as though he had performed

only a very small trick for a magician of his repute, saying "hellohello" he would then, regardless of the visitor's gender, kiss you on the mouth. This very un-American, startling intimacy would be followed by a counter-move, namely, Rudy backpedaling away, deeper into his loft. He would offer you something to drink, tea or alcohol, and maybe some snack foods (tinned oysters, crackers, cheese) set out on the kitchen counter. Often, later, he would cook a meal for you. You might take a quick gander at a painting he was working on in the back room: the long, well-worn table often held an editing set-up with take-up reels for his film of the moment, with a shot list beside it, and a paperback book, face-down, where he'd left off reading.

When I first began visiting Rudy, he and Yvonne were living with their young son Tom in their loft on East 14th Street, down the block from the Academy of Music (later the Palladium disco). East 14th Street had by then become a raunchy, "transitional" area, with drug dealers congregating under the marquee, hookers up the street, and hippies and poor Hispanics as neighbors. A few years later, in 1975, they took some money he had inherited from his mother's estate and the sale of a de Kooning, and bought a more comfortable loft on West 29th Street, where Rudy lived with Yvonne for the rest of his life. It was from this former manufacturing loft, with horizontal windows pulled open by a chain, that he could see the skyline of water towers and office buildings across the way, and the plant-friendly fire escapes and snow-swirled rooftops and truck-lined alleys below, which he frequently photographed and painted. The surrounding view had something archaic about it, 1930s–1940s industrial metropolis: pure Rudy, like the photograph he had presciently taken in 1947,

Chelseascape III, of smoky factory rooftops, and now was living amidst, having returned, this time in style, to Chelsea.

Soon after we became friends I found myself collaborating with Rudy, thirty years my senior, on a short film based on my script, *The Casserole Dish*, a sendup of a silent melodrama about two friends who fall out after one of them gets married. I had cast Bill and Phyllis Zavatsky as the married couple, and I was (of course) to play the lead role of the Bachelor who dies in the end. With my love of the antiquarian, I had envisioned it as a sort of homage to the silent films of Griffith and Stroheim, and began describing some of the compositional and lighting effects I had in mind. But Rudy, who grew up much closer to the golden age of silents than did I, had no interest in recreating that burnished tradition. I soon learned he had only one way to shoot a film, and that was quick and direct. If a lighting or camera setup took more than ten minutes, he got impatient. Though we had been slated to share the direction, after the first day's shooting Rudy came to me and said no film could have two bosses, it was better if I were to direct alone; he offered to stay on and do the camerawork and editing. (In the end, all the valuable, poetic touches of that highly disposable picture came from Rudy's cutaway cinematography.)

We edited the film at the Burckhardts' farmhouse in Maine and, in long country walks, as breaks from our labor, I learned about Rudy's past. Edwin Denby was there as well, and I fell in love, in a manner of speaking, with the old poet. Edwin had a bacheloric autonomy and dignity that I aspired to, so much so that I ended up adopting one of his cat's kittens, as symbolic appropriation of his character. Yvonne, who had taken to Edwin from the first, considered herself

very lucky to know him. Edwin seemed like a beloved uncle—in any case, a respected member of the family—who mostly kept to himself but also washed the dishes, helped with the housekeeping, and read to Thomas when the boy came down with a fever. I remember Edwin reading aloud from a Bram Stoker gothic novel (not *Dracula*) and doing the horrified Victorian voices with gusto.

When I first befriended Rudy, Yvonne tended to recede into the background whenever I came over. A calm, slender woman with curly chestnut hair and thick glasses, which magnified her pretty if astigmatic brown eyes, Yvonne seemed to be making room for what she perceived as Rudy's new friendship. Later, that would change, and I would feel drawn to her psychological candor and directness, as much as to his complicated reserve. There was a time in the 1980s when Rudy became hard of hearing, before he agreed to be fitted for a hearing aid, when I found myself seeking out Yvonne and conversing more with her, to get the lowdown about what was going on with Rudy and their lives.

The Burckhardts' refrigerator and bulletin board were covered with invitations to gallery openings, poetry readings, performance-art pieces, experimental-film showings, and dance concerts, all of which Rudy and Yvonne made an effort to get to. You would see them in the St. Mark's Church pews, cheering on a poet who needed a claque, or at some group show of co-op gallery artists. They knew how much it meant to a younger poet or dancer, say, to see their venerable faces in the audience, bestowing a blessing on efforts at innovation. Of course they often liked what they saw, and went home replenished. But beyond any hope of receiving aesthetic pleasure, there was the issue of community. If

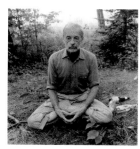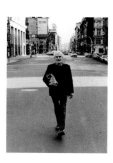

LEFT TO RIGHT: Red Grooms in "Lurk," film still, 1964 | Tom Burckhardt, 1980 | Self-portrait, Searsmont, Maine, 1984 | Edwin Denby on Sixth Avenue, c. 1970

community meant anything in the avant-garde, it meant showing up.

Yvonne and Rudy belonged to a community of downtown Buddhists, and not only practiced meditation but enjoyed attending teachings by their two Tibetan teachers, and made regular financial donations to the center's programs. The spiritual discipline had helped stabilize him, according to Yvonne. He went on retreats and read Buddhist scripture every morning. He embraced an idea of compassion, self-analysis, working toward a natural and quiet mind, and transcending the ego.

There was something poignant about this almost neurotically modest of men taking so earnestly to the notion of struggling against one's ego. In his later years he was quick to blow the whistle on any signs of pride, ambition, competitiveness, or vanity he spotted in himself. Having rebelled so strenuously against the austerities of his Swiss-Protestant background, he had come around willingly to another sort of self-restraint, thanks to the Buddha's teachings. The contrary need to kid any potential solemnities of Buddhist practice can be seen in a late, posed self-portrait: Rudy sits in lotus position, surrounded by the trees of the forest, looking somber, grim, and baggy-eyed, with a few liquor bottles strewn at his side. This self-mocking photograph actually ran with his *New York Times* obituary, as a summing-up of the Burckhardt world-view.

Death of Edwin Denby

Toward the end of his life, one would see Edwin Denby at dance recitals and readings. Frail and translucent-skinned, with a shock of white hair, with his pullover sweater and sports jacket over a thin physique, his exquisite manners and quick, reassuring smile, and a certain neutered or

beyond-all-that quality, there was something angelic about him. Everyone said so. However, in his great poem, "Snoring in New York," he drew this sterner portrait of himself:

> Summer New York, friends tonight at cottages
> I lie motionless, a single retired man
> White-haired, ferrety, feminine, religious
> I look like a priest, a detective, a con
> Nervously I step among the city crowd
> My private life of no interest and allowed

His invariably polite and friendly manner in no way detracted from the lonesome, untouchable cone he walked inside, and which seemed to issue from his conviction that this solitude was his, and perhaps everyone's, ineluctable fate. At the age of eighty, after years of struggling with his physical infirmities, Edwin took his life, on July 12, 1983. Rudy described the actual event in a tender, matter-of-fact (and brave, legally speaking) account he wrote called "Edwin's Last Day," published in the *Poetry Project* newsletter:

> We were alone in our house in Searsmont, Maine. Is this a good time, Edwin asked. Yes, I said. I cooked a small mackeral, sweet peas, and warmed up the rice from the day before. Then we lounged in the living room reading aloud more Holderlin, some poems by John Ashbery, and listened to Wanda Landowska playing Haydn and Mozart on the piano. Edwin said he'd written a note, something about unaided, and that it was so well-written he was proud of it. Yes, pride always keeps sneaking in, I said and we laughed.

Rudy then recounted how, at the end of the evening, Edwin "came back and said: I've lost the pills. I was

annoyed. Ok then I'll have to take you to the dentist in the morning. Good night. As I passed him he gave me a slow, wide, complicated smile and said: thank you—thank you very much." In the morning, Rudy found Edwin's body at the kitchen table.

Modesty and Fame

The frequency with which attributes such as "modest," "unassuming," "diffident," "uncompetitive" are invoked in the critical literature about Rudy Burckhardt is noteworthy enough to be startling. These adjectives correctly describe their subject, up to a point. But modesty also turned into something of a straightjacket for Rudy, and, though he was fully complicit in accepting the role, it may have limited his artistic ambitions and distorted his actual feelings.

Having noted, for instance, his neglect during the Fifties "chamber film" scene and his sudden blip of popularity in the Sixties, he observed that in the Seventies, experimental films "became conceptual, structural, strictly ruled, often heavy-handed and humorless. They were written about in *Artforum*, leaving my films again in the penumbra. However in the last few years, at an advanced age, I believe my films at last have become avant-garde." Reading past the bemused, self-mocking tone, we can see Rudy was hungry to be popular and well known. But "my success in these areas has been spotty, not nearly enough, and I am still far from being famous. It looks like I will have to wait for posthumous acclaim and financial reward."

A dash of rue is also detectable in a remark he made more than once: "I've remained friends with my male friends who got very famous, because I'm no threat to them." These famous friends, such as Willem de Kooning, Alex Katz, John Cage, John Ashbery, Kenneth Koch, Red Grooms, and Larry Rivers, did remain on good terms with

Rudy, but by and large, he was far closer on a daily basis to a series of much younger men who had not yet made their mark.

Rudy wrote in his statement, *A Long Career*: "My films have an audience of poets, painters and beautiful young people." This last demographic mattered a lot because physical beauty was very important to him, particularly the kind he found in youth. "I believe the young people now are as bright as ever I know a lot more [young people] now. I think they're fantastic," Rudy said in *Talking Pictures*. He may have romanticized the young because his own youth had been a time of floundering, when he suddenly found a calling that enabled him to rise above feelings of worthlessness, and to explore the world with freedom and skill. The young returned his admiration by looking up to him, as a sage, though he had fun pooh-poohing the role (quoting Goethe in a mock-profound voice).

Rudy also played the part for young people of the merry prankster. Doris Kornish's independent documentary, *Not Nude Though: A Portrait of Rudy Buckhardt*, so foregrounds his goofy side—ending in what the press kit calls "a wild performance piece scampering through a Loisada garden, followed by a nude headstand in the woods in Maine . . . not your average eighty-year-old"—as to scant the darker, more melancholy shadings of his character.

Writing in *New York* magazine (1980), John Ashbery begins an appreciation of Rudy with the words: "Before there was an underground, there was Rudy Burckhardt." A "Talk of the Town" piece about Rudy in *The New Yorker* (1989) noted that "for many years his efforts got so little public attention that one automatically thought of him as an underground man." But the article continued: "Not long ago, the Museum of Modern Art

accorded the films of Rudy Burckhardt a retrospective, and the Metropolitan had put one of his photographs on a notecard, which makes him seem official. . . . 'Now that I've had a show at MoMA I can't be called underground anymore,'" Rudy told the reporter, with self-mocking chagrin.

In the late 1980s, Christopher Sweet, next after me in the line of number-one sons promoting Rudy, told the Museum of Modern Art's photography curator, Peter Galassi, that it was a scandal for that great New York institution not to have Rudy Burckhardt photographs in its collection. Galassi agreed, and went further, arranging for MoMA to buy a number of albums of Rudy's photographs. When Galassi, Sweet, and Burckhardt met over a lunch to celebrate the acquisition, the photography curator started to apologize to Rudy for the museum's unconscionable neglect of his work, then caught himself in mid-sentence and asked: "When was the last time, by the way, you brought any photos around to our curators?" Rudy answered that in 1950 he showed some of his Mexican travel photographs to Edward Steichen, who seemed unimpressed. After that one rebuff, Rudy never approached MoMA again, deciding, "They don't like my stuff."

I observed another instance of Rudy's tendency to evade recognition, at a meeting with Larry Kardish, the Museum of Modern Art's film curator, when the museum was first arranging a retrospective of Rudy's movies. Kardish offered Rudy twelve programs, each to be projected twice, for a total of twenty-four. The offer was so generous that Rudy couldn't take it in; and then suggested that it might be better to have fewer showings and to mix up the programs chronologically so that people wouldn't "get bored." I ventured that there was something to be gained from a straight historical perspective. Rudy joked

that it sounded "so serious," at which point Larry Kardish said "But this *is* serious." Rudy kept making self-deprecating statements like, "The last time I showed my films they didn't go over so well." In short, Rudy had to be persuaded that the museum was indeed going to mount a serious, scholarly retrospective for the public that would encompass his entire film output.

As it happened, Rudy's other friends rallied around him—most notably, the filmmaker Warren Sonbert, who helped nudge the MoMA retrospective along—and Brooke Alexander, who arranged for there to be a choice selection of old photographs at his gallery (Rudy had finally joined Yvonne on their artist list); and there was to be an exhibit of his new paintings at the Blue Mountain Gallery, all timed to coincide. A trifecta, so to speak. For that season, in 1987, Rudy Burckhardt reigned all over town.

The Diary/Collage Films

Around 1974, Burckhardt began making what were variously called (not by him, however) "diary" or "collage" films. Here is how he described them: "Without a plan, over a period of a year or two, I collect images in the many weathers of New York, or rural Maine in the summer, or wherever I happen to travel. It needn't be any exotic place anymore. Almost anything can go into my films now, if a scene comes out lively, beautiful, or funny it will fit in somewhere; if not, I can keep it around for the next film."

Some of the prime examples of Rudy's diary/collage films included *City Pasture* (1974, 40 minutes), *Good Evening, Everybody* (1977, 43 minutes), *Mobile Homes* (1979, 32 minutes), *Cerveza Bud* (1981, 30 minutes), *The Nude Pond* (1985, 30 minutes), *Mystic Grange* (1988, 25 minutes), and *Wayward Glimpses* (1992, 18 minutes). *The Nude*

Pond, or Just Walking Around, for instance, had poems by John Ashbery, a duet danced by Douglas Dunn and Susan Blankensop, a performance by Yoshiko Chuma (Rudy's daughter-in-law) on a "piano" composed of paint tubes made by Jim Boorsten, and various other bits. About this film I wrote at the time: "*The Nude Pond* is a grand synthesis of the poetic free-association films Rudy Burckhardt has been perfecting for the past ten years. Democratic in its celebration of all contemporary art forms (dance, painting, performance art, music, poetry, and, of course, film), encyclopedic in its images (from New York City interiors to Maine brooks to a Caribbean carnival), it is finally most unique by virtue of its emotional range. The filmmaker has achieved a style which enables him to encompass everything, from the whimsical, even silly, to the deeply philosophical and grave, with all shades of curiosity and neutral observation ('Just walking around,' as the title says) in-between."

Because of their strong diaristic element, and because of Rudy's seasonal movements from Manhattan to Maine, which followed a predictable pattern while his interests in performance and spectacle remained constant, there was perforce a fair amount of repetition and overlap in these films. Each tended to have shots of New York streets in winter, bucolic passages of Maine in summer, with perhaps a visit to the county fair, scenes from his favorite choreographers—Douglas Dunn, Dana Reitz, Yoshiko Chuma—rehearsing their companies in chaste downtown lofts or performing, satyrlike, in the Maine woods, occasionally a woman running naked in an apartment or around a tree, and maybe an animated banana or some other toylike element.

To see any one of these collage films by itself is to be plunged into a luminous world of expanding possibility, of ever-changing composition and subject, a free fall of images impossible to predict. To see several of them together is to be faced with a different challenge. Your mind seeks some meaning, some pattern that will connect these fragments and deepen the experience. Or you tell yourself that there is something spiritually valuable per se in relinquishing the hope of larger meaning and surrendering to the flow of nowness. But if you are familiar with other diary/collage movies by Rudy Burckhardt, you can't help noticing that certain footage resembles bits from earlier works. And you find yourself discriminating. I was usually enthralled by the melancholy city scenes of buildings and passersby, and bored by the bucolic country ones. The dance company sequences were, to my mind, among the least satisfactory: by submitting to another's (the choreographer's) rhythm, Rudy's filmmaking energy often seemed tentative, and the viewer would get neither the dance piece as a whole nor the heterogeneous, poetic density of his street montages.

Rudy trusted his hand, his eye, and his camera, which kept seizing on the same sort of grace note or "indecisive moment." In each film Burckhardt made, including the very last, completed only weeks before his death, there are shots of exquisite beauty and heartbreaking truth. What more can we ask of a photographer or filmmaker than to keep providing visual beauty?

On the positive side, the New York art scene offered Rudy friendship, society, warm approval of his own work, collaborators, excitement, stimulation, and the chance to bask near the limelight of some of the most famous artists of his day. On the negative side, its mutual admiration aspects shielded him from the larger world's reactions, including challenging criticism. The avant-garde scene to which he belonged permitted a higher toleration for repetition and audience turn-off. Knowing in advance that the public may very likely reject their offerings and, moreover, locked in an adversarial relationship with popular taste, avant-garde artists can take heart from other members of the clan, and engage in boosterish statements about each other in coterie publications. Self-criticism, or even mildly ambivalent peer analysis, is scarce in such circles. "As an artist I am like Gertrude Stein: All I want is praise praise praise," Rudy remarked in *Mobile Homes*. And he meant it.

The randomness of these collage films was partly a true reflection of Rudy's consciousness, which seemed to me more fragmented as he grew older. In a probing passage from *Mobile Homes*, he wrote, "My philosophy: Distinctly pessimistic, existential, negative thinking. To unify life's innumerable details into a concept, like a room, a city, a country, etc.—or human relations, development, history (with myself at the center) takes an effort of mind (mostly unconscious) that only operates part of the time. It doesn't take much to make it all fall apart into fragments, tiny specks and instants—watching the digital clock at 34th Street and 7th Avenue that shows each tenth of a second racing by (an invention of the devil) might do it. I believe each one of these states of mind is as real as the other. When the latter takes over, all you can do is wait for the former to return."

On the other hand, one could argue that by demonstrating the lack of a unified self he showed a higher consciousness, in terms of Tibetan Buddhist thinking. Certainly, Rudy's willingness to edit disparate subject matter, accumulated casually and diaristically, into a nonnarrative stream, and the poetic resonance of his images, had a strong influence on a younger generation of brilliant

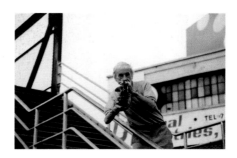

LEFT TO RIGHT: Rudy Burckhardt, 1991 | 34th Street, New York, 1978 | Daytime TV, New York, 1988 | Shadows, New York, 1985 | **OPPOSITE:** DETAIL Self-Portrait, Searsmont, Maine, 1984

experimental filmmakers (Warren Sonbert, Peter Hutton, and Nathaniel Dorsky), who revered him as a precursor and elder statesman. They saw the late Burckhardt collage films as ever-renewing inspirations, rather than as repetitive.

He also continued to make the occasional shorter, thematically focused movie, which tended to be more successful, in my view. For instance, the 1975 *Default Averted* (the title comes from a tabloid headline of the day) responded directly and lyrically to New York City's brush with bankruptcy. In it, we see buildings being demolished, the city under siege from snow and creditors, and an obstinate urban environment persisting, to the music of Thelonious Monk and Edgar Varèse. *Doldrums* (1972) was another shorter, beautifully self-contained mood piece.

Sometimes, a particular musical piece, collaborator, text, or self-imposed structural limit would also lift one of these shorter films to a higher level. This was the case with the 1985 *Central Park in the Dark*, an 8-minute collaboration with Christopher Sweet, set to the music of Charles Ives, or the stunning *Night Fantasies*, a nocturnal reverie that floated between New York, Hong Kong, and Maine and that Rudy and Yvonne took turns shooting ("You have to hold the camera, too," he insisted), and which was stimulated by the Elliott Carter score of that name. The silent, bewitching, 8-minute-long *Indelible, Inedible* uses lines from a John Ashbery poem superimposed as titles over some ineffable Burckhardt images. Rudy also employed Ashbery poems in *Untilted*, *The Nude Pond*, *Mystic Grange*, and *Ostensibly*.

I once asked Rudy why he never used the poems of James Schuyler, a New York School poet and a particular enthusiasm of mine. He said he didn't like Schuyler as much; he had tried to put some on a sound track once but "they were too—

tragic or something. Whereas Ashbery's poems always work: because his lines are like dreams, and when you put them over a film image it helps the viewer to see the image in a dreamlike way." I suggested it might be interesting to take a very dramatic, personal poem of Schuyler's, such as the one where his lover chases him around the table with a knife, and see what the effect would be on top of Rudy's diary images. Rudy shook his head no, and replied in a thick mock-German accent with his favorite Goethe line: "Man often inclines to beauty near the end of his days." In other words, enough with the tragic.

He was very fond of quoting these Ashbery lines:

> It's rapture that counts, and what little
> There is of it is seldom aboveboard,
> That's its nature,
> What we take our cue from.

This conviction that rapture must inevitably be fugitive and transgressive, or at the very least not "aboveboard," put him in conflict at times with the orders of domesticity, daily life, and old age.

The Nudes

"Man often inclines to beauty near the end of his days." Quoting the same Goethe line to Simon Pettet in *Talking Pictures*, he added: "And I feel that way, actually, now that I'm older. Might as well look for beauty, you know, as the other thing is there obviously."

What can be said of Rudy's preoccupation with the female nude? It seemed to have a tonic effect on him to photograph young women with their clothes off. Some of Rudy's nudes seem a standoff between prurience and awkwardness—in any case, more fun for the photographer to have taken

than for his viewers to take in. The nudes in Rudy's photographs are, for the most part, young, pretty, and full-breasted. We see a naked woman standing on the Burckhardts' windowsill, sharing it with the televised image of a clothed man; still another, seen only from the back, gazes out at the Chelsea street-scene from their fire escape. What is curious about these shots is how little observation is brought to bear on the mysteries of the flesh. If anything, they seem deeroticized, though perhaps that was intentional on the photographer's part— a way of making nudity more matter-of-fact?

By contrast, there is an everyday mystery and sensuality in Rudy's street photography of women. "In a split second a girl is forever pretty" (a Denby line of poetry), a 1940 photograph of a woman in a white hat and suit strolling past Saks and Company, defines that sensibility. The 1978 photograph of an angelic-faced brunette in a v-necked dress crossing the street as her hair swirls to the side might be called "The Madonna of 34th Street." Another photograph, *V Neck*, 1985, shows a black woman with dazzlingly rounded dorsal bones, exposed to our view by her V-neck ribbed sweater, glancing backward. This visionary quality of tender observation, which is manifested in countless graceful shots of female passersby, their images captured sympathetically without their knowledge or consent, against the busy street, disappears or becomes cruder when he photographically confronts women (and they him) unclothed.

Overall, his itch to portray female nudity, often at the risk of clumsiness, seems another way of playing the amateur. *Shadows, New York*, for instance, taken in 1975, is a fetching but academic/hobbyist study of the effect of shadows on a buxom nude, such as a doting, camera-buff boyfriend might send into a photography magazine. Rudy's nudes, on the whole, are for me

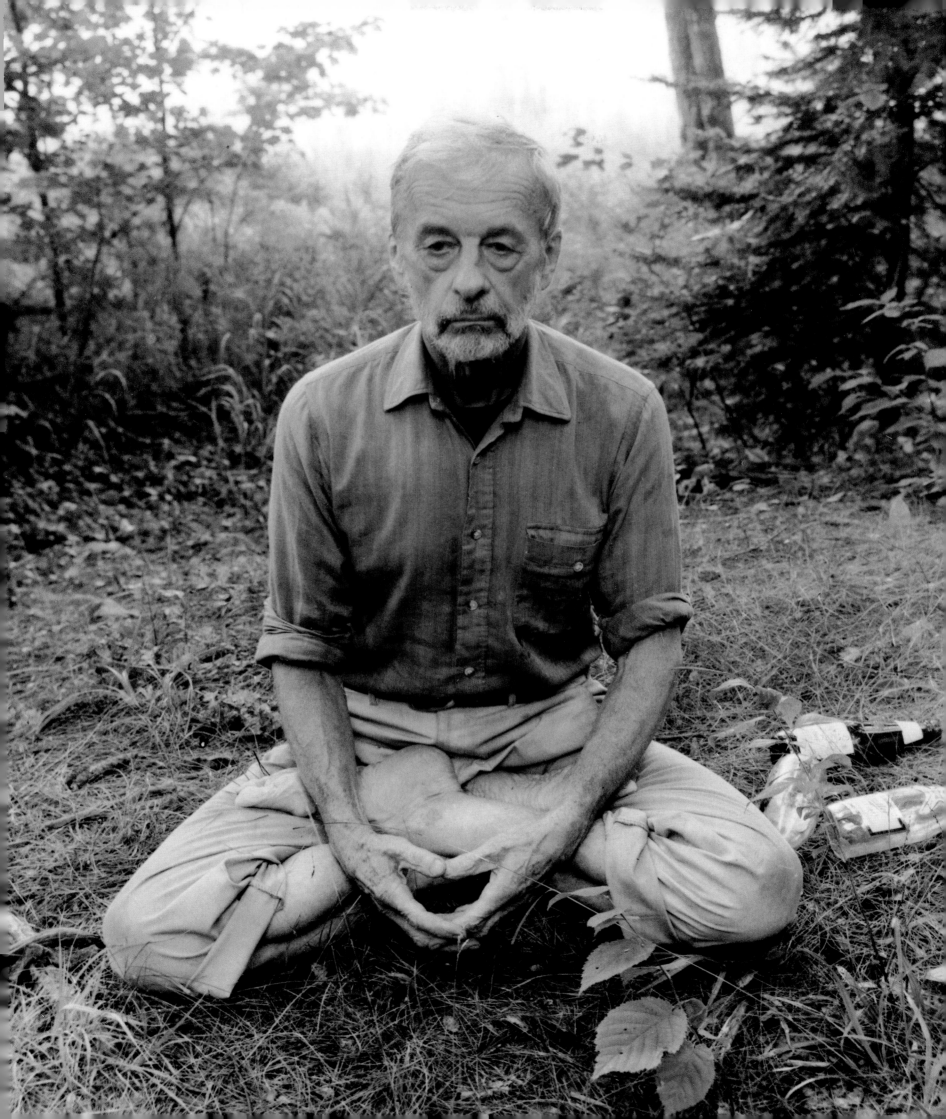

among his least interesting work, artistically speaking.

I should add that this judgment is not shared by all. For instance, the art critic Robert Storr has intelligently come to their defense:

> A considerable number of Burckhardt's paintings are nudes, as are a good many of his photographs. In America these days, with sexual politics being what they are, any man who indulges his interest in the female form by making images of it has some explaining to do. Burckhardt, however, gives no explanation (and no excuses) for his modest valentines to young women. His models run from ordinarily pretty to frankly voluptuous, but all have the same attitude in his presence—and therefore in ours—namely complete comfort with their own bodies and no discernible reluctance about showing them off. The erotic charge of Burckhardt nudes is the opposite of the alternately coy or lurid aestheticism often associated with the genre. Instead, we are offered the sensual enjoyment that youth can give to old age, and that a woman may choose to give to a man, provided that the man in question actually likes women, and the women in question feel that they can afford to be generous in this ancient but much abused way.

This is good, but it still begs the question of whether Burckhardt's nudes are of sufficient artistic merit to stand on their own, without special pleading. That they served other functions for him, of a consolatory or scopophilic nature, there can be little doubt. In Kawabata's great novella, *The House of Sleeping Beauties*, elderly men frequent a sort of brothel where they spend the night looking at, without touching, the sleeping forms of the drugged young women beside them, while reliving through recollection their sensual history. Burckhardt's nudes, at their best, have some of this elegiac, Cavafyesque summons, as well, to the body to remember its past raptures.

Death

In his last years Rudy's hearing had been going, and for a long while he resisted getting a hearing aid—partly out of vanity, perhaps, but also out of a preference for withdrawal. You began to notice that his responses to statements were vague and not always on the mark. Evenings, when he and Yvonne had friends over for dinner, he would drift into a benign silence and smiling approbation, clearly not catching some of the talk around him. Eventually he gave in, and had a hearing aid installed, which enabled him to rejoin the conversation. In the last year, he required two hearing aids: but the telephone became a torture for him, he misheard and took down wrong messages, while in restaurants the background noise sometimes turned into feedback, or his hearing aid started unaccountably to whistle.

There remained an air of melancholy around him, the sad eyes with deep blue pouches under them lighting up less and less. In the past he might have mocked someone, such as Paul Strand, by calling him "a gloomy guy." Now, he took fewer pains to disguise his own dejection. Not that most people enamored of Rudy's pluck registered it; but he kept photographing and painting broken trees; the signs were there, in retrospect. His ability to get around had slowed, at the end. He still did yoga every day, but in the street he would complain to his wife that she was walking too fast. He also had frequent insomnia, and would get up and read.

Yvonne did what she could to keep Rudy's spirits up. "Yvonne worked so hard on that marriage," Dana Reitz, a dancer and close friend of the Burckhardts, told me. "She was always trying to engage Rudy, bring him closer. But he would go away in his head." Yvonne believed in change, spiritual growth, and the value of working on relationships. There was something very American about her quiet optimism. By contrast, Rudy was more of a fatalist. He relished quoting Edwin's smiling response to this or that misfortune: "Can't be helped."

In the summer of 1999, Rudy and Yvonne went up as usual to their home in Maine. "I am going to join Edwin at the bottom of the pond." So began the suicide note the 85-year-old photographer and filmmaker left on the kitchen table in the early morning hours of August 1, 1999. The note continued: "Sorry for the trouble. I don't want to be a burden. I love you all."

Suicide provokes us, will not go down smoothly. Some who are left behind may feel guilty and angry at the suicide, for having kept us in the dark and then thumbed his nose at us. On the other hand, some will salute the Roman courage of one who took his life before enfeeblement set in, as the ultimate assertion of free will. There had been emphysema and the usual lessening of physical strength and memory that comes with aging, and the fear attached to these diminishments. But even they did not slow him down from completing two last films (*Scattered Showers*, with music by Tom Burckhardt, and *On Aesthetics*, based on a Kenneth Koch poem), and several paintings in the last months of his life. A number of exhibitions and publications about his work were in the offing, and he had recently been honored by a major retrospective of his work in Valencia, Spain. He took himself out in the midst of productivity and ever-widening recognition.

Jacob, his oldest son, thought that "there was a certain amount of shutting down that summer" on the part of his father. "He didn't bring his movie camera to Maine. That surprised me. And he painted all these fallen tree trunks, which are—somber in retrospect." On the other hand, Jacob received a letter from Rudy, which was written the day before he drowned himself, and arrived after his death. It was "totally routine," asking his son to send certain prints to some client, and had a warm, chipper tone. Partly because of this letter, Jacob thinks that Rudy's suicide might have been more of a spur-of-the-moment decision than a precisely plotted one. There will always be unresolved questions about Rudy's death, just as there are about his life and artistic career.

If there were times when, in view of his immense visual gifts, one might have wanted Rudy to take himself more seriously or apply himself more rigorously as an artist, the opposite is also true. He had earned the right to play; why shouldn't he make whatever suited him at the moment? What counts is that he created so many beautiful, haunting images to begin with, and kept at it to the very end. When we consider the whole body of Rudy Burckhardt's work, its variety and sweep, and the many essential pictures he left behind that continue to provide exquisite pleasure, it seems something like coming upon a secret treasure vault, hidden in plain sight. From today's vantage point, which subsumes all his photographs and movies in the same fond, historical backward glance, we are left with the steady, invigorating charm of a lost world captured by his lens.

A NOTE ON SOURCES: The main sources consulted for this essay were *Talking Pictures: The Photography of Rudy Burckhardt*, by Rudy Burckhardt and Simon Pettet, Zoland Books, Cambridge, Masachusetts, 1994 (a shorter version of this book-length interview, entitled *Conversations with Rudy Burckhardt about Everything*, by Simon Pettet, was initially published in 1987 by Vehicle Editions); *Mobile Homes* by Rudy Burckhardt, Z Press, 1979; and *Rudy Burckhardt* (with essays by Vincent Katz and Robert Storr), IVAM Centre Julio González, Valencia, 1998. Most of the quotes not attributed in the text to published materials derived from interviews and conversations with the author. I am especially grateful to Yvonne Jacquette, Jacob Burckhardt, Edith Schloss, Yoshiko Chuma, and Dana Reitz for their openness during interviews. Other sources consulted include: *Aerial Muse: The Art of Yvonne Jacquette* by Hilarie Faberman (with essays by Bill Berkson and Vincent Katz), Hudson Hills Press, 2002; *An Afternoon in Astoria, by Rudolph Burckhardt*, catalogue essay by Sarah Hermanson Meister, Museum of Modern Art, 2002; *Edwin Denby: The Complete Poems*, Random House, 1986; *Dancers, Buildings and People in the Street*, by Edwin Denby, Curtis Books, 1965; *Fairfield Porter: A Life in Art*, by Justin Spring, Yale University Press, 2000; *United Artists* 17, March 1983, edited by Bernadette Mayer and Lewis Warsh; *In Relation to the Whole*, by Rackstraw Downs, Edgewise, 2000; *Basel in the Age of Burckhardt*, by Lionel Gossman, The University of Chicago Press, 2000; and *The Last Avant-Garde*, by David Lehman, Anchor Books, 1999.

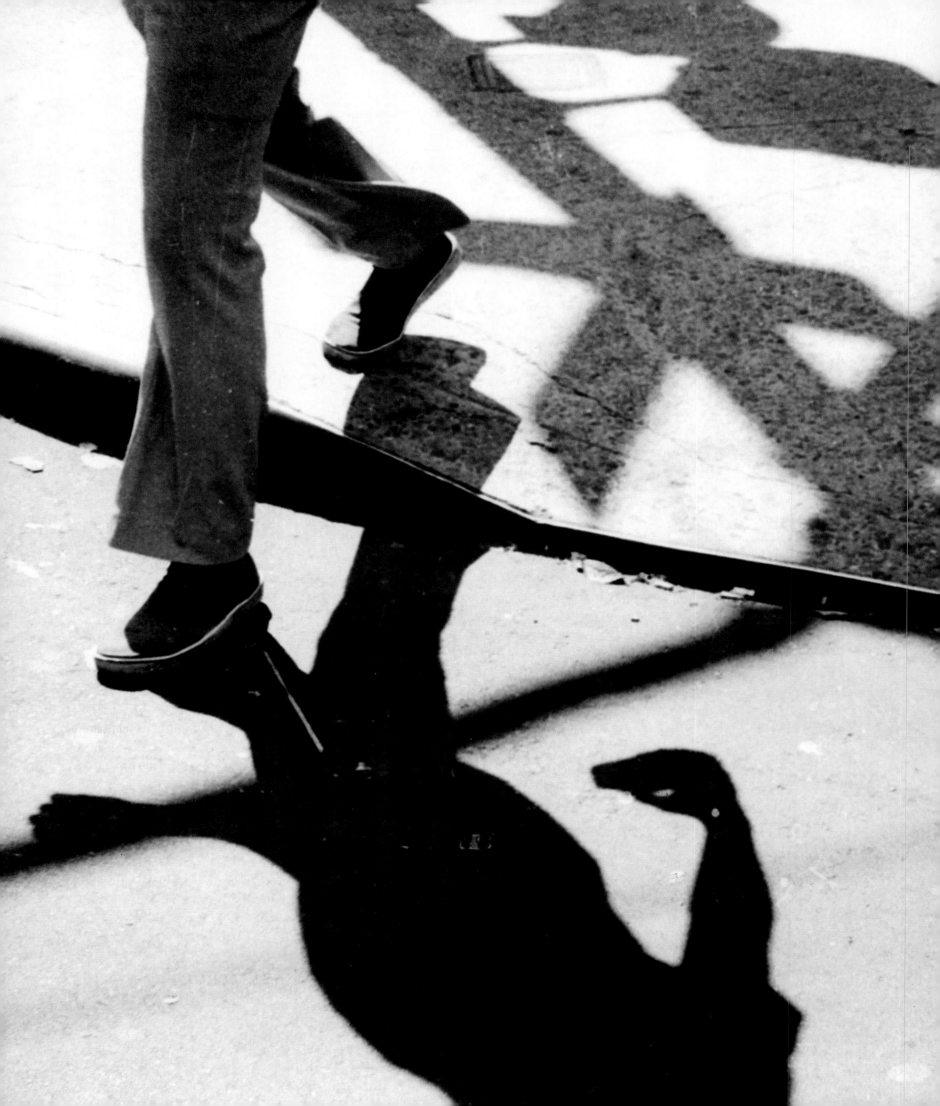

rudy burckhardt: art's friendship

By Vincent Katz

RUDY BURCKHARDT BECAME a quietly integral figure of the New York art scene as it was transitioning from interesting outpost to outspoken center. In the 1930s, sharing a Chelsea loft with critic and poet Edwin Denby, Burckhardt's experience of the art world was largely the experience of seeing friends. There were few galleries showing contemporary art and less money to pay for it, but living was cheap. Burckhardt remembered hearing Stravinsky coming from de Kooning's next-door record player (at a time when record players were scarce). The painter offered to give Burckhardt a lesson, telling him to paint a crumpled piece of paper in sunlight. Burckhardt demurred, saying he had no interest in crumpled paper. An odd willfulness: he was inexorably attracted to the human—or to its nonhuman counterpart, nature.

In New York, Burckhardt found his ideal setting—a city where people looked good, dressed sharp, and moved fast midtown, or dragged their feet, more down at the heels, in places like Astoria, Queens. He liked to find the unusual perspective—whether of Times Square or an anonymous borough overpass—and he worked for those views. A newcomer in Manhattan, he was thrilled by the hurtling buildings' angles and by the characteristic shadows that engulfed pedestrians in their concomitant canyons, especially on warm spring days when one could linger there in shirtsleeves. His eye could not take it all in. It took years before he could combine people and tall buildings in the same image. He began instead by focusing on details of bodies and clothing, and specifically not complete details but fragmentary ones, evoking the experience of incessant movement that New York implies. Whether one is walking or at rest, one's visual experience there tends to be fractured. Depending on one's mood, this fracturing can be stimulating or it can drive one to the madhouse. Burckhardt's moods ranged from reflective to buoyant. His photographs are filled with the optimism that light and fresh vision entails. This is so as much at the end of his career as at the beginning, and it applies equally to his city and his nature photography. The social meanings and psychological implications of clothing or expression were not his concern. Burckhardt's best images retain their ability to surprise us; their seemingly casual genesis is belied by complex composition that strikes us as true to life's visceral touches.

In the 1940s, he discovered a method for photographing the city that suited his temperament. He would enter a high office building, call the elevator, and ask the elevator operator for the top floor, acting as though he had some business there. Once arrived, he would find the stairway and, usually, be able to ascend to the roof. From such unusual vantages, he took some of his most memorable images—New York's historic buildings and skyline seen from on high, and such details as a fractured caryatid surveying the city. He took few shots; there was time spent in waiting for the right situation, then two or three shots, and the moment would pass. In New York, in particular, he took fewer exposures than on some of his European promenades.

Part of Burckhardt's outlook, which colors his photographic imagery, stems from his belief in the essential good nature of humanity. Not that he was naive, or immune to suffering. He lived through two world wars and was well aware of man's ability to do harm. Rather, he seemed to think, while a few people with a lot of power are capable of radical wrongdoing, the majority of the population does possess an essential component of goodness that allows it to understand and be

 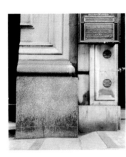

PAGE 46: DETAIL Curb, New York, 1973 | **LEFT TO RIGHT:** Side Street, Basel, 1932 | Larry Rivers and Kenneth Koch with Collaborative Painting II, ca. 1962 | Tony Smith, New Jersey, 1960/66 | Sterling Mount Co., New York, 1938

understood. At least, that is what he unerringly expresses in his photographs. People always look their best, and if you compare Burckhardt's people to those of other artists throughout time, you begin to realize how hard that is to achieve. Partly, it is because he usually chose to photograph outdoors on those days of prime good-feeling—times when the temperature and atmosphere are at their apex. Partly, it comes from an open way of looking at people, with appreciation, without flattery. How he translated that looking into photography remains somewhat mysterious. Unlike Gary Winogrand, Burckhardt does not usually photograph the incongruous. Even when Burckhardt photographs beautiful women, one senses they are beautiful partly because of their harmoniousness with their urban surroundings. Burckhardt would be more accurately called not a street photographer but a city photographer, as his view is more encompassing.

Burckhardt took great photographs of people, simultaneously allowing them their natural habits, and exalting that daily experience in a manner not unlike that of poets he admired, such as Frank O'Hara and Ted Berrigan. Burckhardt enjoyed rapport with artists from the beginning of his life in New York. As a staff photographer for the seminal journal *ARTnews*, Burckhardt photographed artists in their studios. His images of Jane Freilicher, Alex Katz, Willem de Kooning, Hans Hoffman, Marisol, Joan Mitchell, Jackson Pollock, Larry Rivers, Mark Rothko, and many others reflect an intimacy that few photographs of artists share. Burckhardt was a colleague, an artist, and as such, when visiting an artist's studio, whether he was talking or taking photographs made little difference to his contemporaries. The fact that he usually took few photos per visit helped. On the street and in the studio, he knew how to blend and how to fit the scene.

Burckhardt's casual air, his chosen informality, should not be confused with lack of formal acuity. His photographic accuracy, care of composition, and precision with light and atmosphere can be seen in his first photographs, taken in Basel in 1933. It was after he moved to New York, however, with its right angles and solid planes, that a modernist formalism first made itself felt in his work. Burckhardt was an admirer of Mondrian in the 1930s and spoke of emulating the Dutch-born artist's geometric harmonies, which also took the city as their frame of reference. In a series of studies in Astoria, Queens, Burckhardt found aspects of his new city that were not well known to foreigners or to artists, who tended to paint and photograph such eminences as the Brooklyn Bridge or the Woolworth building, or, as in Georgia O'Keeffe's case, the propulsive energy of Manhattan's highrises, or genre scenes of neighborhoods. In his Astoria pictures, Burckhardt, with few distractions from pedestrians or traffic, was able to find a formal beauty in nondescript circumstances.

This careful formalism, combined with empathy for the normal, would hold him in good stead when he returned to Europe. His photographs of Tuscan fields, or of the great Greek temple at Segesta seen from afar, emanate a quality of being there. As with all Burckhardt's best work, he evades the frequently encountered lack of connection, in which a cliché of what a thing should look like unfortunately precedes the actual picture, confining it to a weak afterimage. In 1956, Burckhardt and Denby published *Mediterranean Cities*, their meditation on being in those places—some ancient, some modern, many a combination of both—that entranced them with human warmth. Denby's sonnets and Burckhardt's photographs were not composed together; sometimes

they do not take precisely the same places as subjects; yet they share a sense of being in the right place at the right time.

> Winter's green bare mountains; over towns, bays
> And Sicilian sea, I sit in the ghost stones
> Of a theatre; a man's voice and a boy's
> Sing in turn among the sheepbells' xylophone;
> From a distant slope sounded before a reed pipe
> Sweet; a goatherd, yellow eyes and auburn down
> Smelling of milk, offers from a goatskin scrip
> Greek coppers, speaks smiling of a lamb new born;
> Doric tongue, sweet for me as to Theocritus
> The boy's mistrust and trust, the same sky-still air
> As then; so slowly desire turns her grace
> Across the years, and eases the grief we bear
> And its madness to merely a powerful song;
> As the munching boy's trust beside me is strong
> ("SEGESTA")

Burckhardt's art should be seen in its totality to appreciate his full achievement. He was not a photographer who did other things on the side. His 100-plus films represent a masterful and unique opus in the history of twentieth-century underground filmmaking that is only slightly known. Despite a 1987 film retrospective at the Museum of Modern Art, New York, and frequent screenings for small, loyal audiences, even his most ardent admirers are hard pressed to differentiate his later films. This is partly due to the fact that he gradually left behind the narrative, collective-effort comedies of his early and middle years for a more contemplative and complex type of filmmaking—film-collage one might call it—in which diverse visual elements were edited together and combined with an equally diverse aural array to form something that uncannily gives the feeling of a stream-of-consciousness

 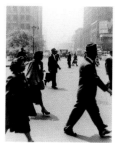 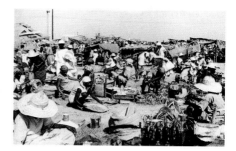

LEFT TO RIGHT: Arezzo, 1951 | Herald Square, New York, 1947 | Untitled, Haiti, 1938

experience. Much of the visual effect was achieved, as Burckhardt put it, "in the camera." He had become so sensitive to how his filming would translate to the screen that he was able to shoot—by feel, without a stopwatch—scenes of such duration that they would later fit together with little or no editing. These are tour-de-force pieces that do share a common nature, yet have distinctly individual flavors that deserve to be better savored and discussed.

Burckhardt long maintained a surprising ability to appreciate the new. Like Denby, he refused to be tied to any particular era, once it had entered history. Burckhardt was intensely sensitive to the vibration of a day or an epoch, and he remained open to the discoveries of those younger than himself, which kept him fresh as an artist. Times Square was a key locus for Burckhardt, as was the spot at 23rd Street where Fifth Avenue and Broadway intersect, creating a wide-open space, extended in effect by trim Madison Square Park and presided over by the narrow, angled Flatiron Building. Times Square was the site of one of the first photographs in which Burckhardt was able to show the interaction in scale between pedestrians and skyscrapers. It was also a place to which he returned in succeeding years, in films as well as photographs; he also made paintings of the locale. One of his best films, often quoted by other filmmakers to give a taste of the times, was his 1967 color short *Square Times*, in which brightly colored clothing, movie marquees, and neon lights dance beneath a dusk sky. Burckhardt was able to renew his faith in Times Square, no matter how many facelifts it underwent. One wonders how he would view it now that, like most of America's inhabited landscape, it has been dominated by corporate uniformity. He might have been able to find some

unexpected perspective, allowing us to see even that commercial eyesore with fresh eyes.

In Charles Baudelaire's description, the *flâneur* is someone always ready for a new experience, who can keep going when others have long ago retreated to the safety of their homes. It has more to do with an attitude than with the physical action of walking through the city; not everyone who goes for a stroll is a *flâneur*. While primarily an urban activity, we can imagine an extended definition of *flânerie* that would include interested wandering in a variety of locales. Burckhardt extended his wanderings beyond the urban environment. His photographs of the American South, taken in the 1940s, are almost diametrically opposed to Robert Frank's project "The Americans," embarked upon some ten years later, with the help of a Guggenheim grant. Frank, another ex-Swiss transplant, had ideas about America—that it was unfair, that it was vulgar, that it was absurd—which he set out to illustrate. Burckhardt, by contrast, set out enthusiastically to find what he would see. His photographs of rural settings are open; they show empty spaces, industrial architecture, and people going about the public parts of their lives.

Photographing on the street takes a lot of nerve, especially if the photographer intends to shoot point-blank at his subjects from close range, as Burckhardt did, without breaking the atmosphere by asking permission or waiting for someone to pose, and without the benefit of a hidden camera. Walker Evans's photos in the subway preceded Burckhardt's, but Evans's use of a hidden camera led to more muted results, aside from the fact that Evans, like Frank, was often out to illustrate a social theme. In addition to nerve, to take good photographs in a crowd requires a dancer's sense of timing. The dancelike

quality of Burckhardt's photographs is no accident when one considers that Denby, one of the greatest critics of his time, was primarily a critic of dance, and the two attended and discussed countless performances. The choreographer Merce Cunningham, some time after Burckhardt's photographs of people passing each other on the street, had a similar impulse, claiming he wanted to choreograph in the manner of people's chance urban movements. These movements were based on the premise of getting somewhere fast; the interaction between people can be accurately described, as Burckhardt has described it, as simply avoiding collision. In fact, the goal of much of Burckhardt's art, as of Cunningham's, was to wrest the art free from narrative. Where Burckhardt differed from Cunningham and his colleague, the seminal mid-century aesthetician John Cage, was that Burckhardt was passionately involved in people, and their emotions, as much as they chose to show.

In New York, people tend not to show much emotion, and Burckhardt respected that. After mastering city photography in New York, Burckhardt was able to take his expertise to other cities, and for each place he visited, his intentionally passive approach allowed him to bring out the character that existed there. At the same time as he was beginning to photograph New Yorkers, in the late 1930s, Burckhardt left on a trip to Haiti with Denby. When Denby returned to New York, Burckhardt stayed on, nine months in total, eventually living with a beautiful Haitian woman, Germaine, whom he photographed. He also made his first travel film there. His photographs of the outdoor market at Port-au-Prince were taken with an insider's point of view. As he would be with New York's artists, so too with the locally known and unheralded multitude in this Caribbean city, Burckhardt blended in. Passing through more or less unnoticed—because

of his body language, his way of talking to people—he was able to photograph the milieu from inside. Burckhardt's Haiti photographs are remarkable for their formal, abstract qualities—the balance of lights and darks and shapes he achieves in a split second—and for the social information they reveal. On his travels, as well as in New York, Burckhardt was an avid admirer of fashion and style, and his photographs are endlessly rich with telling detail.

Burckhardt photographed extensively on his travels—in Trinidad, Mexico, Greece, Spain, and Morocco. In Mexico, he did a series that evidences his interest in people, how they live, while simultaneously taking a self-referential step back. He took these photographs either through open ground-floor windows, or sometimes by entering through an open door. They are photographs of photographs; family portraits arrayed on walls, that convey the delicacy and care of a family gathering, or images of religious figures. A theme that runs through Burckhardt's photographs is the street life of children. Often smiling, engaged in the wild dance of public childhood, these children too had a momentary bond with Burckhardt. Maybe they smiled because they found him odd; they certainly found him unthreatening, and probably he knew what to say to make them feel comfortable with him, enabling the photographic opportunity.

Besides New York, the other city that most attracted Burckhardt as a photographer was Naples, where he took a splendid series in the early 1950s. Edwin Denby wrote that each city has its own luxury, and Naples chose for itself the most delicious—that of children. Burckhardt said that Naples was the one place where people actually asked to have their picture taken. Unlike cultures that believed a photograph stole part of the soul, Neapolitans believed the photographer was giving them a gift.

They would ask Burckhardt to wait while they went to gather children, babies, parents. The resulting photographs, far from being posed, are electric with the energy of the city. They have a dreamlike quality possessed by Burckhardt's best photographs, whether in the subway, on the street, or in a broad field. The experience was essential to Burckhardt; he both waited for it and created it.

With the decades, New York changed and Burckhardt's photographs, embracing that change, intuitively and subtly changed as well. There is something besides the subject that is different, though it is hard to pin down. There is a greater freedom with focus; the feeling of the instant prevails, and since that instant passes quickly or rattles, as the subway, then it should not be encased in utter clarity. There is an amazing sense of closeness to people's faces, even more than in the early photographs, which were often taken of feet and legs. Continuous throughout Burckhardt's work is a sense of poetry in daily life. This can be a dreamlike, almost surreal poetry, or it can be a plainspoken poetry, that reminds one of the poetry of James Schuyler, in which intense observation of whatever situation one finds oneself in, no matter how apparently mundane, yields an unimagined richness thus appreciated. Burckhardt's later New York photographs are full of this quality, as the photograph in which two young people sit on skateboards on the sidewalk talking while three men approach and three others load or unload sheets of material from (or to) a car's rear hatch to (or from) a hand truck. The whole scene is marvelous, almost miraculously framed, and every action in it is completely casual. It is the attention paid to a scene to which most people would have given only a passing glance that creates an atmosphere of great emotional focus. Within that focus, and staged, as it were,

with various distances and depths of field between the actors, and informed by background elements such as taxis, buses, buildings, a metal signpost, subway grating, and sidewalk slab divisions, the main action takes place in the foreground. It is a conversation between the two young people, one a child of perhaps eight or nine, the other a young woman of twelve or thirteen. Their conversation is calm, casual too, but serious—they are not joking but rather the girl is imparting some information to her younger friend, and he is paying attention to what she is saying. The girl is on the verge of womanhood: she is pretty, and soon she will be beautiful. She will no longer sit on skateboards on the sidewalk, but will rise to enter the adult life of the city around her. The transitoriness of this scene is lightly stressed, and there is an allegorical element to the image as well. The boy, of European origin, is listening intently to the young woman, of African origin, and we can see for a second an image of the photographer himself, who left his strict European environment for the fluidity of New York and was always attracted to peoples of the African diaspora (in the South, he consistently chose to photograph "on the wrong side of the tracks" and was accosted by a policeman because of it). There could be a lesson here, not just for the photographer, but for all of us: to listen to the African story, in all its variants, and to listen to beauty.

As the years went on, Burckhardt became less enamored of New York. New York had changed drastically from the 1930s and 1940s, a time when de Kooning could go for two decades without a solo gallery exhibition. It was then a small world of artists, and the artists could infiltrate New York's midtown energy with a feeling of discovery. As the art world swelled in the 1950s, and then exploded with the possibility of real money in the 1960s, Burckhardt was always near the center—

LEFT TO RIGHT: Naples, 1951 | Untitled, New York, 1985

close friend to leading figures, documenter of key faces, and photographer of thousands of art-works for Leo Castelli and other gallerists. He liked seeing his friends succeed and often spoke admiringly of a work of art as being "big-time." One imagined, when he said it, that he meant it stacked up against Veronese, Rubens, Velázquez. Somehow city life itself became tiresome, with its demand for constant strain.

Burckhardt sought nature's calm, and at the end of life, that became a bed for him, an antithe-sis to the city's manufactured rushing—rushing, it must be admitted, that he had cherished for the greater part of his time. In the 1950s and 1960s, Burckhardt went to Maine in the summer—as artists and others have traditionally sought inspi-ration in tranquillity—in order to return to New York with renewed fervor. Later, he claimed to have found painting more satisfying, more con-suming, than photography. A photograph is taken in a second; a painting takes time to develop. In particular, he grew attached to painting in Maine, where he would leave his easel set up in the

woods, covering painting and easel with a sheet of plastic each night, returning the next day to continue work. Having zeroed in on several woodland images that captivated him—close-up views of tree trunks, groups of fern leaves—he painted more in the 1980s and 1990s than he had earlier in his life, and he improved as a painter. It may be that he achieved his painterly vision through photography; many of his images are paralleled in the two mediums. What is certain is that, late in life, continually evolving as an artist, he found the imagery and technique to attain a new level in his painting, and he was gratified by the critical attention those paintings, as well as his photo-graphs, achieved. It is also certain that Burckhardt's work—his photography in particu-lar—has not yet achieved its appropriate position in the canon (he is still rarely included in antholo-gies). Now, with a glut of derivative, pointless images threatening to numb us into insensitivity, Burckhardt's wry poetic wit, with its compass and appreciation of humanity's range, stands out in ever greater contrast.

plates

London, 1933

Tartinette, Paris, 1934

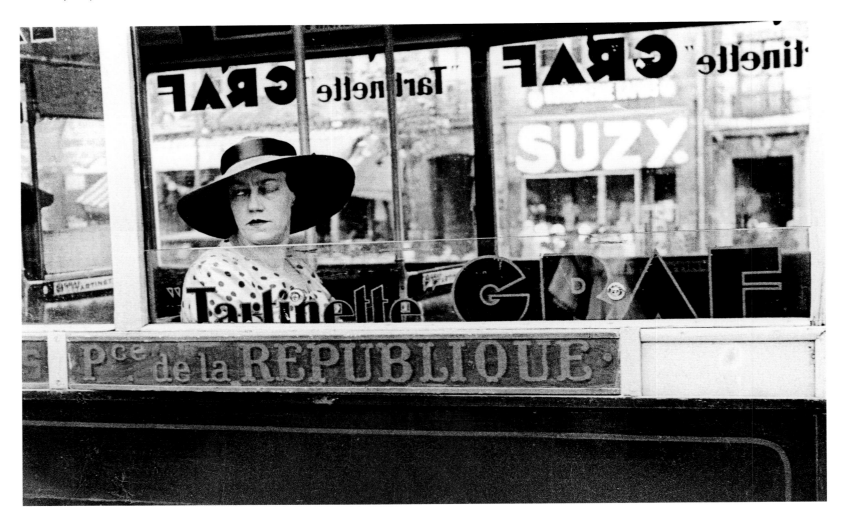

Edwin Denby, 1937

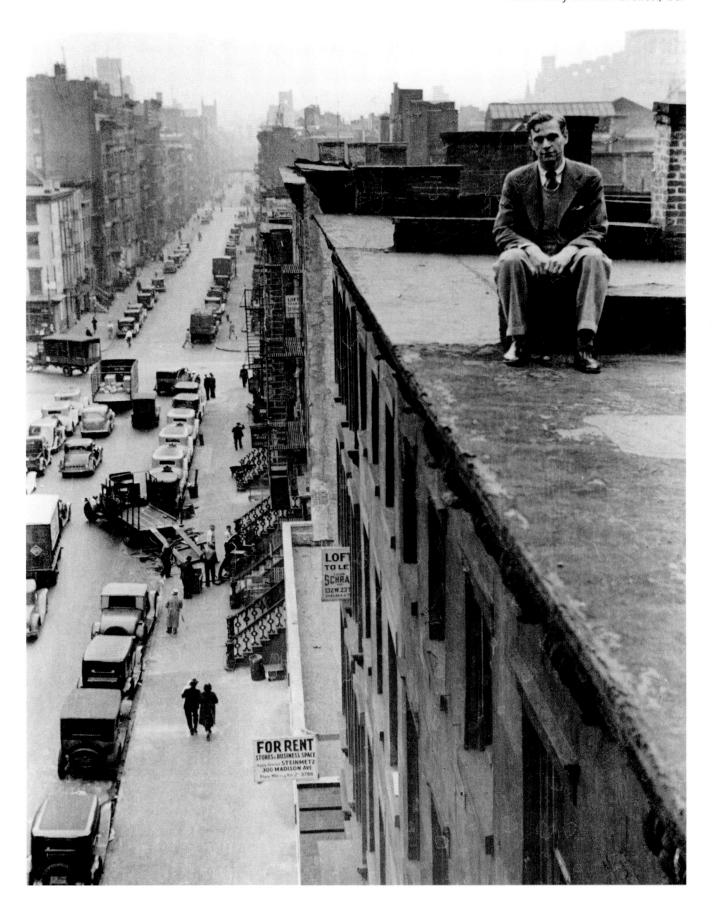

Willem de Kooning, 22nd Street, 1938

Untitled, New York, 1938/39

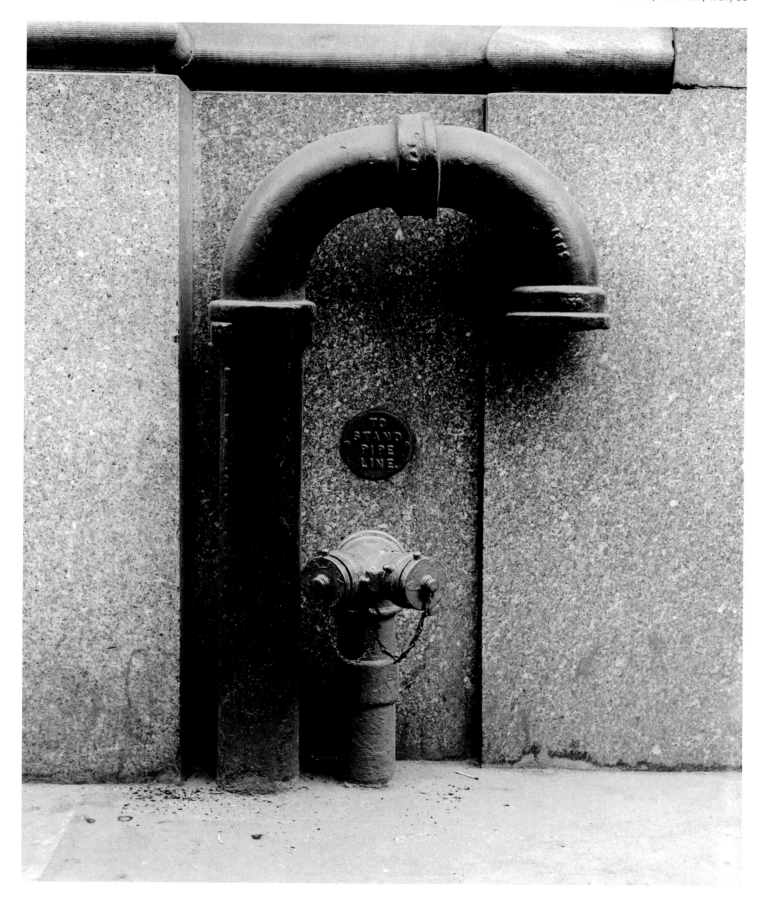

No Encroachment, New York, 1938/39

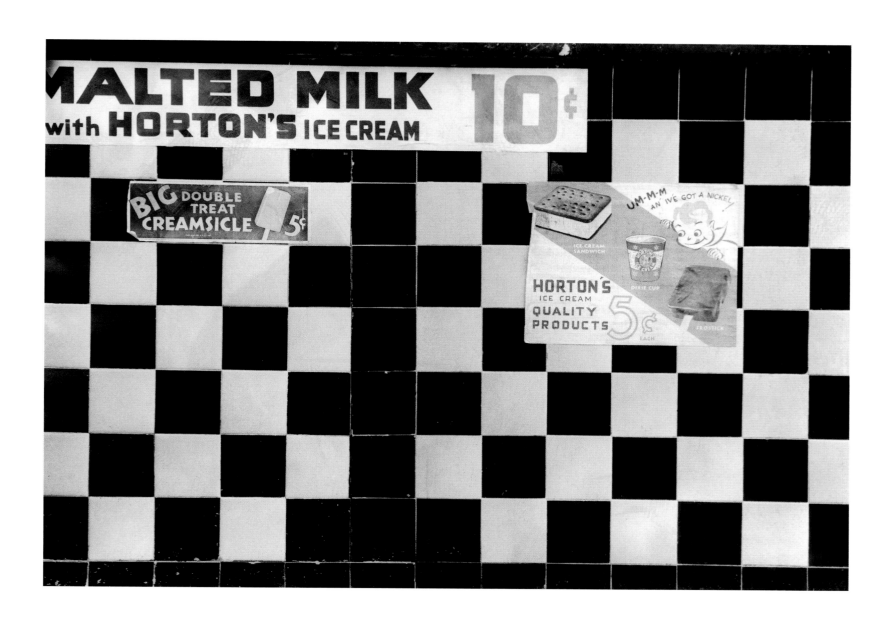

Haircut 20¢, New York, 1939

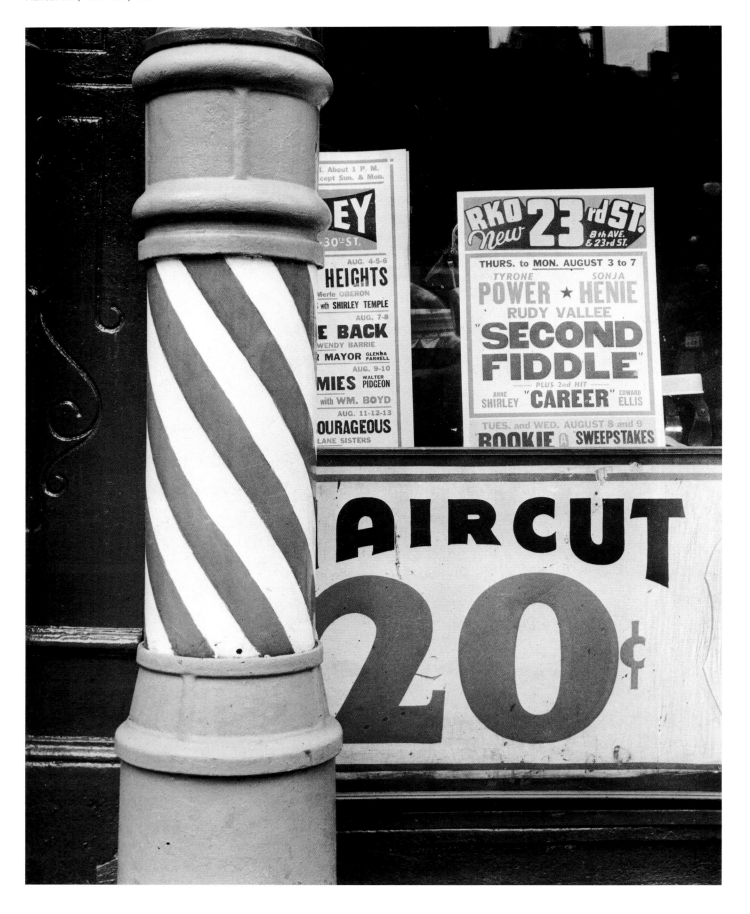

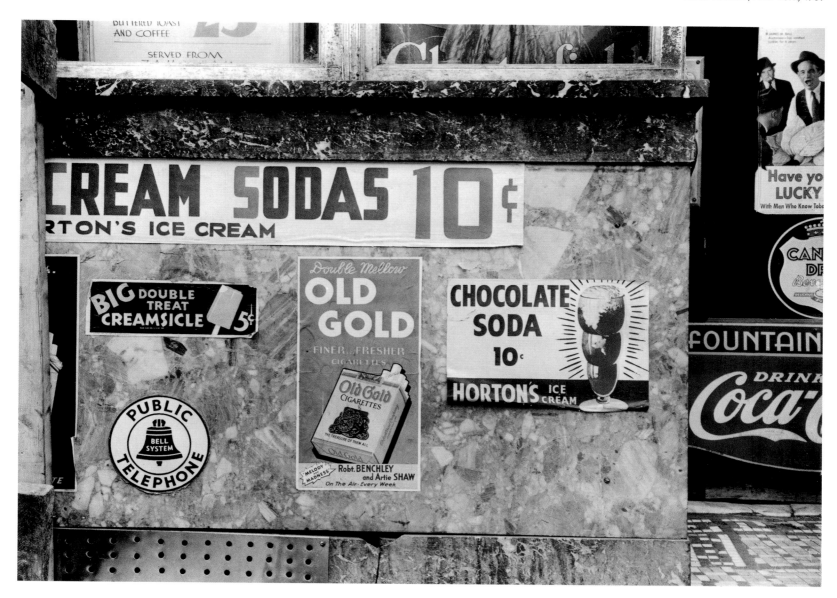

Mussolini, New York, ca. 1940

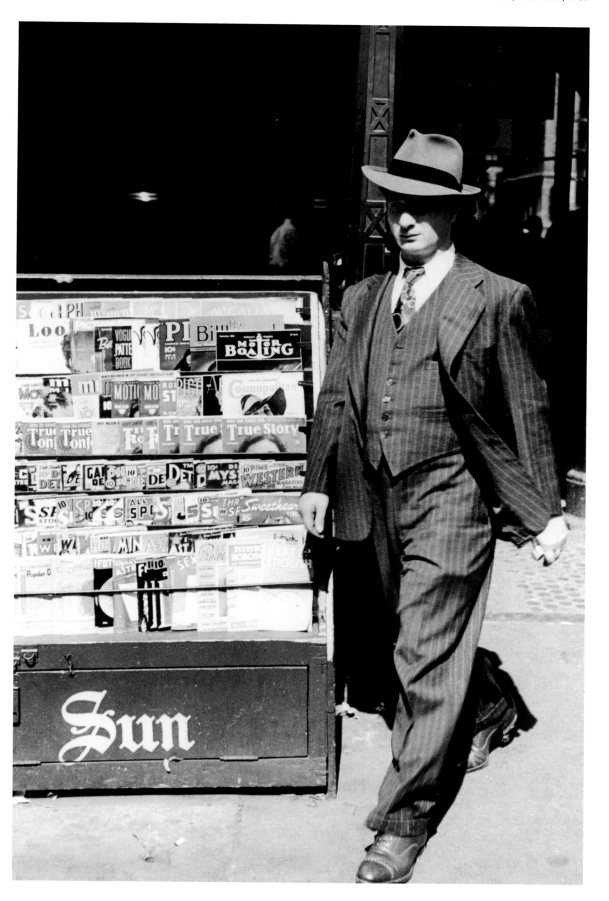

Lifebuoy, New York, 1939

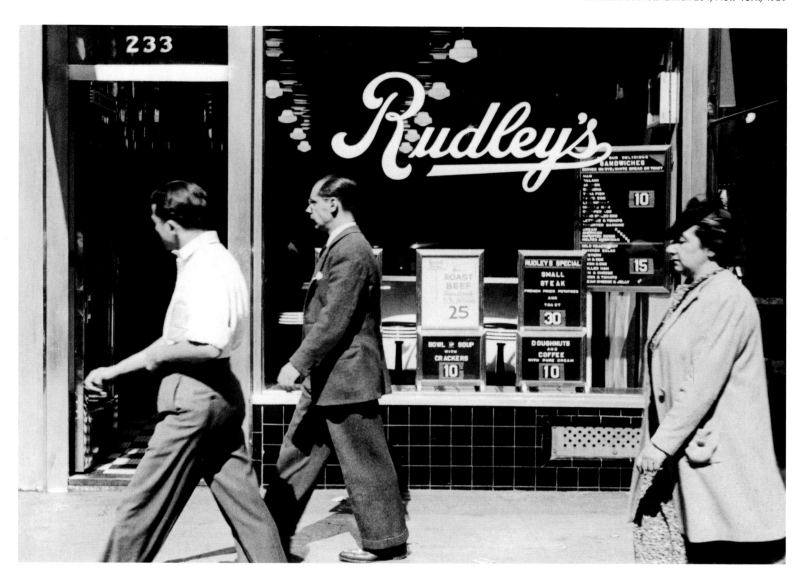

New York Moment I, 1940

Circles, New York, 1934

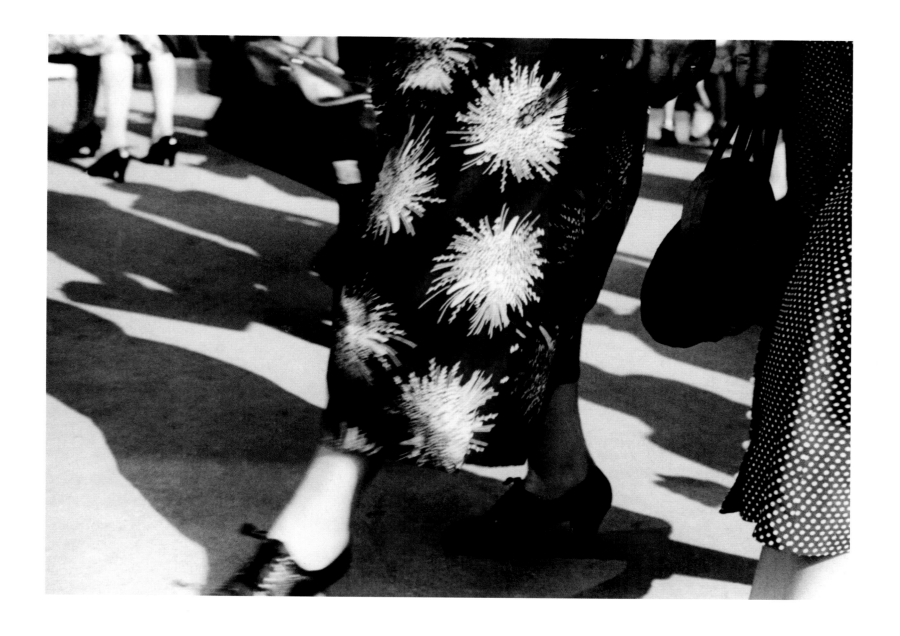

Queens, 1940

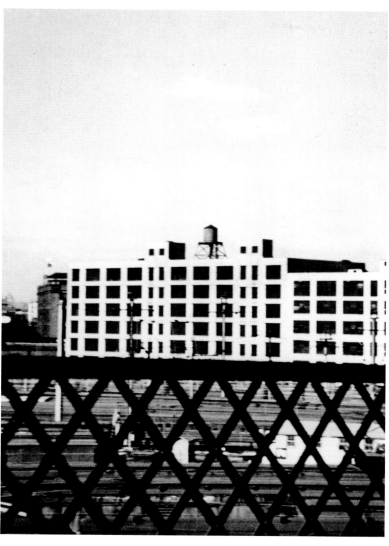

Astoria, Queens, 1940

Jumbo Malted, New York, ca. 1940

Queens, 1940

A View from Astoria, Queens, 1940

Wood Fence, Astoria, Queens, 1940

Broadway and Union Square, 1940

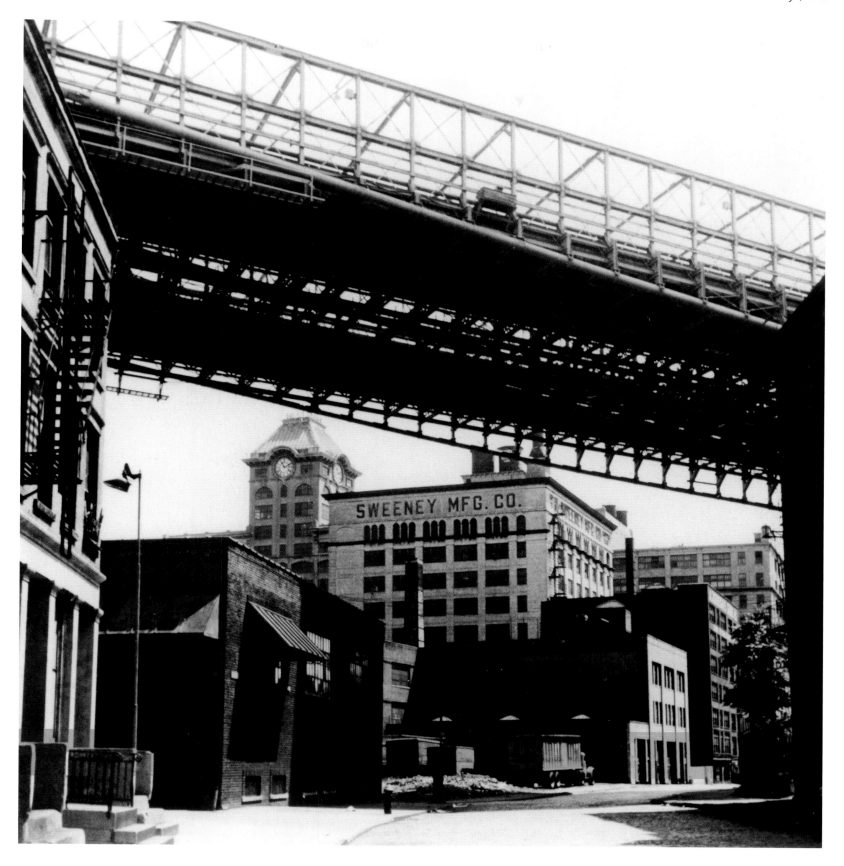

Sunday Best, Trinidad, 1942

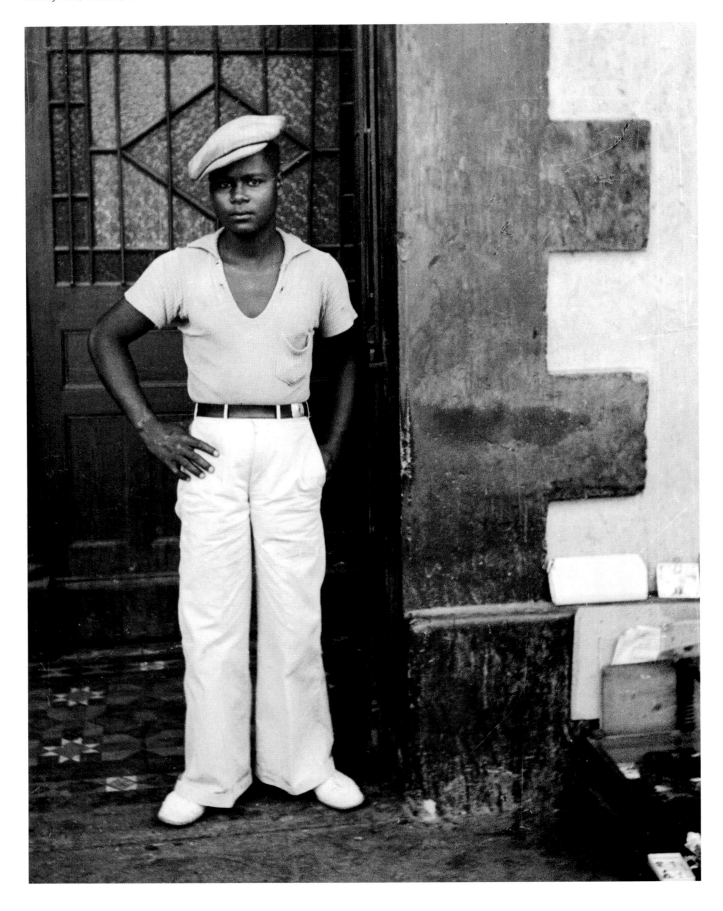

Port-of-Spain, Trinidad, 1942

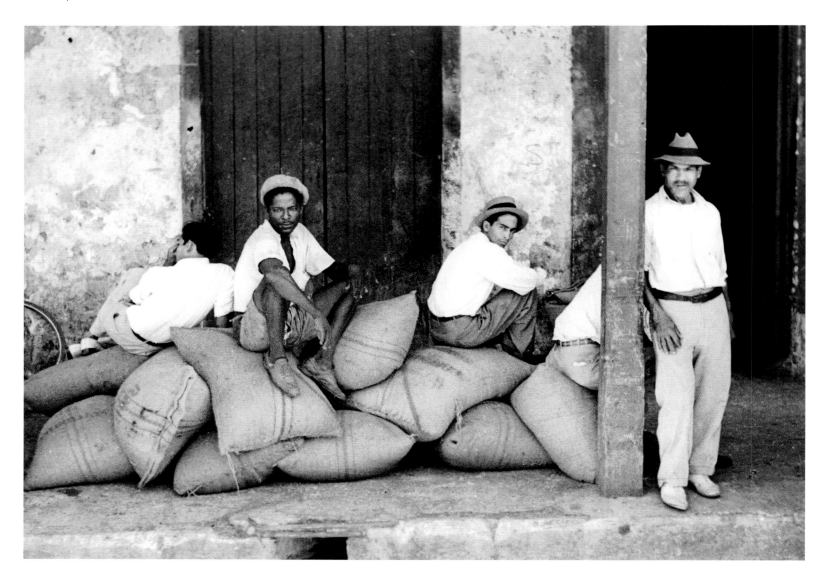

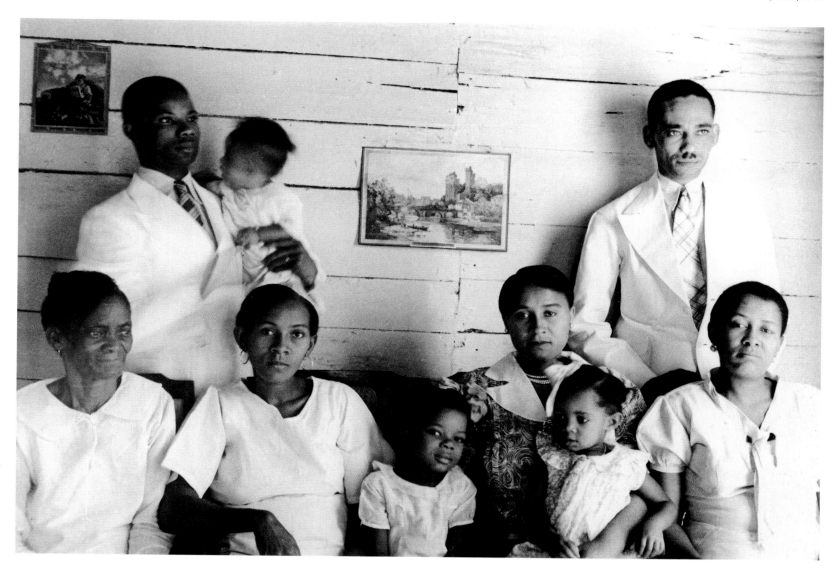

Fruit Vendor, Port-of-Spain, Trinidad, 1941/44

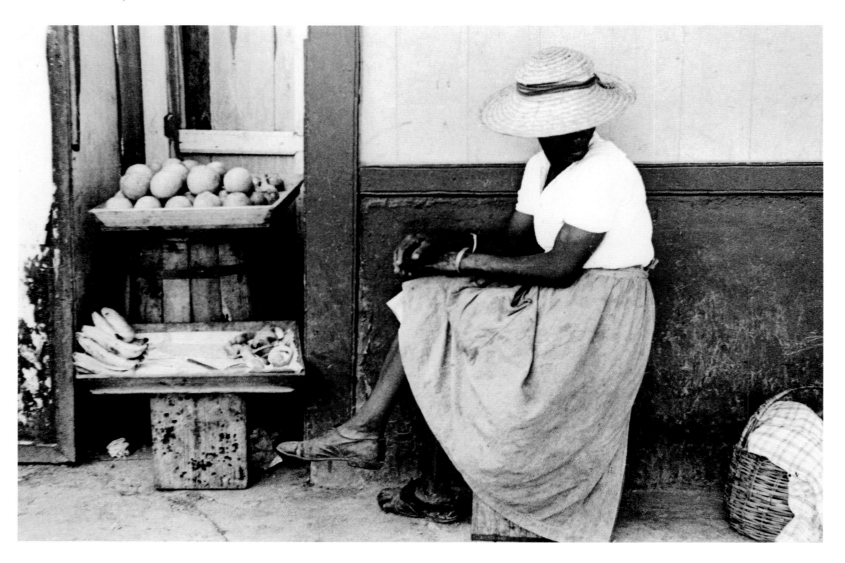

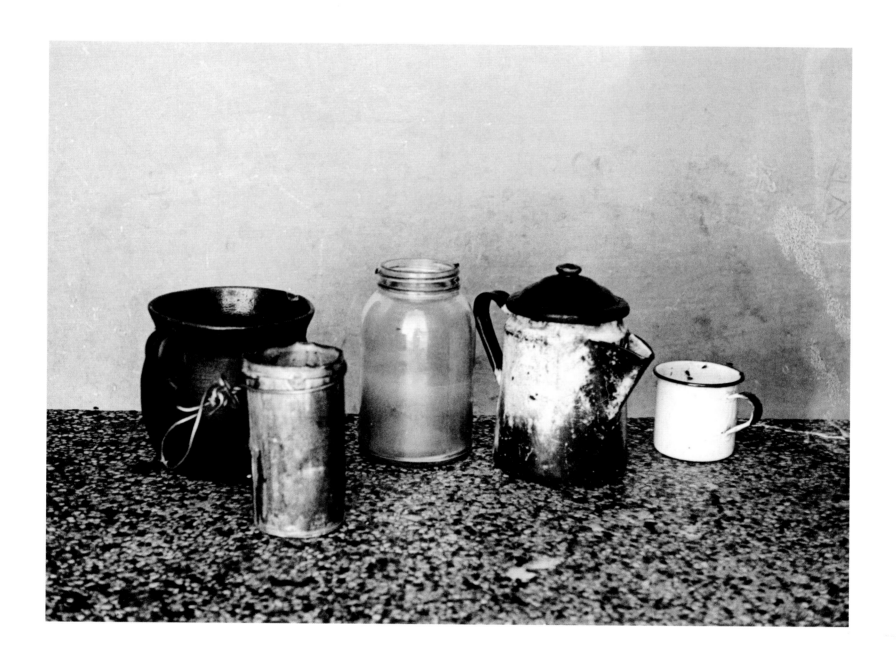

Still Life, New York, 1945

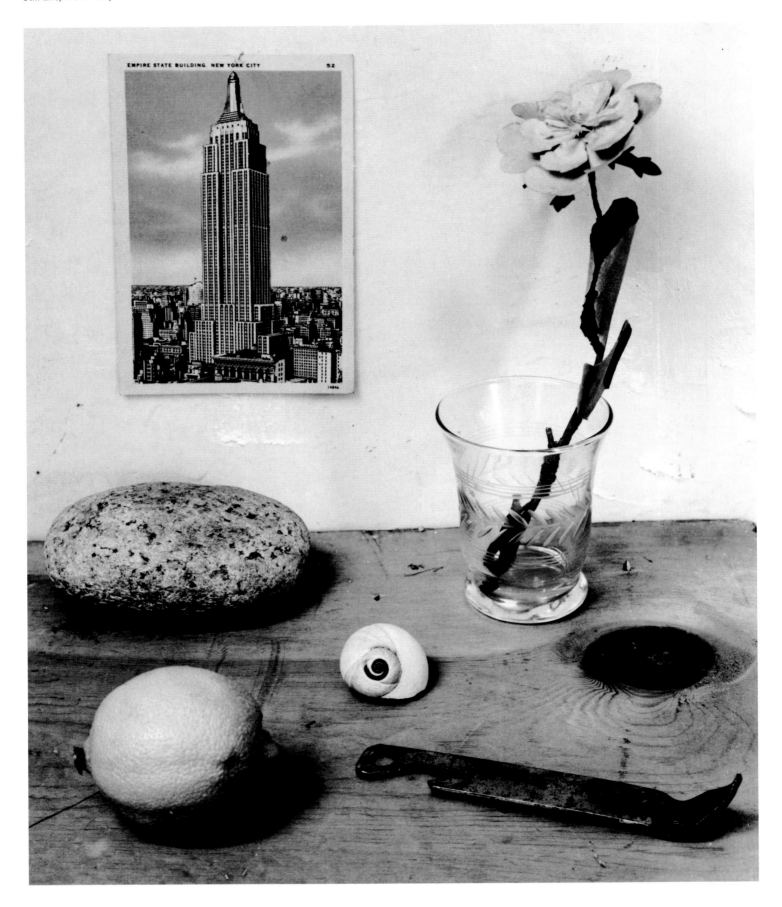

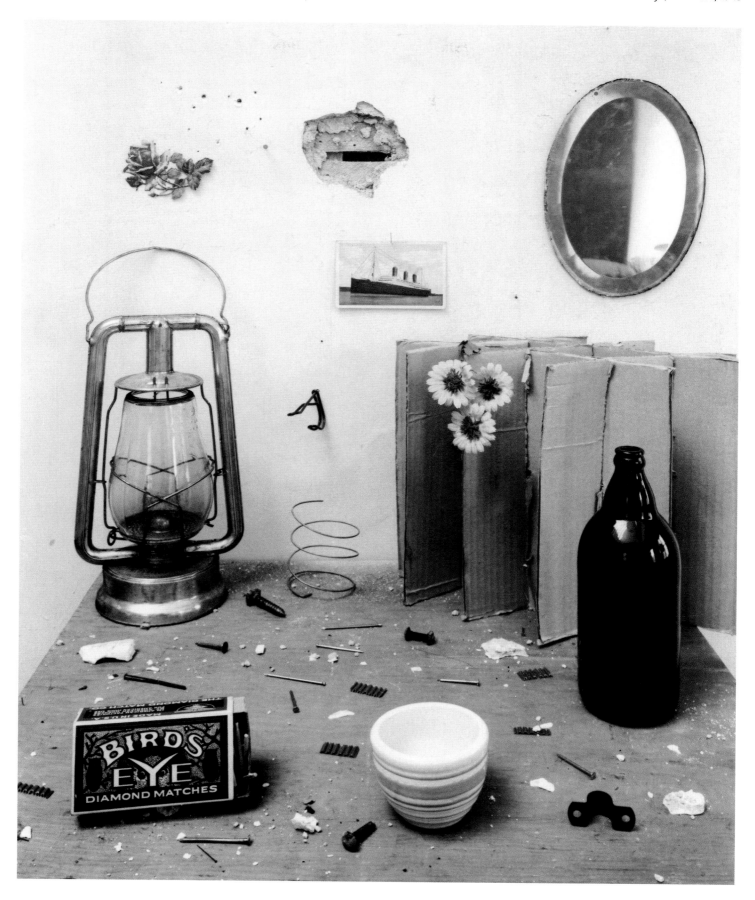

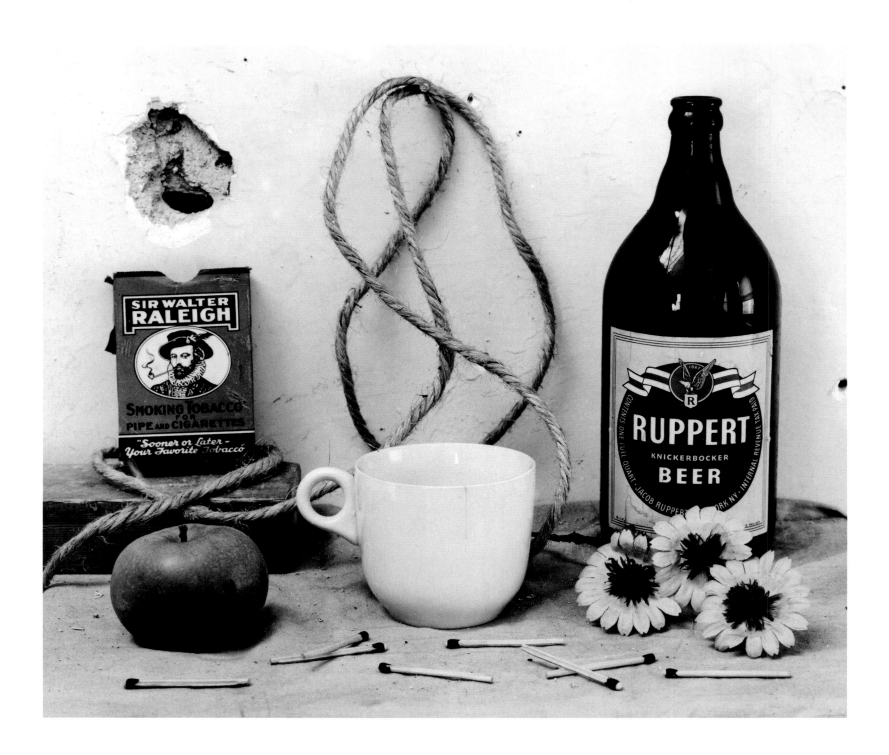

Untitled, Mexico, 1946

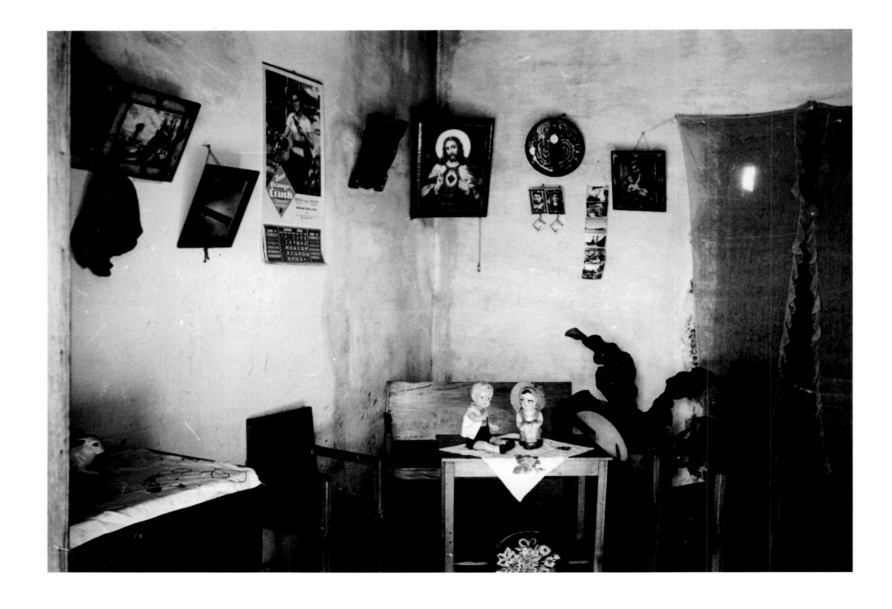

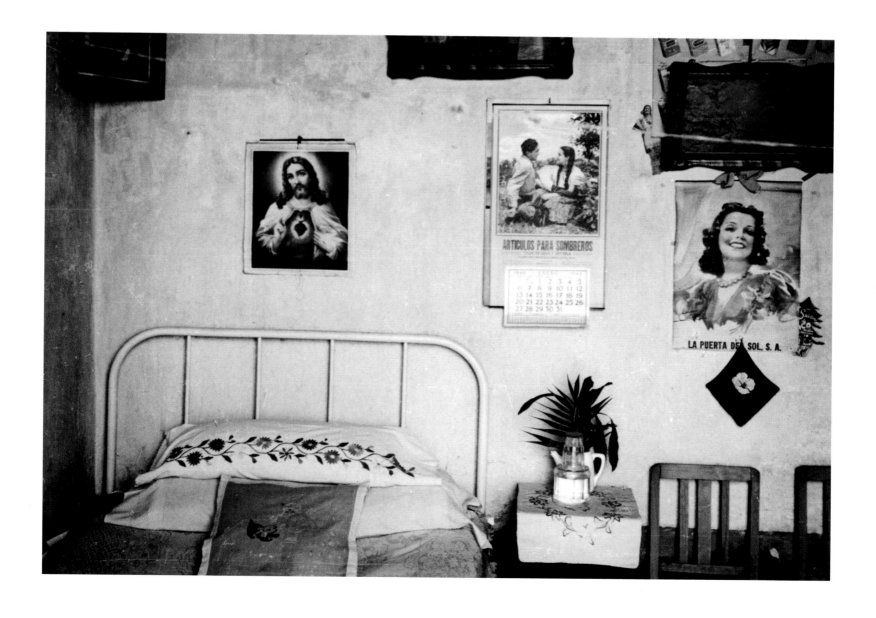

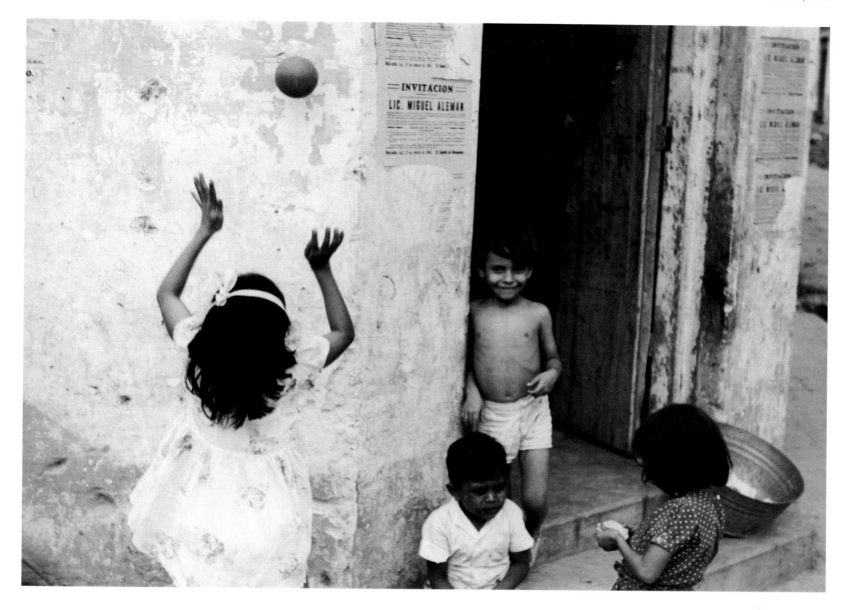

Two Women, Paris, 1947

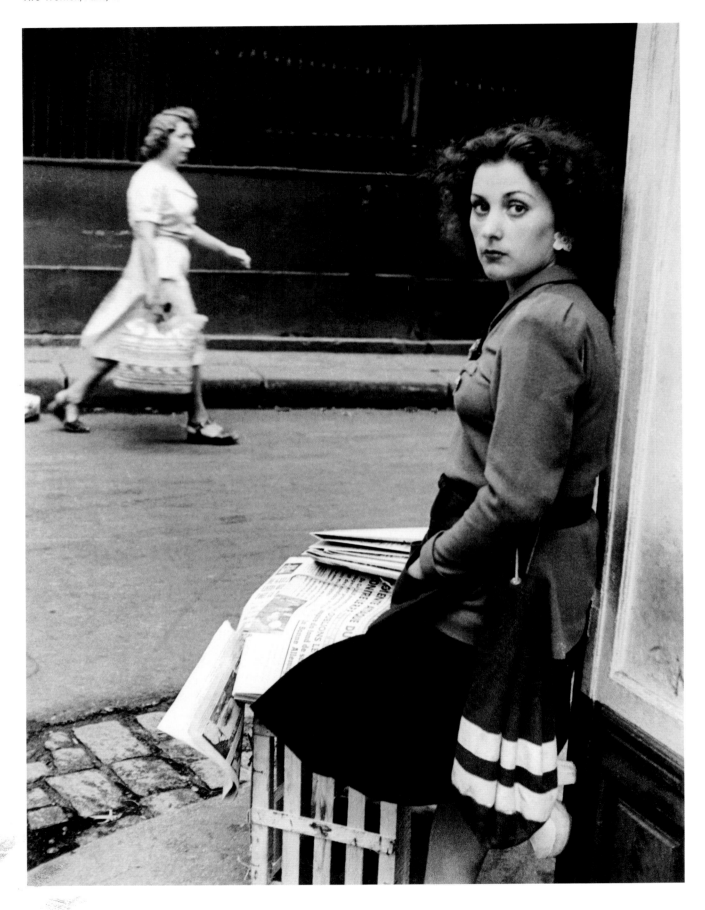

Subway, New York, ca. 1947

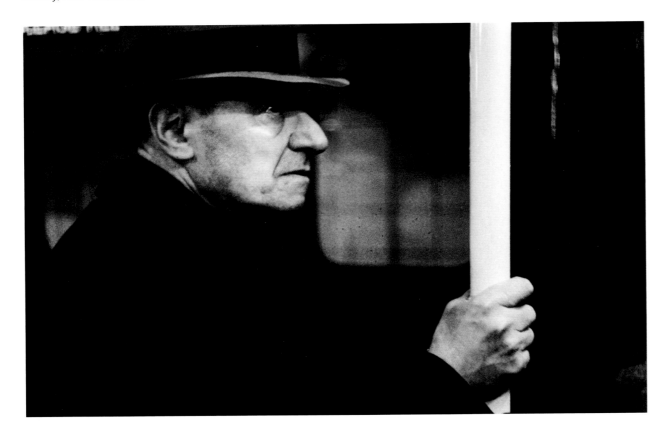

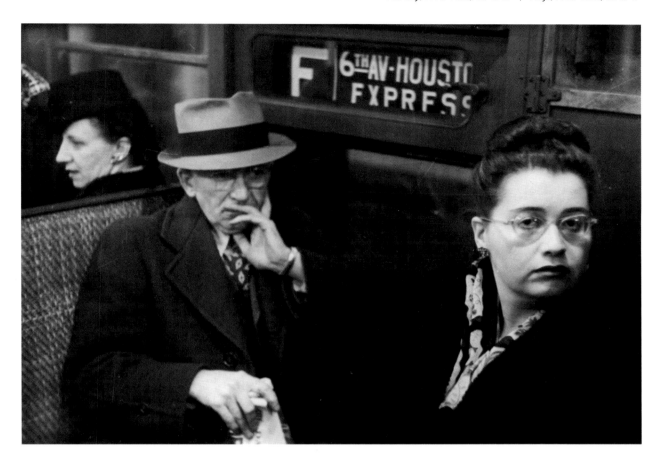

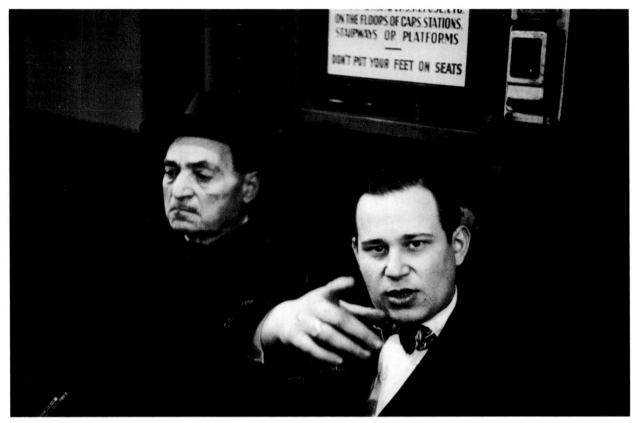

Men's, New York, 1947

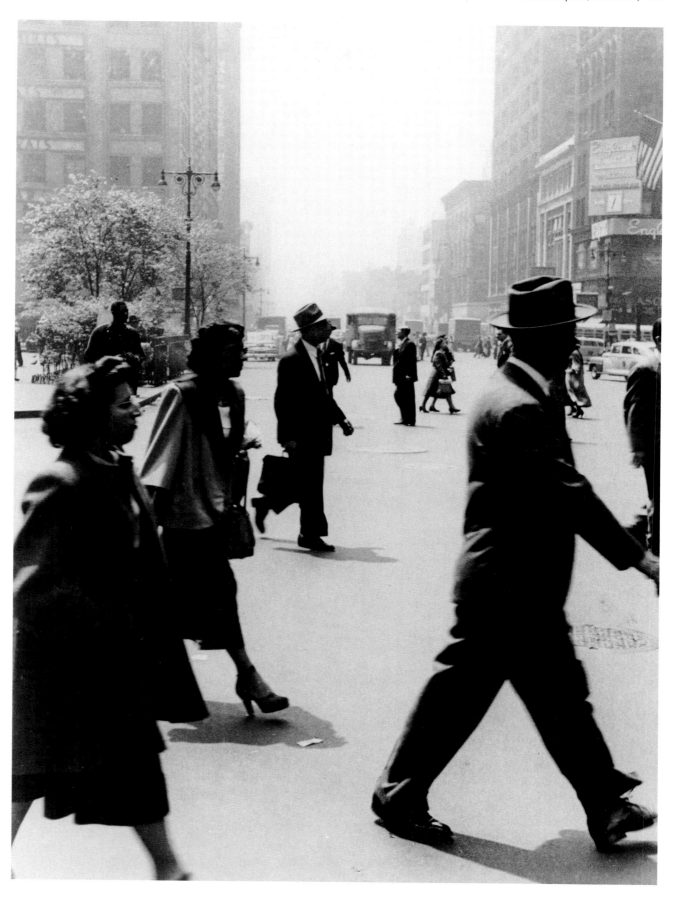

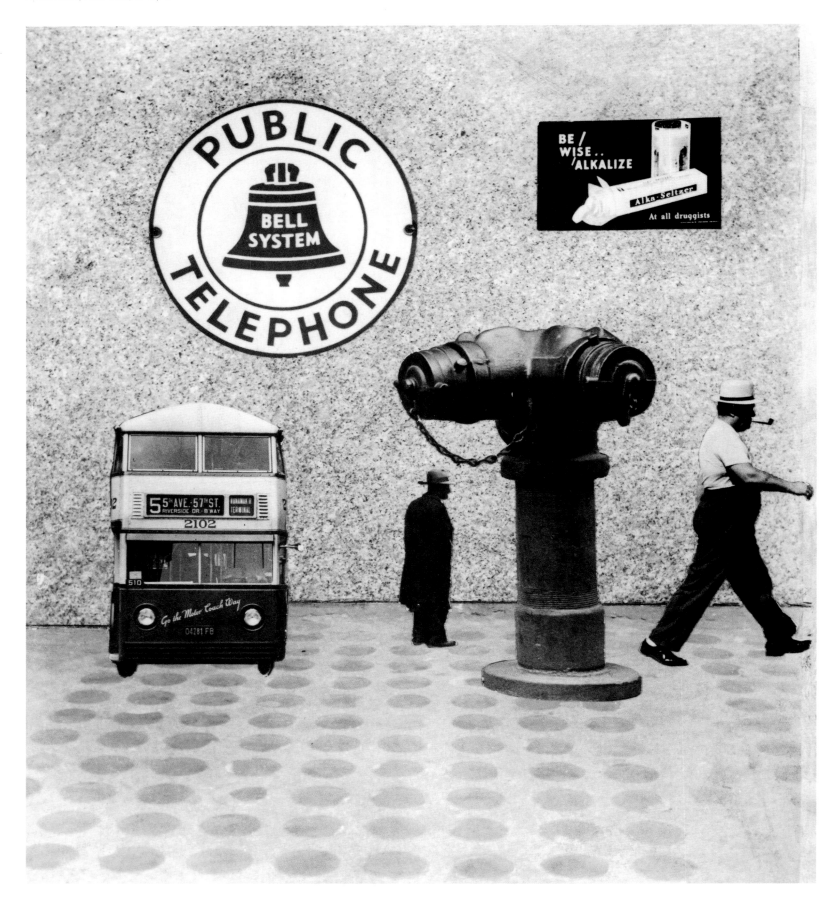

Rooftops and Water Towers II, New York, 1947

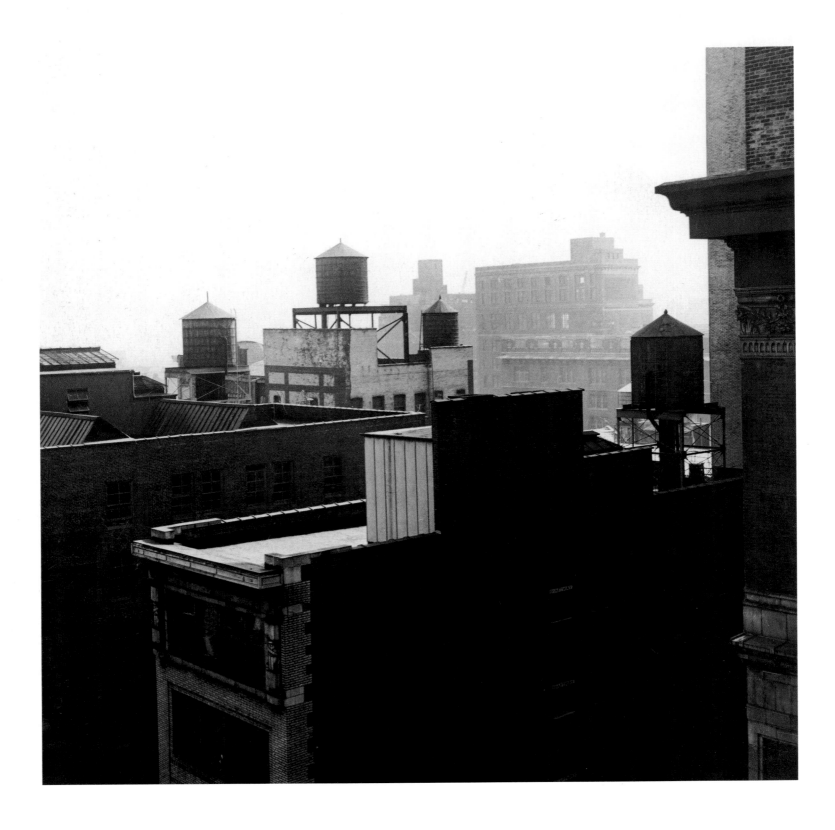

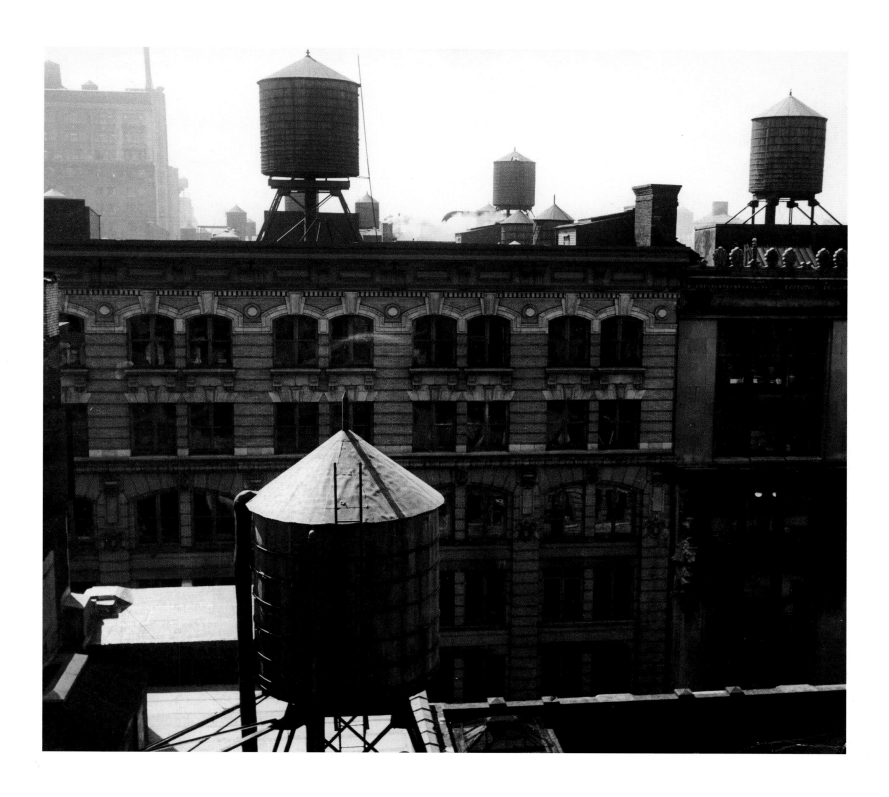

Chelseascape, New York, 1947

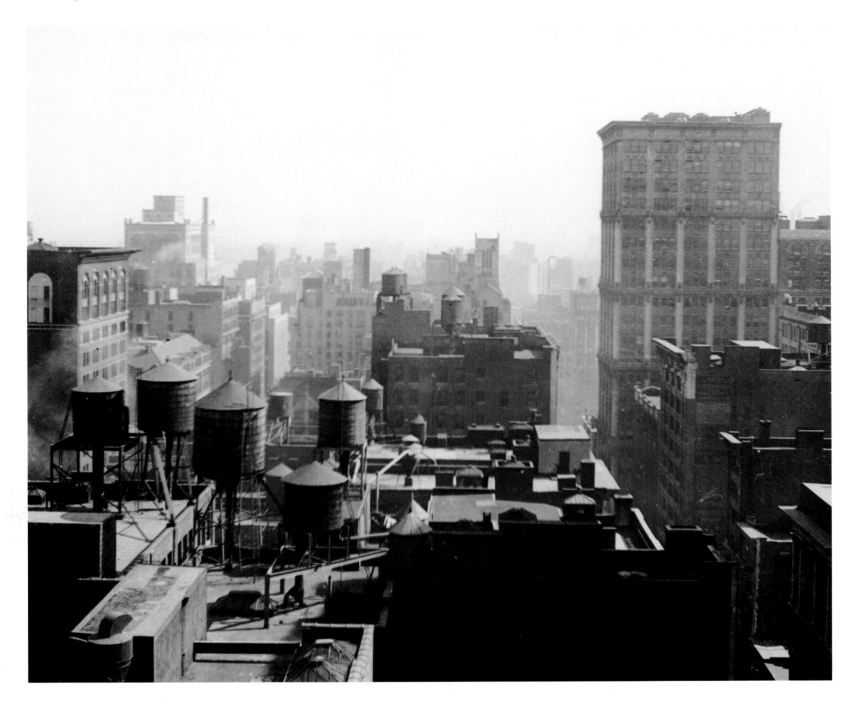

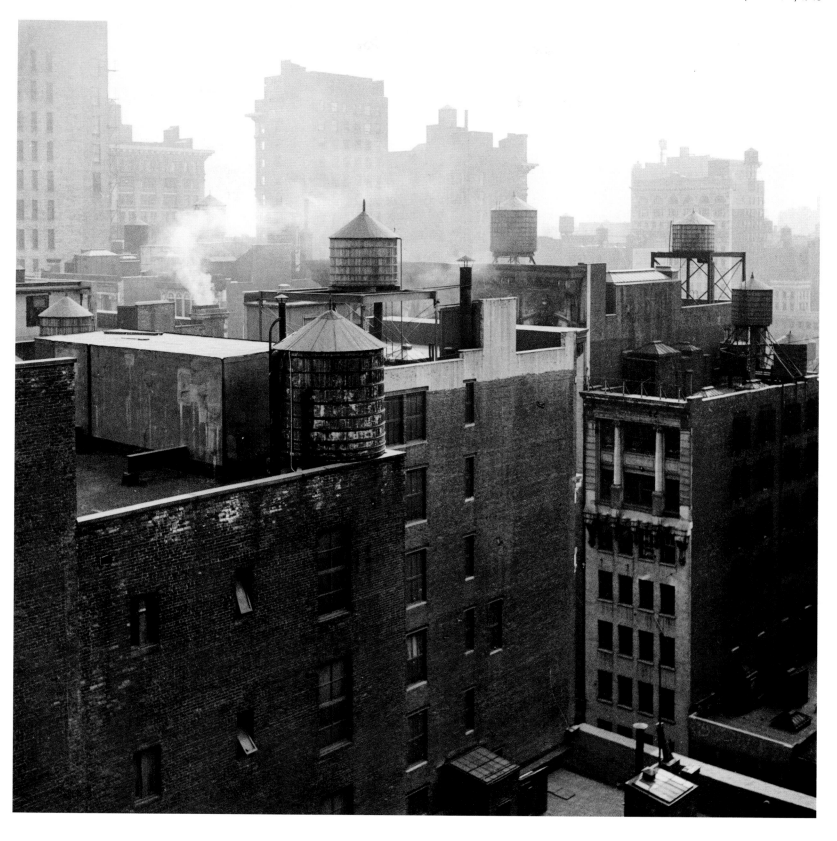

Times Square, New York, 1947

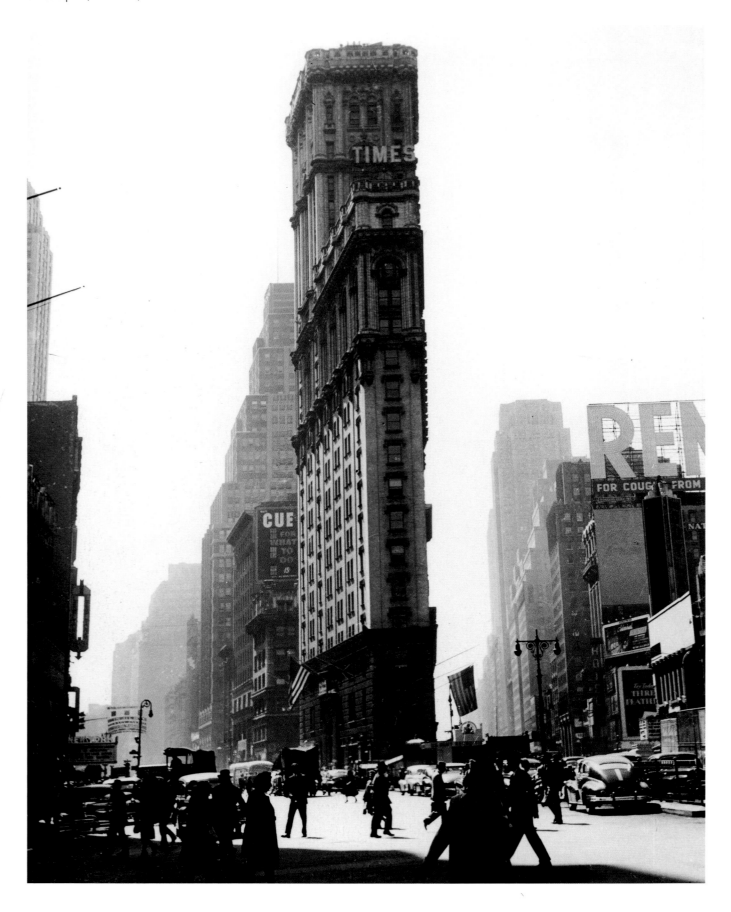

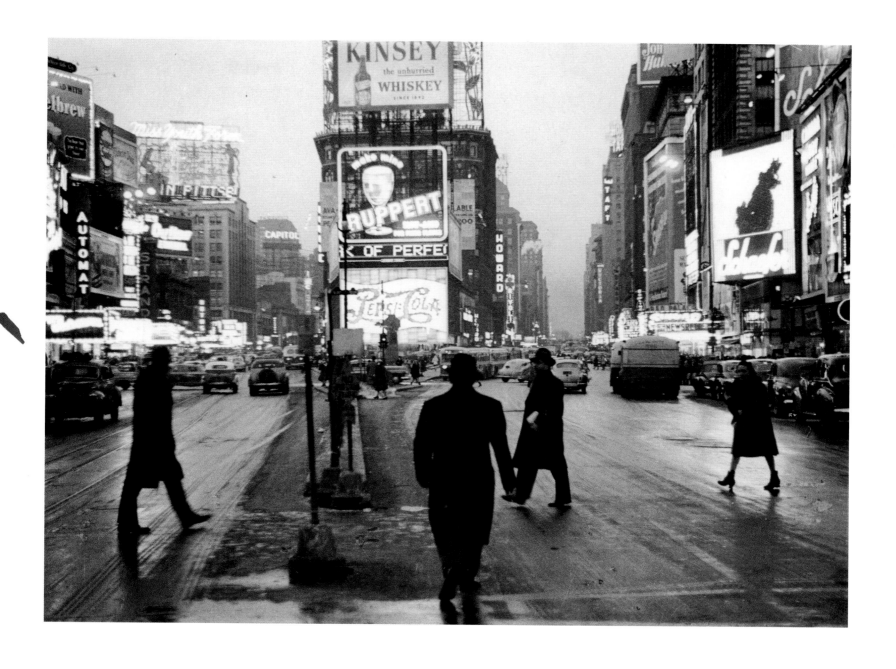

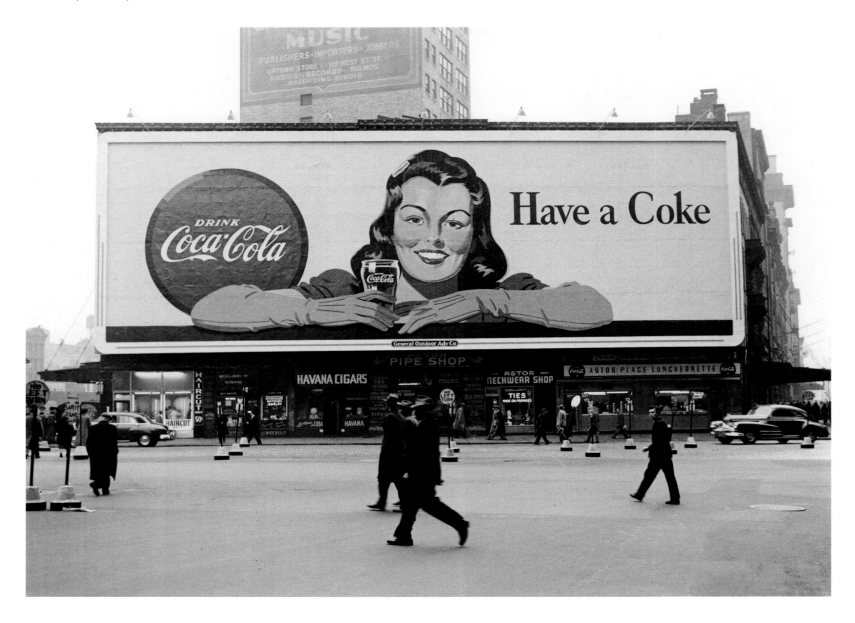

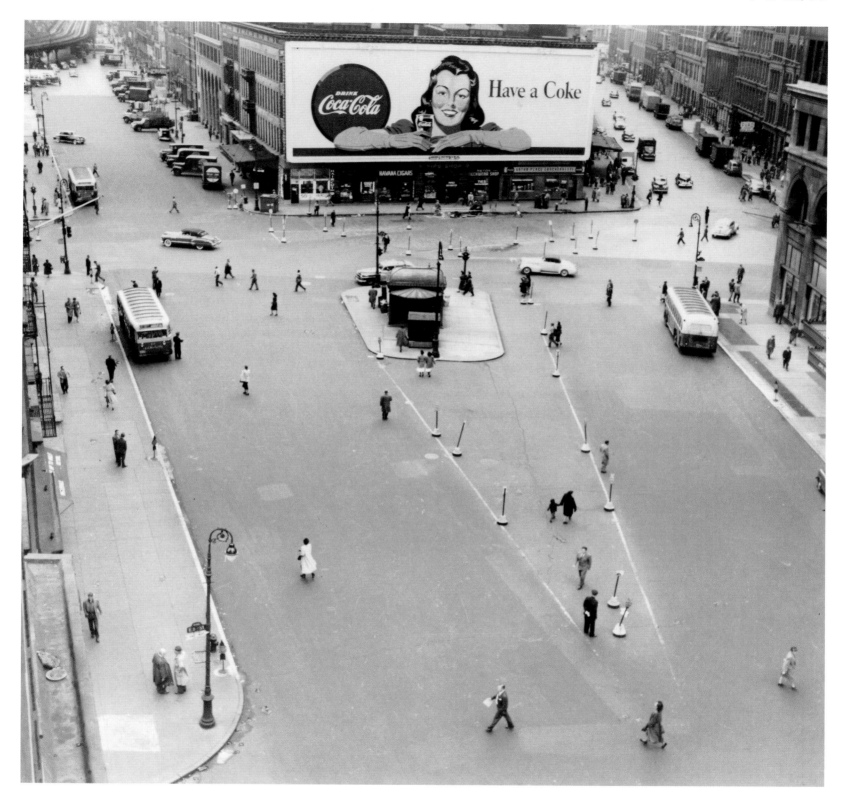

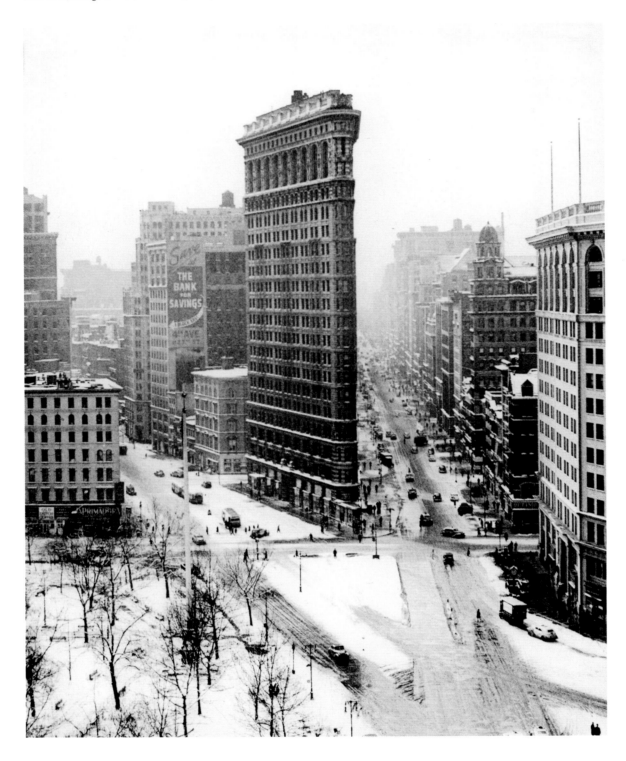

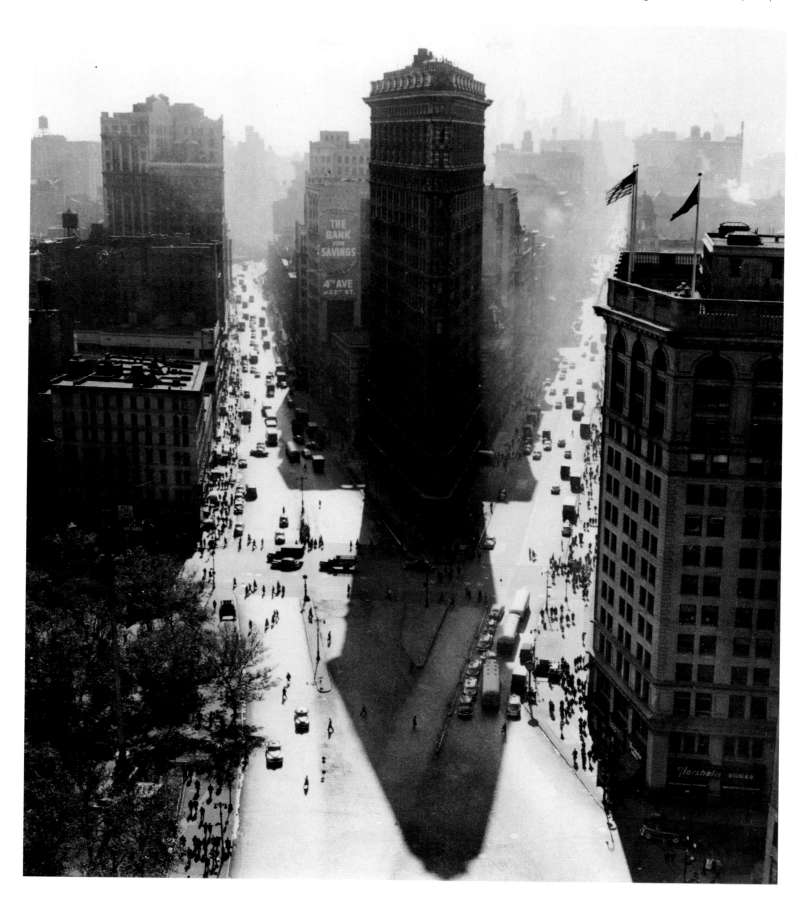

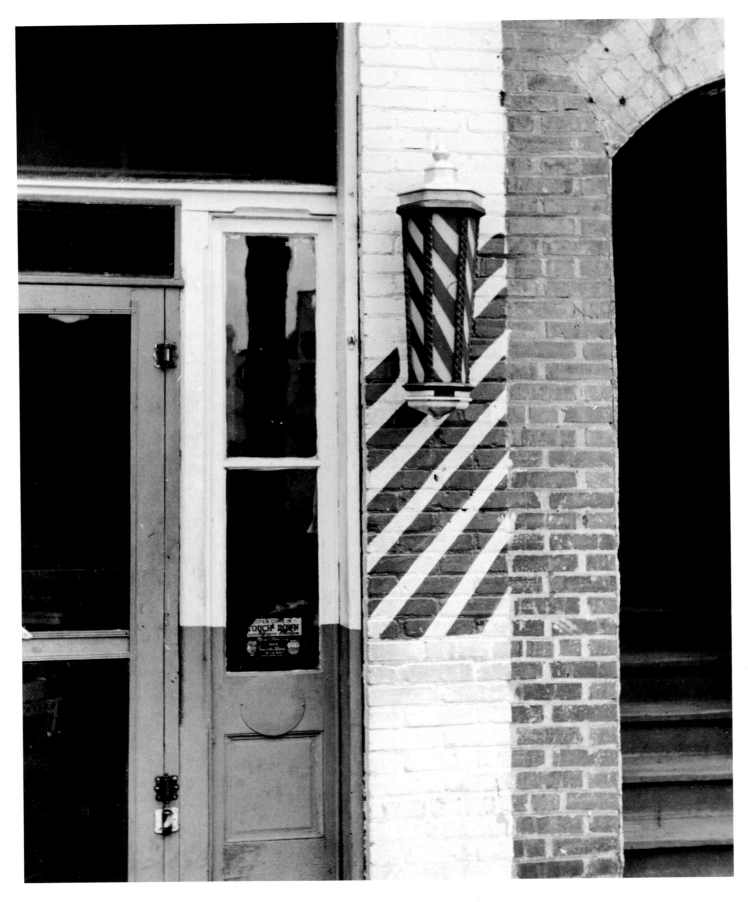

Lunch Basket, Montgomery, Alabama, 1948

Composition, Little Rock, Arkansas, 1948

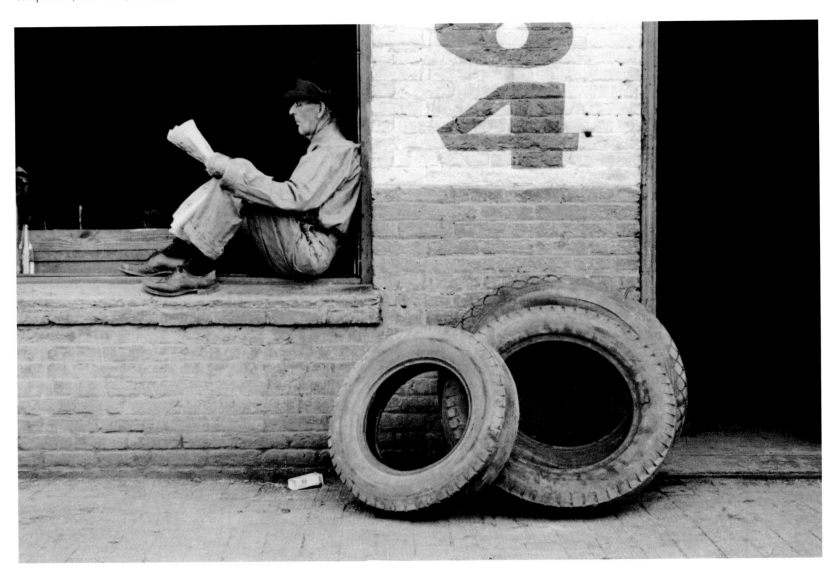

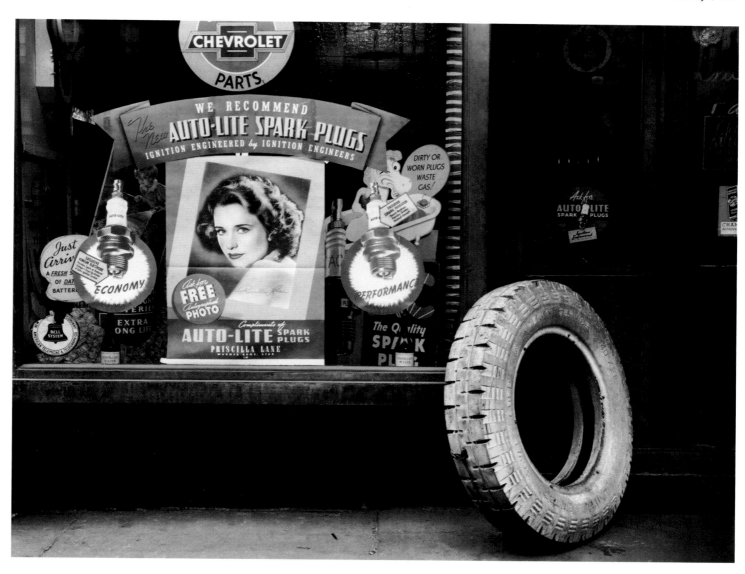

Jackson Pollock, Springs, New York, 1950

Jackson Pollock, Springs, New York, 1950

Willem de Kooning Drawing *Woman I*, New York, 1950

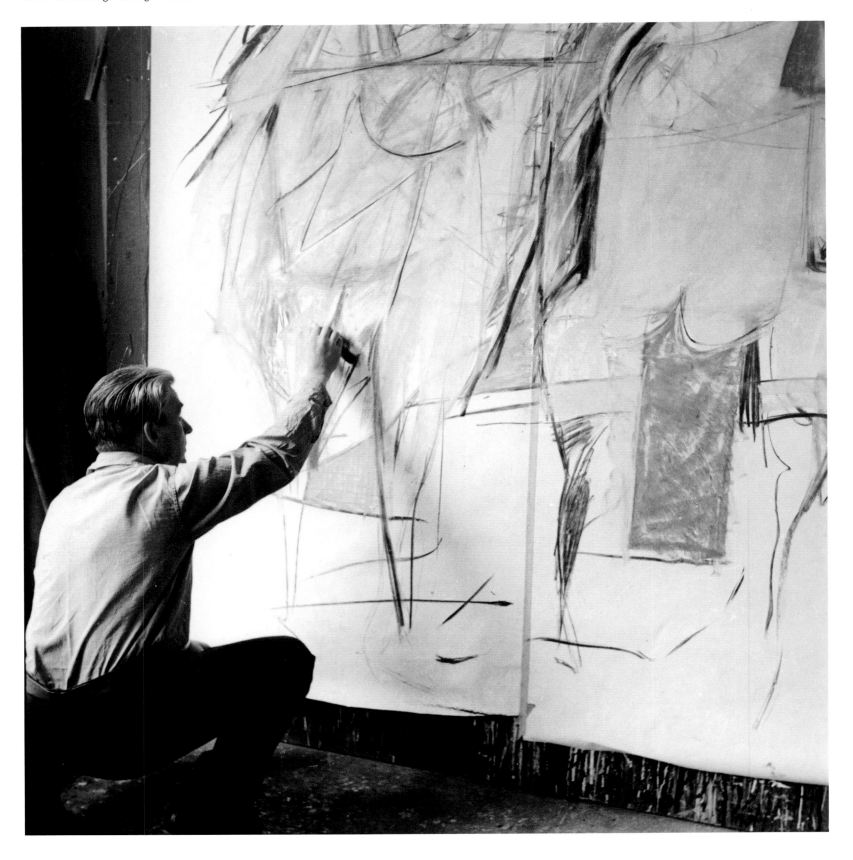

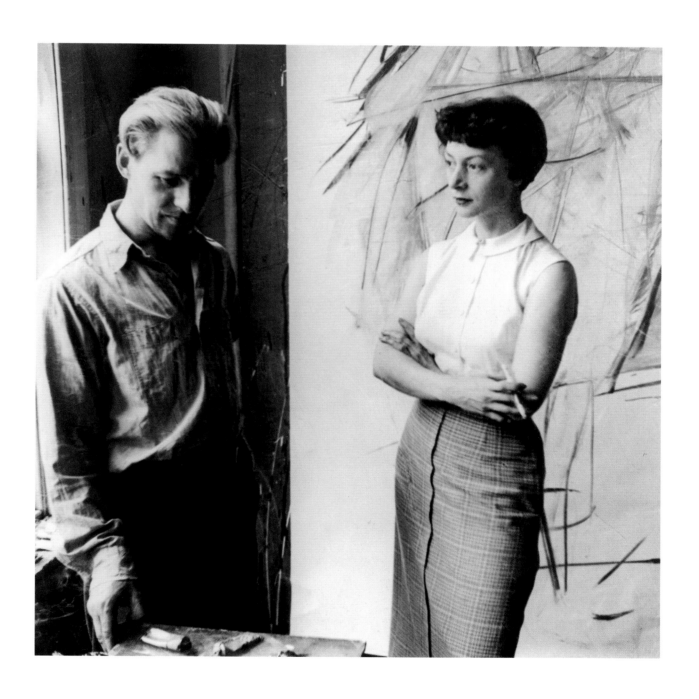

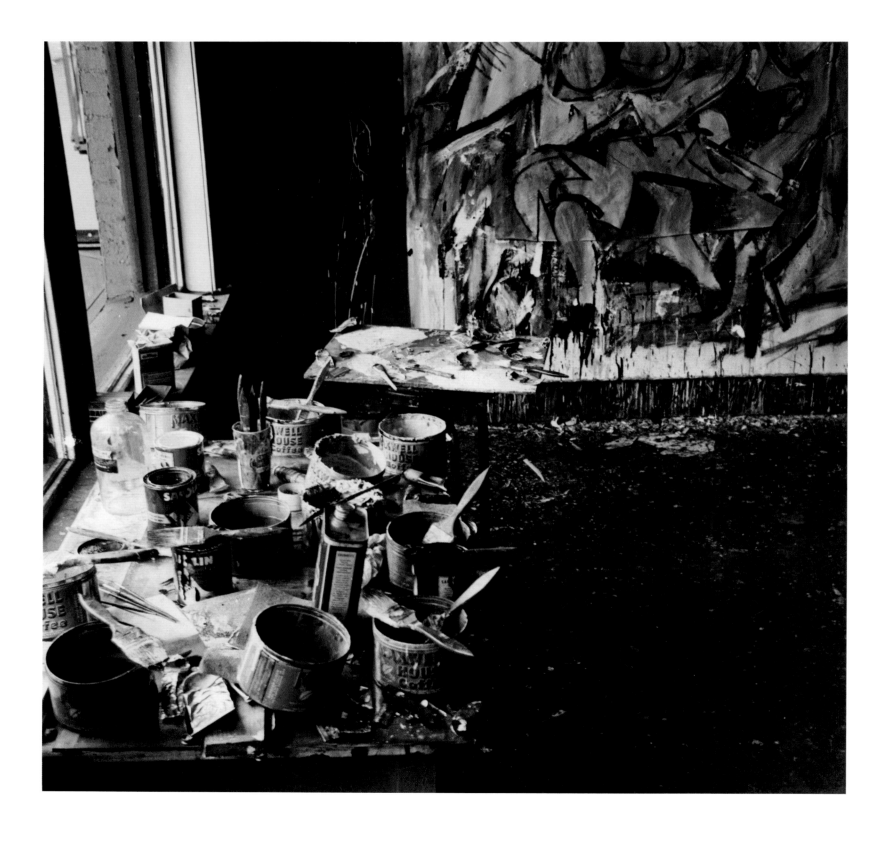

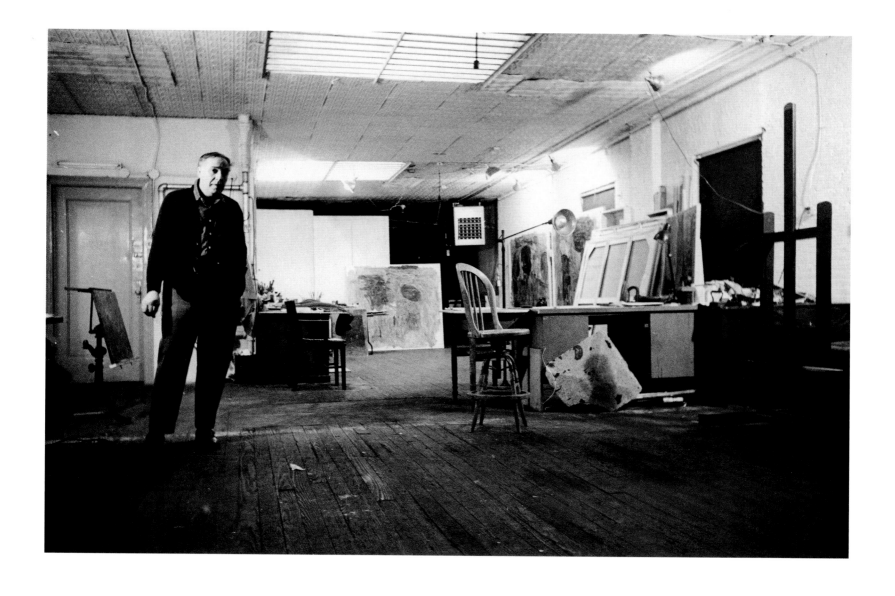

Itea, Gulf of Corinth, 1951

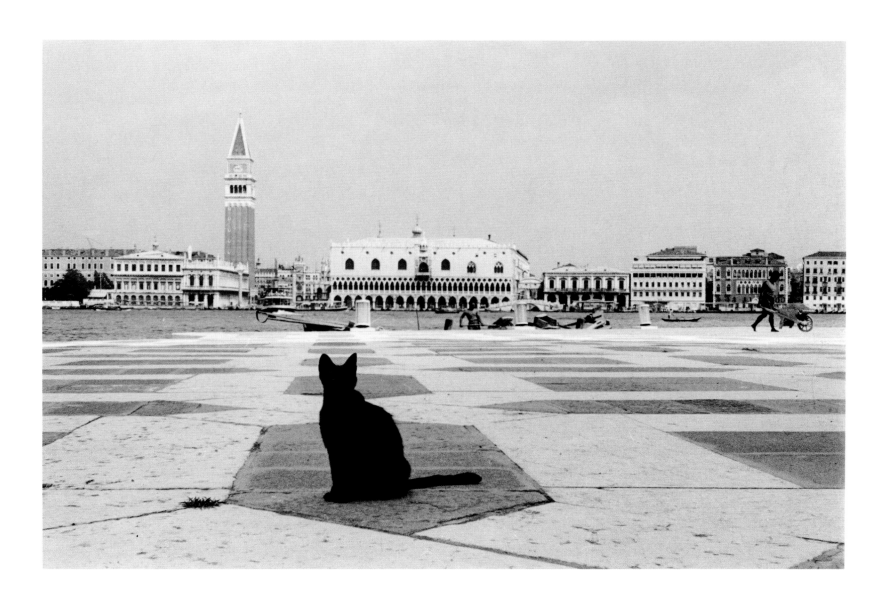

Venice from Campanile, 1951

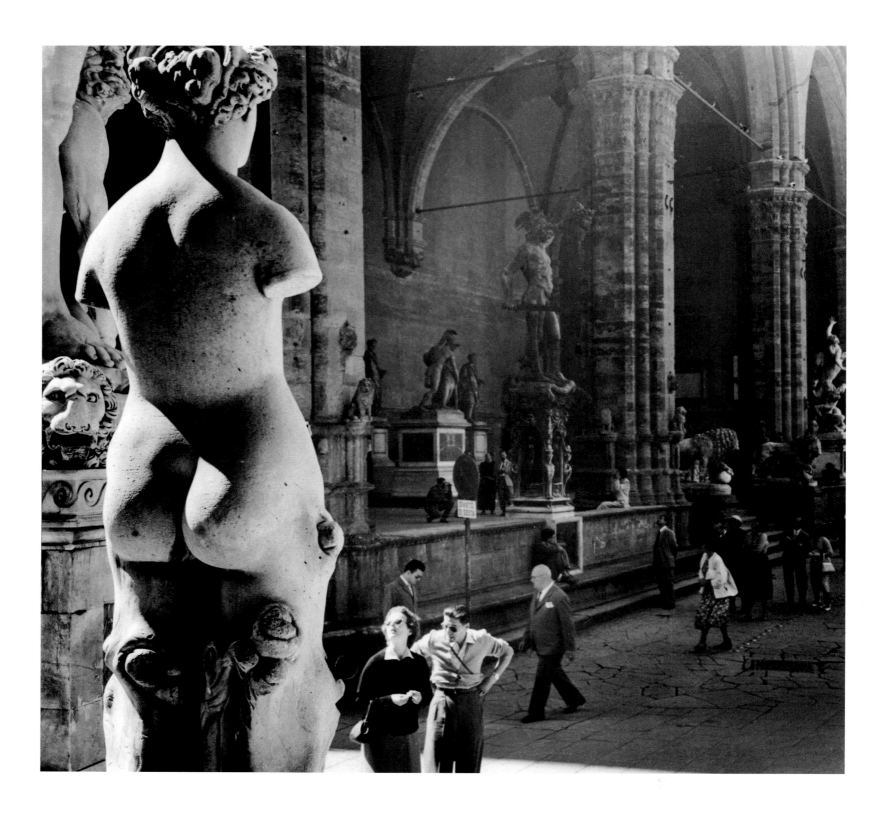

Madonna and Pants, Naples, 1950

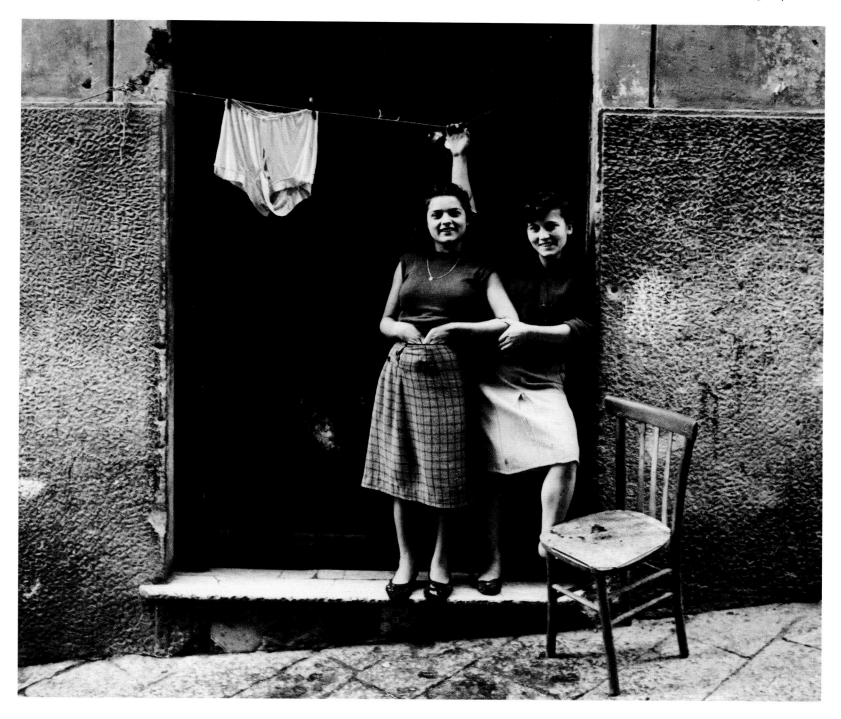

Polka-Dot Dress, Naples, 1951

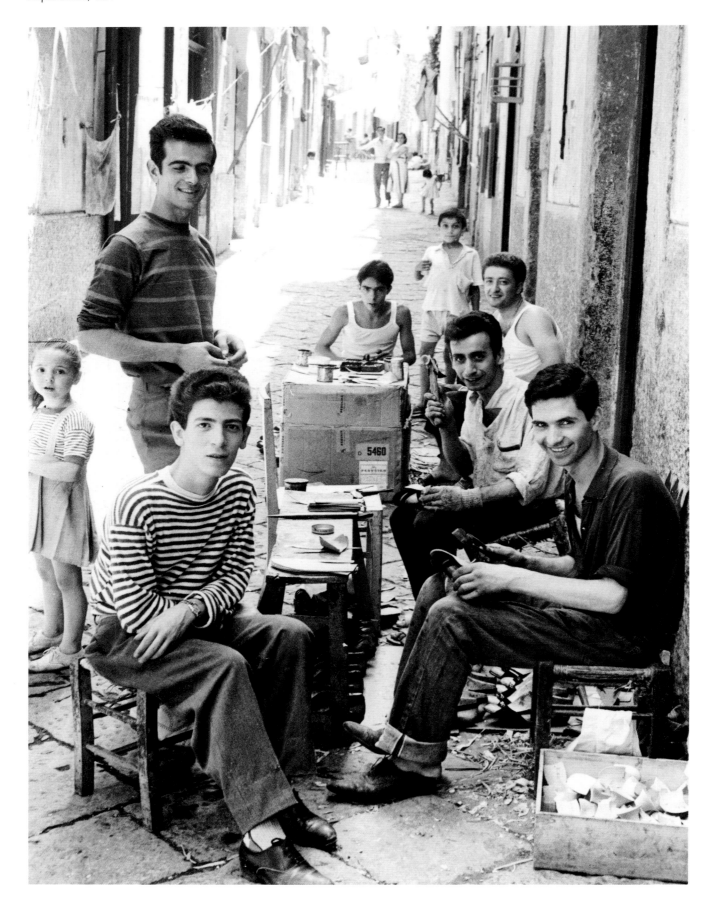

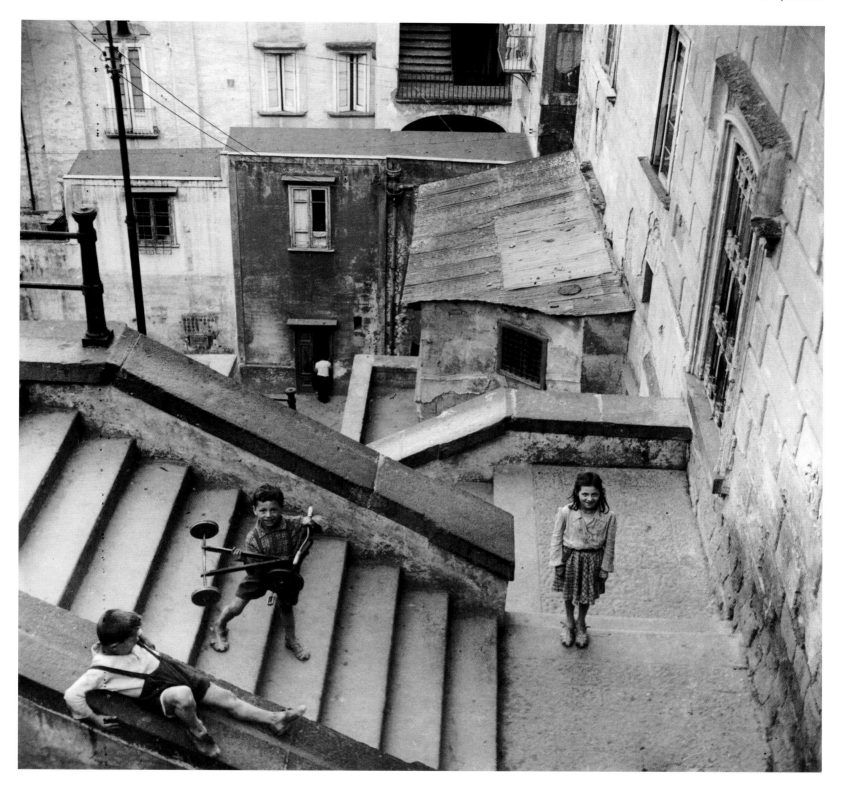

Houses, Ischia, 1951

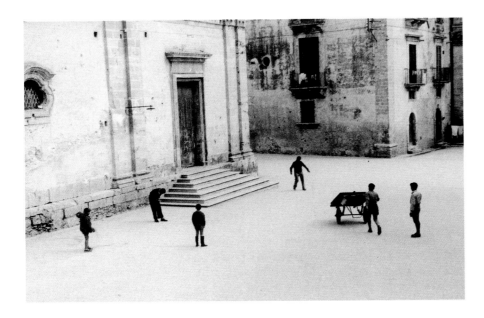

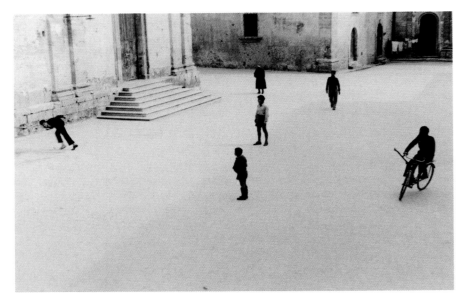

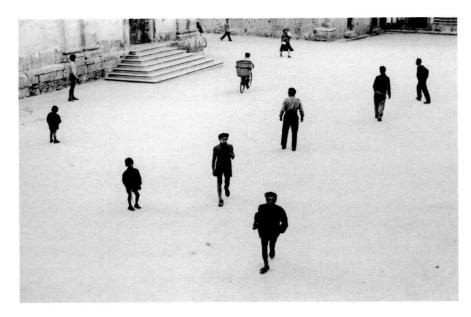

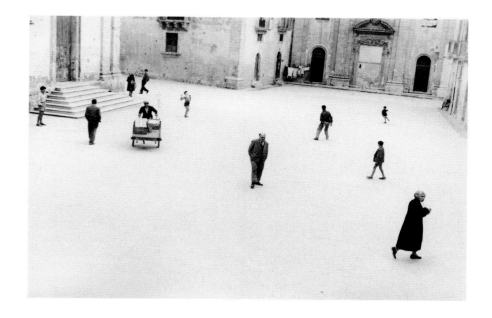

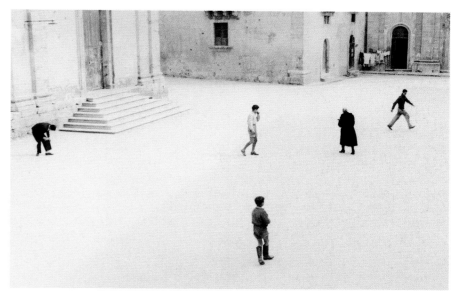

Caryatid, New York, 1952

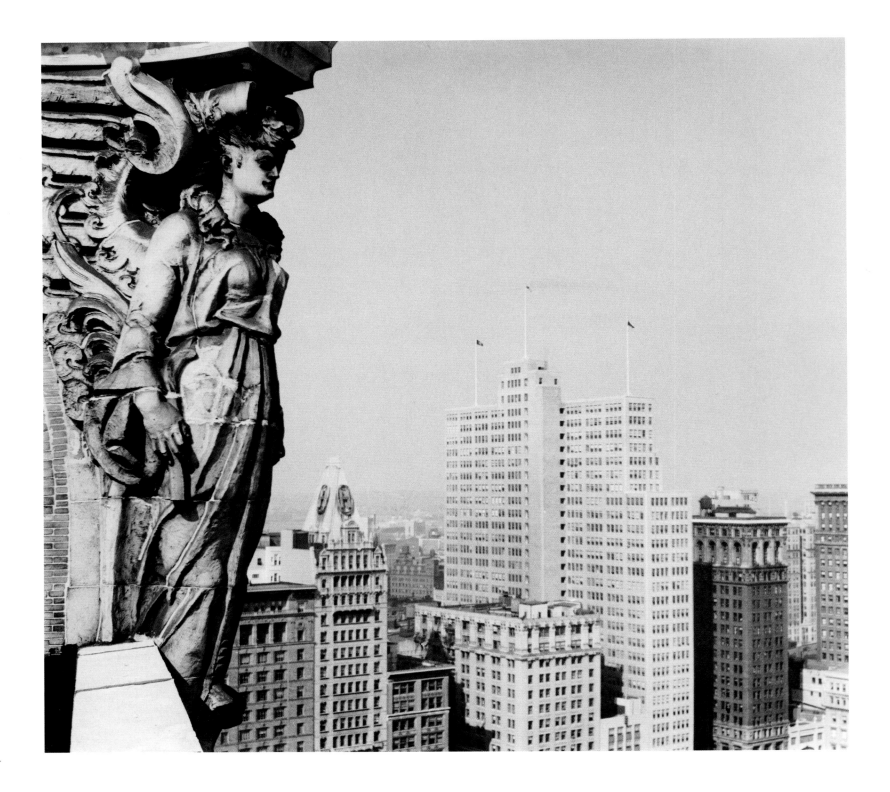

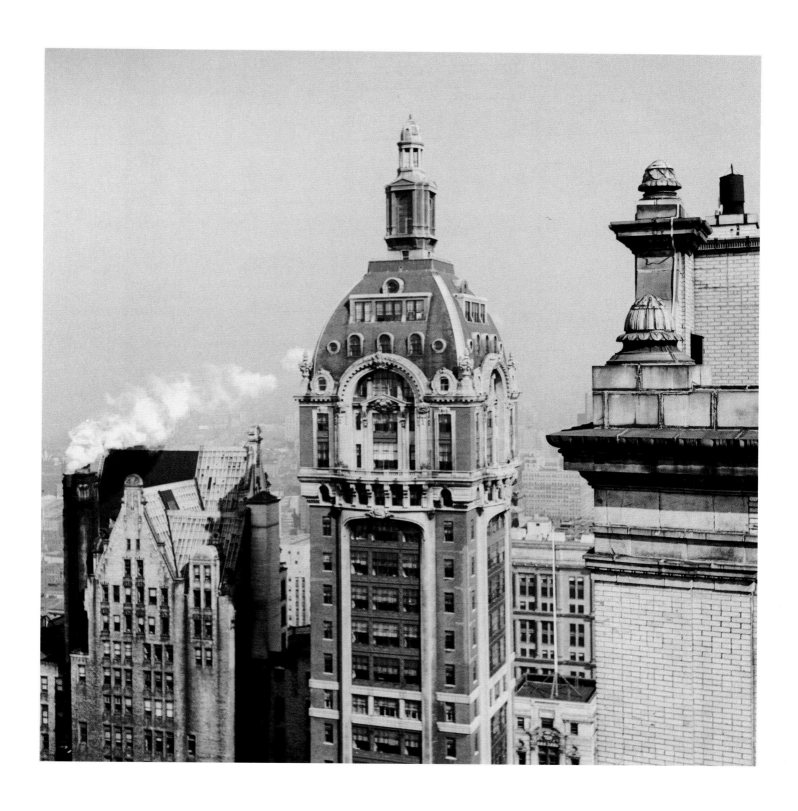

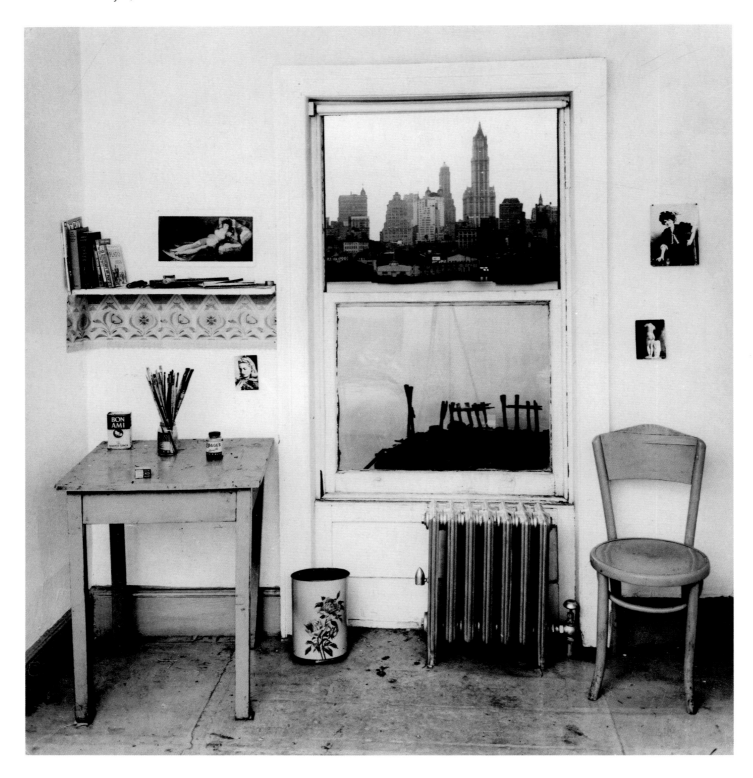

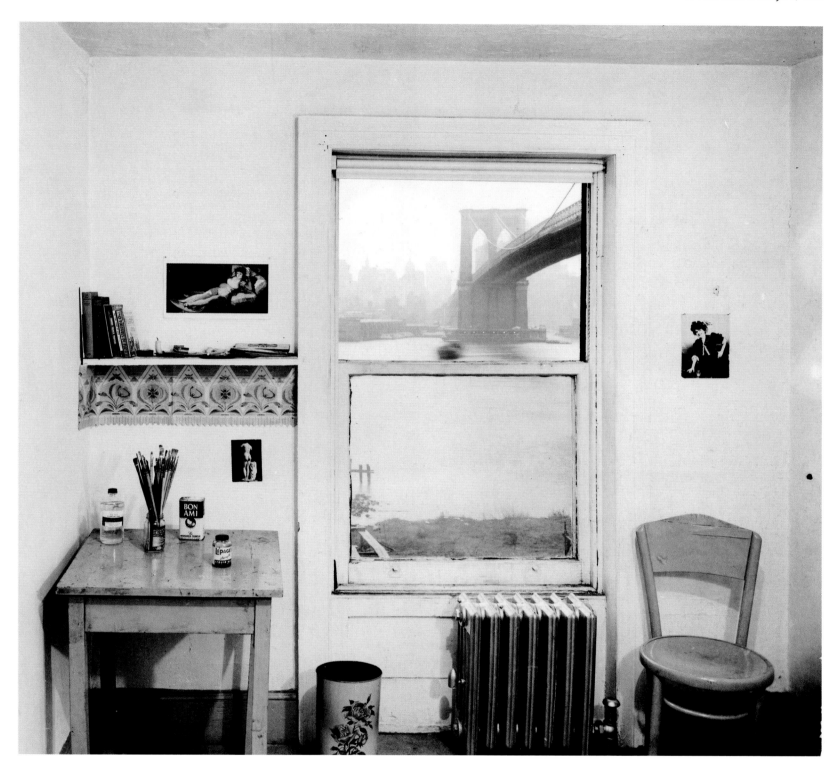

Tall Ferns, Deer Isle, Maine, 1954

From Jane Bowles's Roof, Tangier, Morocco, 1955

Gedra Dancer, Goulimine, Morocco, 1955

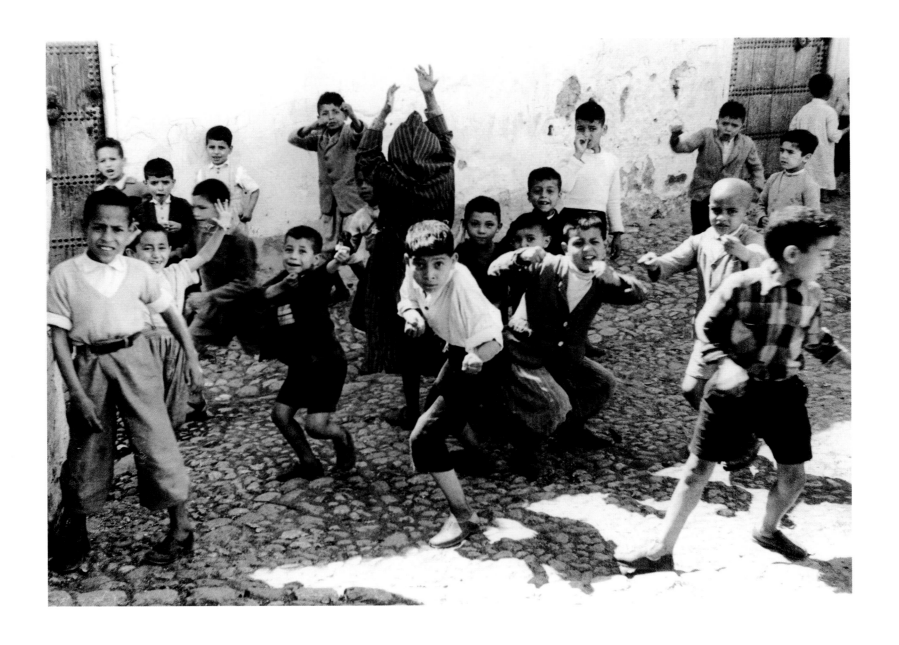

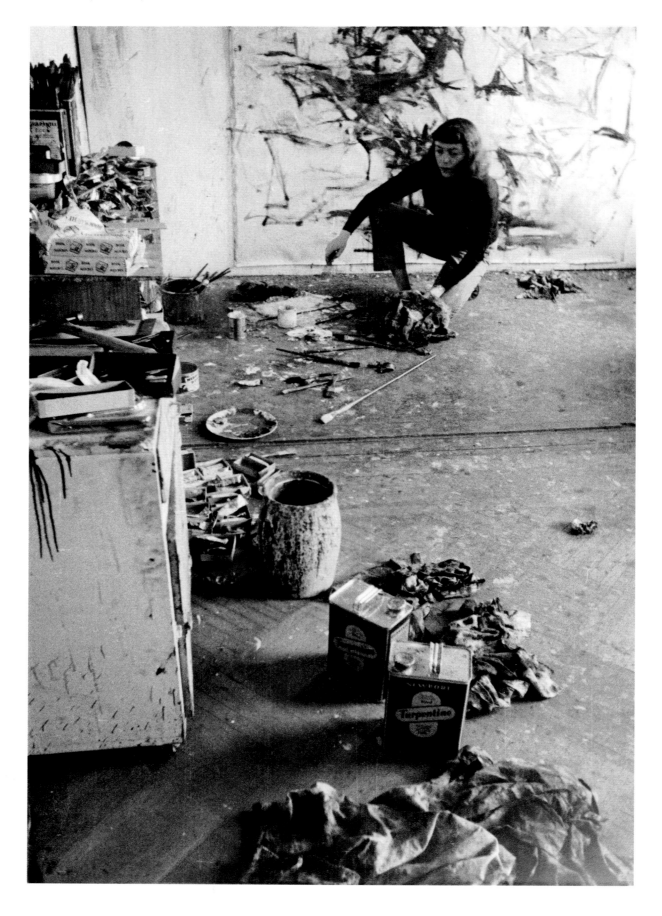

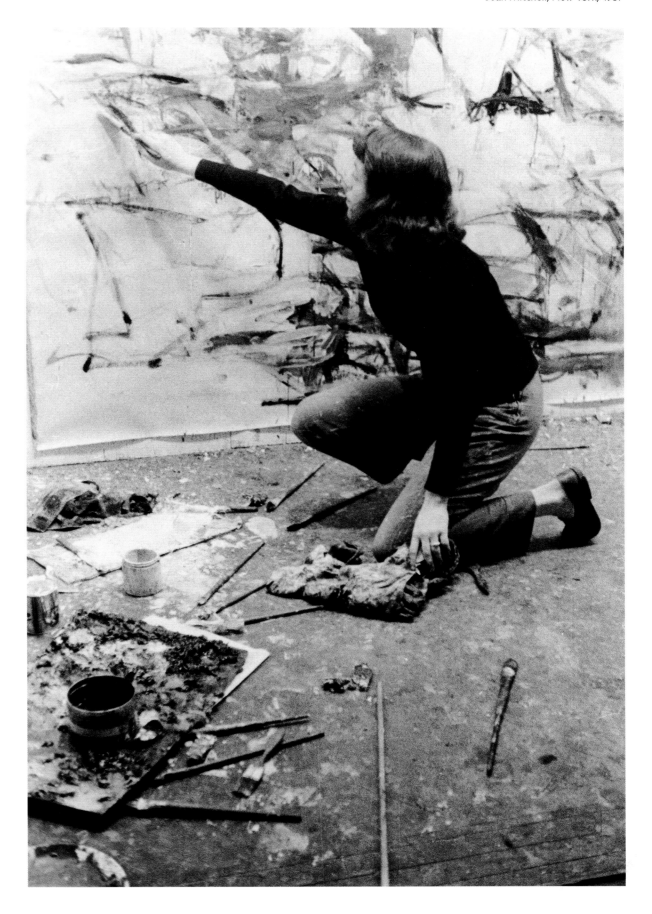

Mark Rothko, New York, 1960

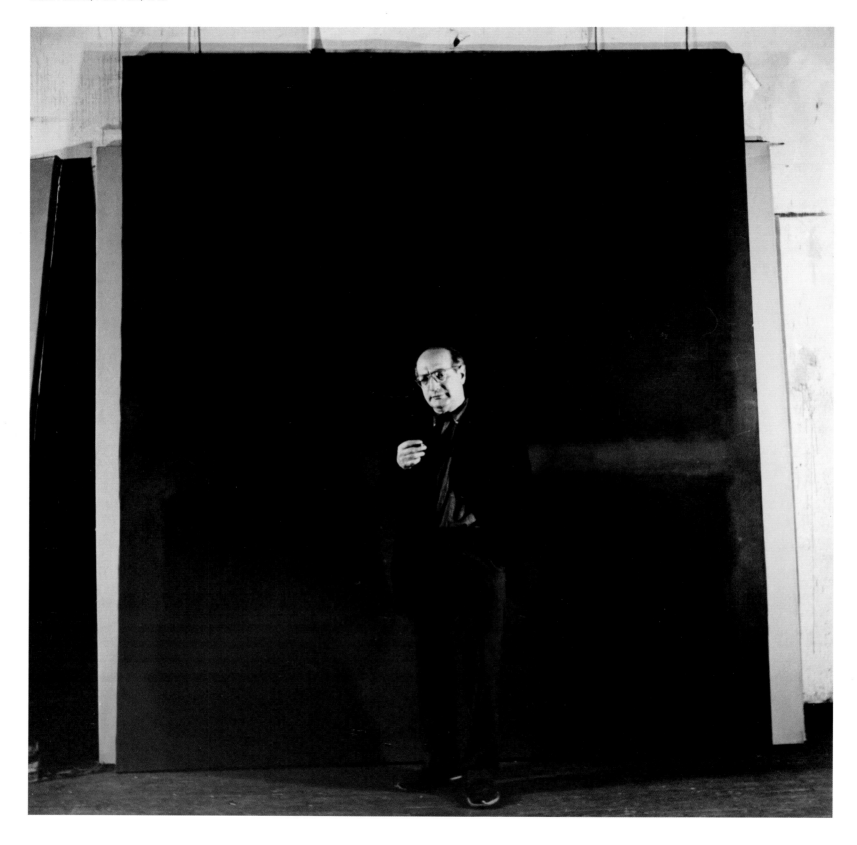

Curb, New York, 1973

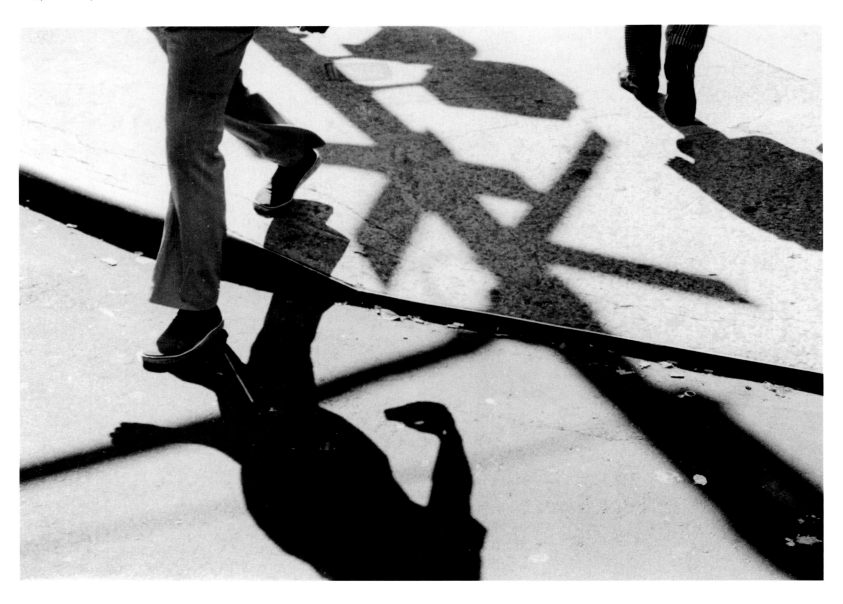

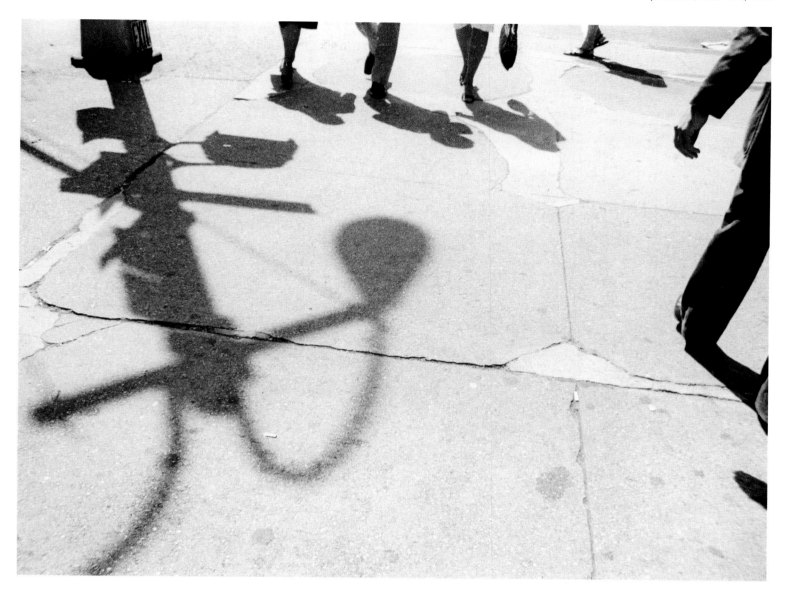

Flatiron Building I, New York, 1973

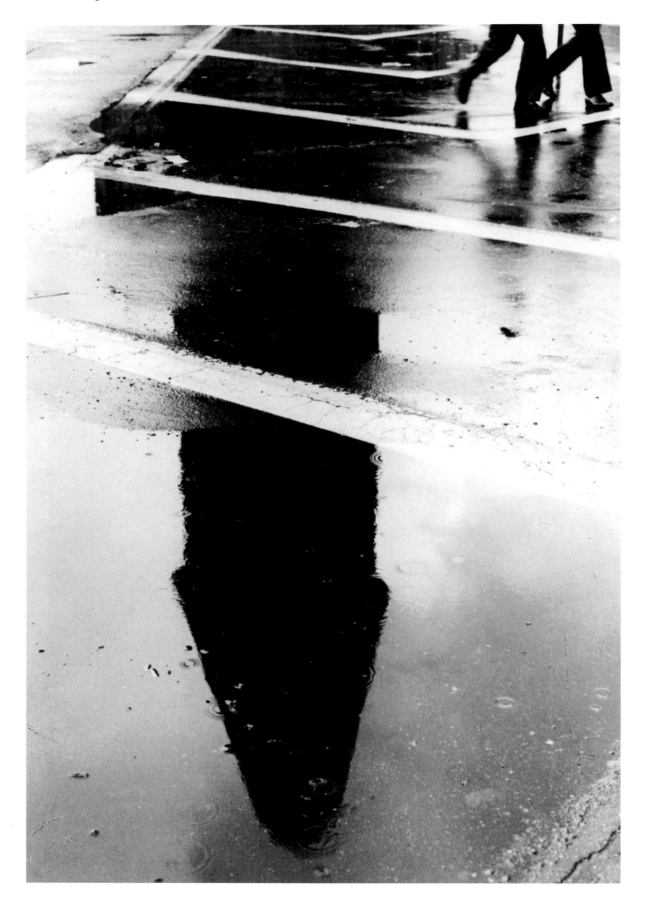

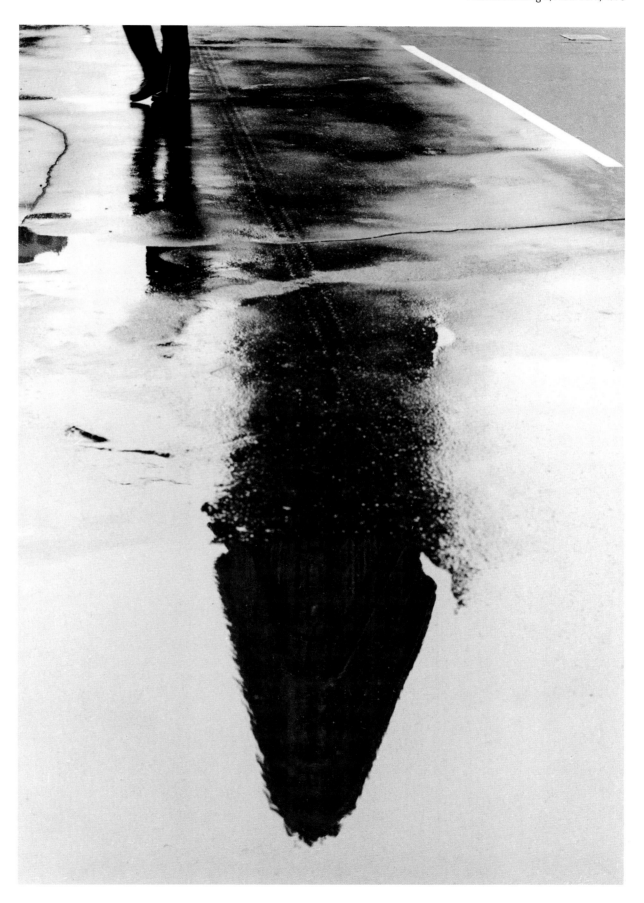

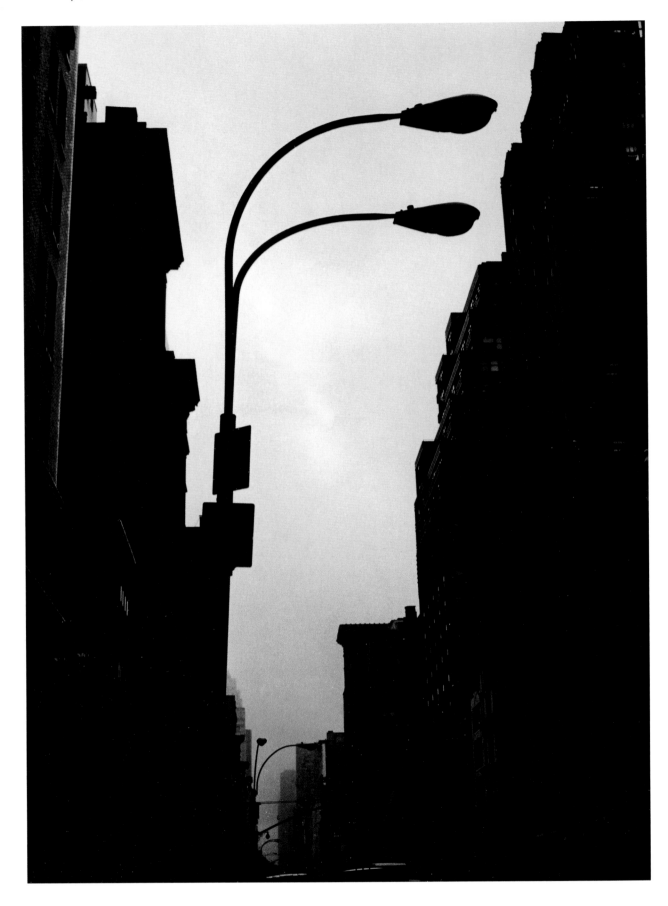

Untitled, New York, 1970/78

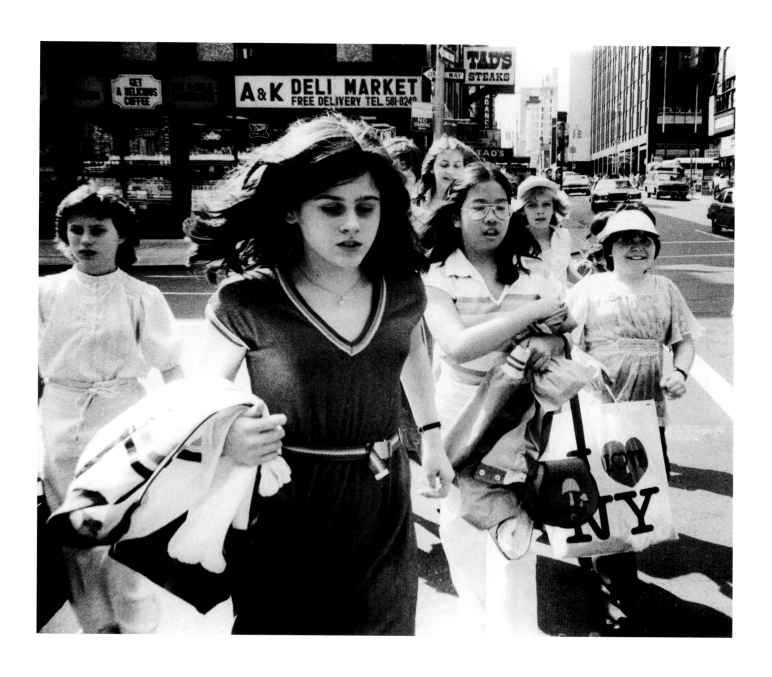

Nude, New York, 1978

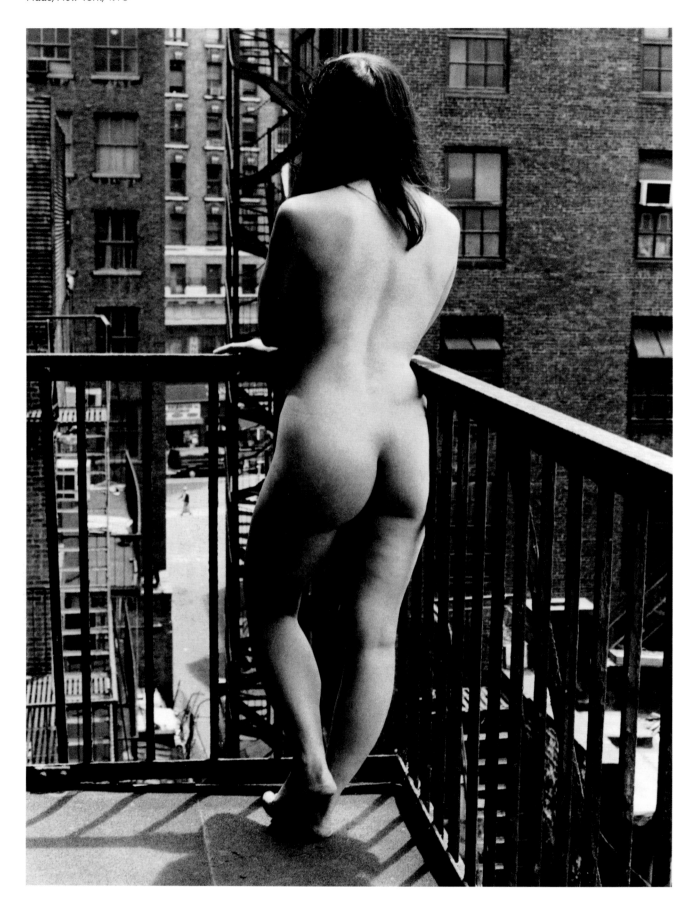

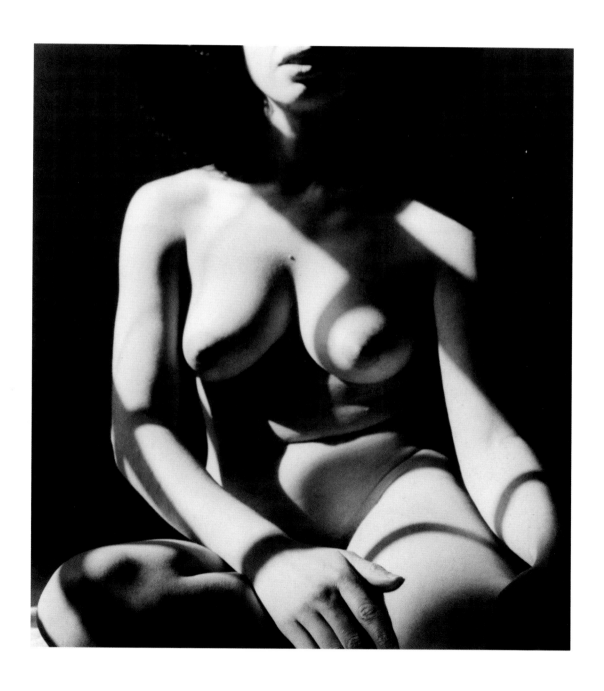

Untitled, Searsmont, Maine, 1960/70

Untitled, Searsmont, Maine, ca. 1973

Ferns, Maine, ca. 1989

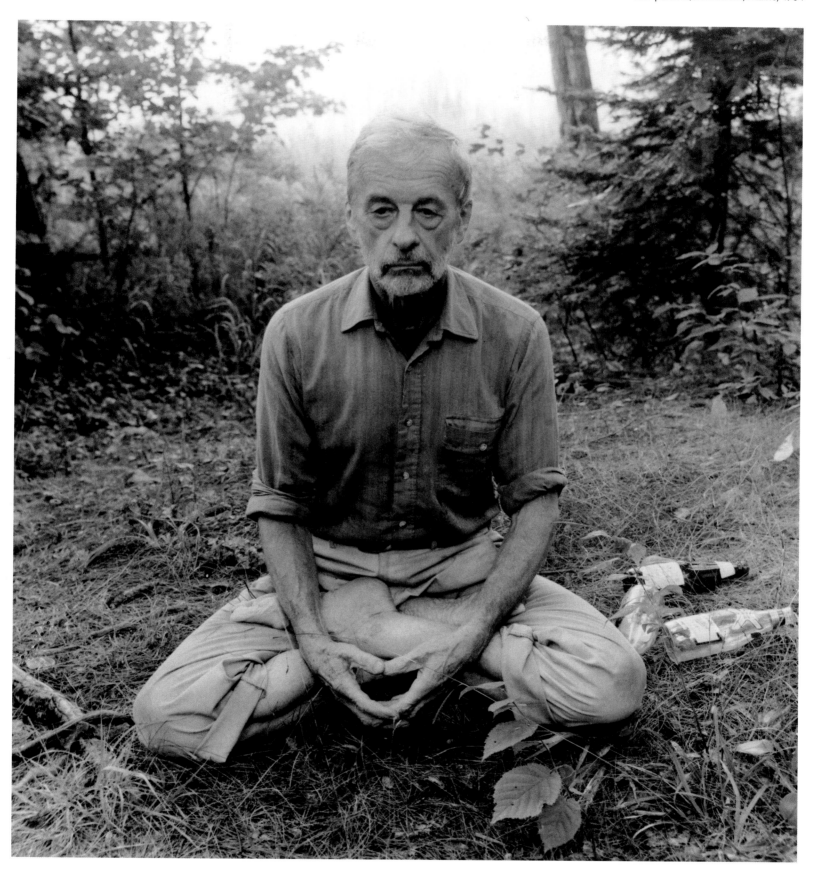

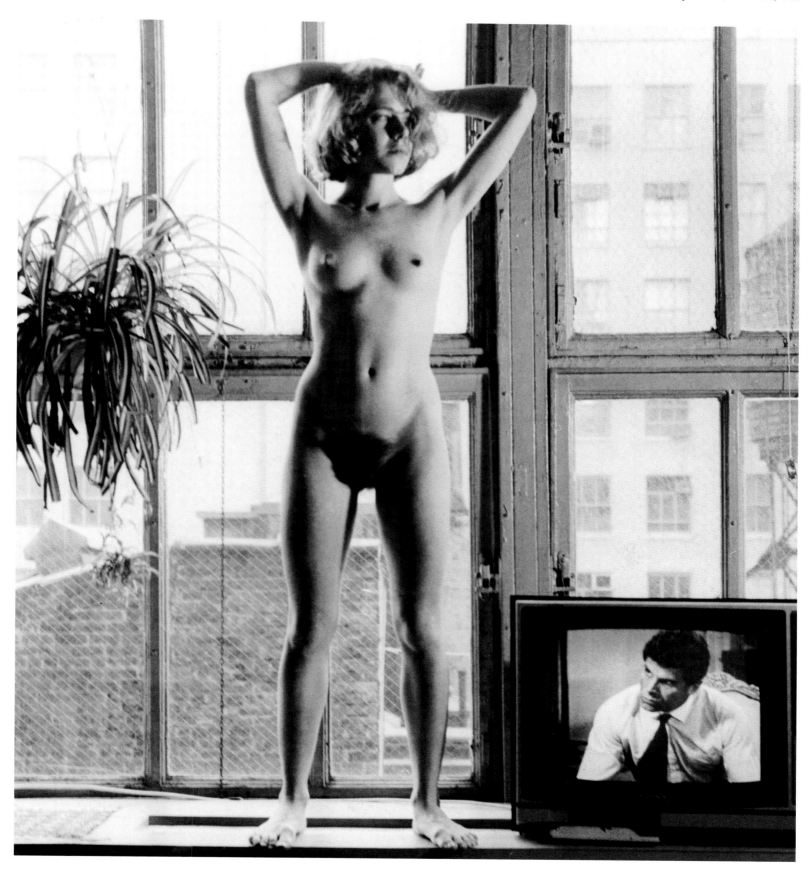

Bomba o Terremoto, New York, 1985

Untitled, New York, 1992

Glitter, Searsmont, Maine, 1992/94

Birch Bark, Searsmont, Maine, 1997 | Birch Tree, Skowhegan, ca. 1994

Bunchberries, Searsmont, Maine, 1997